Cathy Joseph

Outdoor Lighting: **Fashion & Glamour**

Published by AVA Publishing SA
rue du Bugnon 7
CH-1299 Crans-près-Céligny
Switzerland
Tel: +41 786 005 109
Email: enquiries@avabooks.ch

Distributed by Thames and Hudson (ex-North America)
181a High Holborn
London WC1V 7QX
United Kingdom
Tel: +44 20 7845 5000
Fax: +44 20 7845 5055
Email: sales@thameshudson.co.uk
www.thamesandhudson.com

Distributed by Sterling Publishing Co., Inc.
in USA
387 Park Avenue South
New York, NY 10016-8810
Tel: +1 212 532 7160
Fax: +1 212 213 2495
www.sterlingpub.com

in Canada
Sterling Publishing
c/o Canadian Manda Group
One Atlantic Avenue, Suite 105
Toronto, Ontario M6K 3E7

English Language Support Office
AVA Publishing (UK) Ltd.
Tel: +44 1903 204 455
Email: enquiries@avabooks.co.uk

ISBN 2-88479-020-9

10 9 8 7 6 5 4 3 2 1

Design by Gavin Ambrose

Cover image by Farrokh Chothia

Production and separations by AVA Book Production Pte. Ltd., Singapore
Tel: +65 6334 8173
Fax: +65 6334 0752
Email: production@avabooks.com.sg

Acknowledgements

Many thanks to all the photographers who contributed their pictures to this book and generously gave their time and shared their expertise. Thanks also to Brian Morris, Natalia Price-Cabrera and Laura Owen at AVA Publishing, Sarah Jameson for picture research and Gavin Ambrose for the book design.

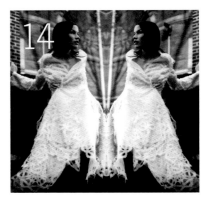
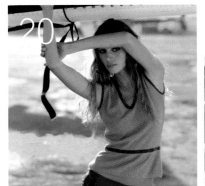
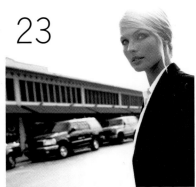
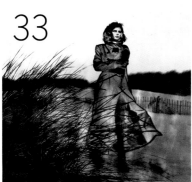
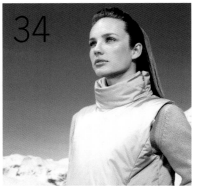

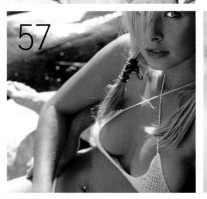
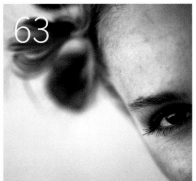
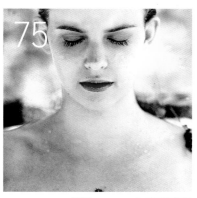
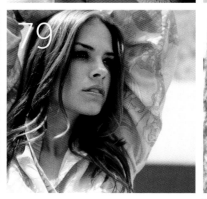
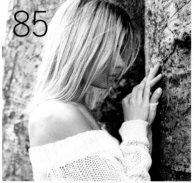
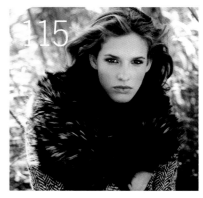
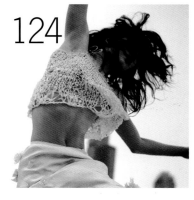
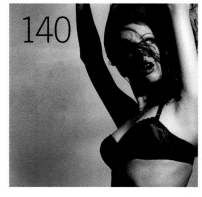

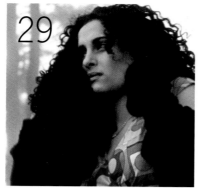

Contents

Introduction

Fashion and glamour photography is about selling dreams; dreams of the lifestyle that goes with the clothes, the shoes, the location and perhaps the body too. Aspirations differ and so do the pictures that reflect them. Even within the same publication, one spread may appeal to lovers of exotic luxury while a few pages later the mood is of soft and subtle romance or perhaps fast-paced urban living. Magazines need to satisfy all their readers and photographers need the versatility to please magazines.

Unless cleverly disguised with intricate backgrounds and props, studios are not usually the kind of places dreams are made of, for all the convenience they offer. Like it or not, most fashion and glamour photographers find the bulk of their work takes them out on location. After all, where better to show off a bikini than on the golden sands where it's likely to be worn? Or a winter coat than in the chill of a frosty morning?

Outdoor photography comes with its challenges. True, you have less control than in the studio. Instead of having everything to hand, you have to take it all with you and, as anyone who has ever boarded an aircraft with several cameras, an array of lenses, stocks of film, flash equipment, reflectors and more will tell you, that's no easy feat.

There is also more planning involved, often to an extremely tight schedule. Locations have to be found, travel arrangements made, meals organised and so on. Not simply for the photographer and model, but the whole team which will often include a make-up artist, stylist, the client or art director and photographer's assistant.

Then there is the biggest consideration of all, the lighting, which is the principal subject of this book. No, you can't pre-plan every exposure when you're shooting outdoors and yes, you may get hit by a freak thunderstorm that means a whole afternoon looks like a write-off, but there is no greater tool at the photographer's disposal than the light from the sun. It's a time-consuming business, waiting around for the clouds to burn away, or hoping against hope for a ray of light to shine through a dark grey sky, but when it all comes together, there is nothing more magical.

Using natural light in photography, just as in painting, is an art in itself, involving instinct, experience and skill. You know when you've pulled it off when the viewer is hit between the eyes by the impact of a shot, without being at all aware of the tricks and skills to achieve it. This could be as subtle as the careful placing of a reflector (or even the choice of its colour), a matter of waiting half an hour for shadows to grow longer, or the artful use of flash to complement the sun.

Few great photographs happen by accident. Learning to understand natural light, to manipulate, supplement and control it, is the best way to make success more likely. This book aims to help by revealing the thought process and techniques behind a collection of stunning images, from the client's initial brief to the printed page. It shows how the photographers have achieved their final results by the choices they have made. Every decision counts, from the timing of the shoot to the angle of the camera.

The pictures show the diversity of styles within the umbrella of fashion and glamour photography and the extraordinary range of effects possible from the starting point of a single light source. They also represent different sectors within the industry, from editorial and cover shoots to catalogues, model and personal portfolios.

The market you are working for will no doubt influence the lighting. If it's purely personal, you can have fun and experiment, otherwise there will be a client to satisfy and a brief, of varying stricture, to follow. With editorial shoots for fashion and lifestyle magazines there is usually a set theme, inspired by the time of year and the clothes or accessories to be featured. The photographer, particularly if well established, is often given a lot of freedom to interpret this, working together with a stylist or art director. The location, the desired mood of the pictures and the look of the model, will all influence the choice of lighting.

For other jobs, you have to do what you're told and if that means every picture must be shot in bright, direct sunlight, it's up to you to make the very best of it. Some clients will have a hatred of backlight or side light, some a passion for strong flash with an underexposed background. You will undoubtedly have to tackle the trickiest outfit to expose correctly – the black-and-white ensemble.

Whatever commission you work on, the most important traits of an outdoor photographer are probably patience and flexibility. The weather can put paid to the best-laid plans and with the clock ticking, you have to be inventive enough to find alternatives, even when there appear to be none. As one photographer remarks in this book, 'Time is money, and having the light is like gold.'

The pictures on the following pages are here to provide ideas, solutions and a source of inspiration in a demanding, challenging but highly rewarding area of photography. They should also demolish any preconceived notions that you get what you're given when shooting outdoors. With planning, thought and skill, the possibilities are endless.

How to get the most out of this book

Divided into seven chapters, this book sets out how to get great results when shooting fashion and glamour outdoors. Read in its entirety, it covers all the ways in which light can be used and manipulated to best effect, from choosing the time of day to adding artificial lights and creating mood through filtration and reflection. Alternatively you can dip into the book at any point. Each spread is self-contained, concentrating on a particular aspect of outdoor lighting. As such, the book can be used as a problem solver for specific areas of interest, for example, how to effectively balance flash with daylight.

The text

The main (or, in some cases, sole) picture on each spread is accompanied by four paragraphs of text, with the headings, The brief, The location, Composition and Lighting and technique. These explain the background to the picture and the thought process of the photographer as he or she set out to achieve it. The image is analysed to pinpoint its strengths, look at compositional devices and see how the location was chosen and used to best effect. The technique and lighting employed are described in straightforward easy-to-understand language, with specific photographic terms explained in the glossary at the back of the book.

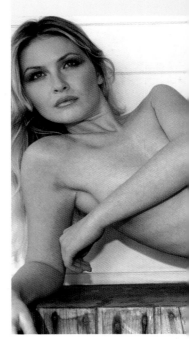

Fact file

		Technical detail	
Photographer:	Marco Tenaglia	Camera:	Nikon T9
Client:	Photographer's portfolio	Lens:	24mm
Model:	Mila, IS Model Management and Blush Model Management	Film:	Fuji Astia
		Exposure:	Not record
Location:	Sabaudia, Italy		
Time of day:	Mid-afternoon		

'When you're shooting outside yo have to have an open mind to different possibilities depending the circumstances – especially changes in the weather.'

Marco Tenaglia

Diagrams

These show the direction of the sun, position and type of camera and any additional equipment that was used, such as reflectors and flash or tungsten lighting units.

Quotations

The photographers' own words refer to their picture and explain what they were trying to achieve, any problems they encountered and tips they can pass on.

Technical details

Camera, lens, film and exposure are included in a panel alongside every picture. This helps the reader understand how the choice of equipment may affect the result.

Inspiration

The pictures are intended to provide a source of inspiration and ideas and can be enjoyed in their own right by professionals, students and all followers of fashion who appreciate quality imagery.

Information

The written information explains how the pictures were achieved, thus giving the reader the background knowledge and confidence to try a similar effect for themselves.

Fact file

Information in this panel includes the photographer, the client, the model and agency, location and timing of the shot. A fact file accompanies every picture in the book.

Shade over model from roof of bar

35mm camera (hand-held)
Flashgun on hotshoe

Sun

The brief

This was taken for Marco Tenaglia's own portfolio, to show potential future clients who will want to see the range and style of his work. He prefers not to pre-plan his pictures in detail although he usually has an idea of what he hopes to achieve. He often finds that new possibilities develop during the shoot as the light changes or he finds a different angle that works well. It's important for him that the whole team, including the model, the make-up artist and his assistant, co-operate together and that everyone is receptive to ideas.

The location

The beach at Sabaudia, near Rome, is one of Marco's favourite locations because it offers a variety of angles, backgrounds and props within a small area, allowing him to take many completely different shots. Here the model is reclining on the window seat of a beach bar, which was closed at the time.

Composition

Marco has framed the shot very tightly, so the model is almost leaning against the edge of the picture. The diagonal of the arm across her chest works well with the angle of her raised leg, making the pose look comfortable and natural rather than awkward. The green window is an important element because it means the eye is drawn to the model's face, which stands out against the white background.

Lighting and technique

The roof of the bar provided open shade, so there was no direct light from the sun falling on the model. This can have a subtle and flattering effect for portraiture, but Marco wanted to lift the skin tones a little more and so used a small electronic flash mounted on the hotshoe of his camera to provide fill-in. The humble portable flashgun is an inexpensive and simple way of enhancing natural light. It can be made fairly versatile too, by diffusing it with tracing paper, bouncing it off a white wall or ceiling, or using an extension lead to vary its position. To balance flash with daylight for a fill-in effect, the general rule is to expose correctly for daylight and underexpose the flash by one or two stops. You can do this by setting the film speed indicator on the flash by two stops more than the film in the camera (ISO 100 film becomes ISO 400 on the flash). In this case, Marco overexposed the film by one stop from the suggested meter reading to make the skin look clear and flawless.

' If you're overexposing by one or two stops to make the skin look smooth, the make-up needs to be stronger so that it looks normal in the final result.'

Marco Tenaglia

This was taken outside the same beach bar but facing in the opposite direction, towards the sea. Later in the day, the sun was lower here, and coming from behind and to the left of the model, as she is in the picture. Again Marco used on-camera flash to brighten up the skin tones and fill-in areas of shadow. ⤓

Fact file		Technical details	
Photographer:	Marco Tenaglia	Camera:	Canon T90
Client:	Photographer's portfolio	Lens:	24mm
Model:	Mila, IS Model Management and Blush Model Management	Film:	Fuji Astia 100
		Exposure:	Not recorded
Location:	Sabaudia, Italy		
Time of day:	Early evening		

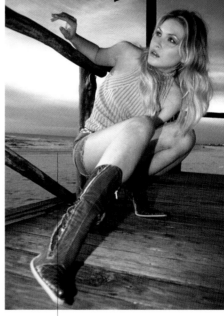

The pictures

Each spread is illustrated with one or more images, by the same or different photographers. The images have been chosen not only for their impact and quality but because they illustrate a particular technique or aspect of lighting.

Supporting pictures

These are used to further explore the theme of the spread. They are accompanied by a caption explaining technique, plus technical details and fact file panels.

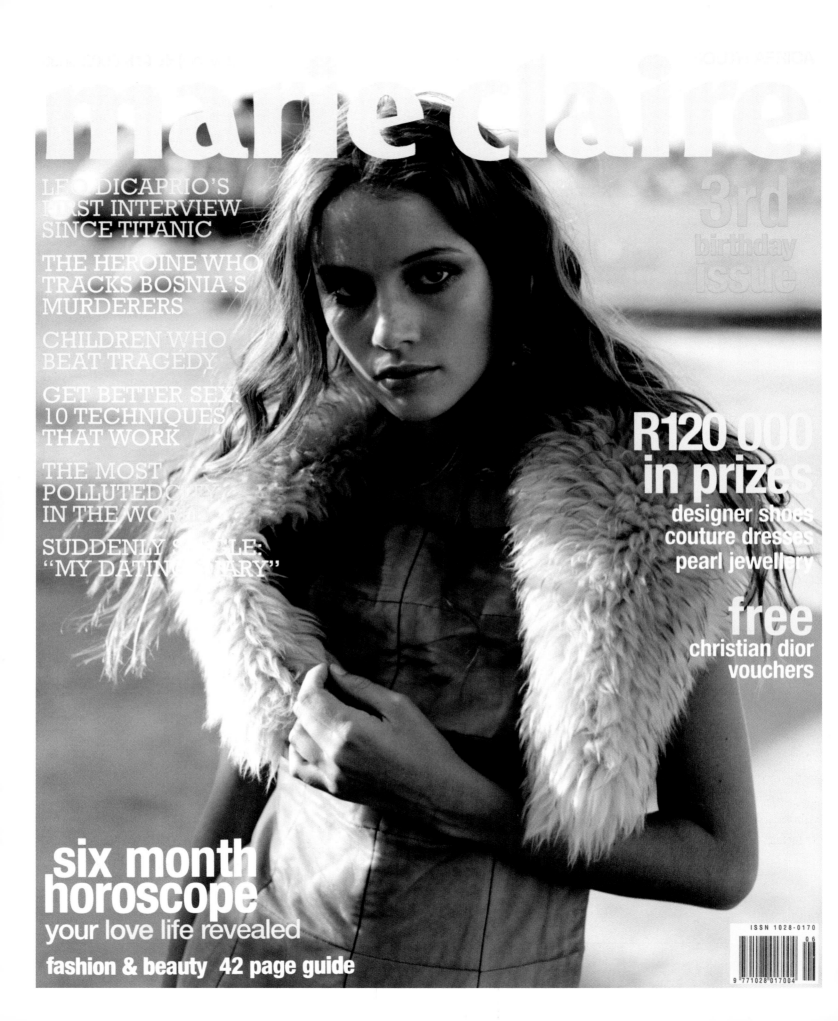

marieclaire

3rd birthday issue

LEO DICAPRIO'S FIRST INTERVIEW SINCE TITANIC

THE HEROINE WHO TRACKS BOSNIA'S MURDERERS

CHILDREN WHO BEAT TRAGEDY

GET BETTER SEX: 10 TECHNIQUES THAT WORK

THE MOST POLLUTED CITY IN THE WORLD

SUDDENLY SINGLE: "MY DATING DIARY"

R120 000 in prizes
designer shoes
couture dresses
pearl jewellery

free
christian dior
vouchers

six month horoscope
your love life revealed

fashion & beauty 42 page guide

ISSN 1028-0170

9 771028 017004 06

Chapter 1: **Planning for the light**

The day of a fashion shoot – and more often than not it will be a single day – is generally pressurised and allows little time for artistic pauses, changes of mind or mistakes. Forward planning is essential and this will usually begin with a brief from the client or, if it's personal work, the photographer's concept.

All sorts of factors need to be considered before a shoot, and these are explored throughout the book. Perhaps the three most important are the fashion items to be featured, the location and the light. Make sure you're familiar with the former well in advance as it will be the basis for most of your decisions. The stylist, fashion editor or even the fashion designer are your allies here.

Wherever possible, explore the location before the shoot, too. Keep your eyes open for interesting natural or architectural features; look for different angles, props and backgrounds and take Polaroids or digital snaps of your findings.

The light goes hand in hand with the location. Observe the effect of the different position of the sun throughout the day. Look out for areas of open shade, hard, graphic shadows, reflective water, sand or buildings – whatever will contribute to the effect you are after.

Once you've done your research you can draw up a plan of where and when you intend to take each shot, saving everybody time on the day. Of course there are no guarantees that it will all go smoothly, but you can certainly shift the odds in your favour.

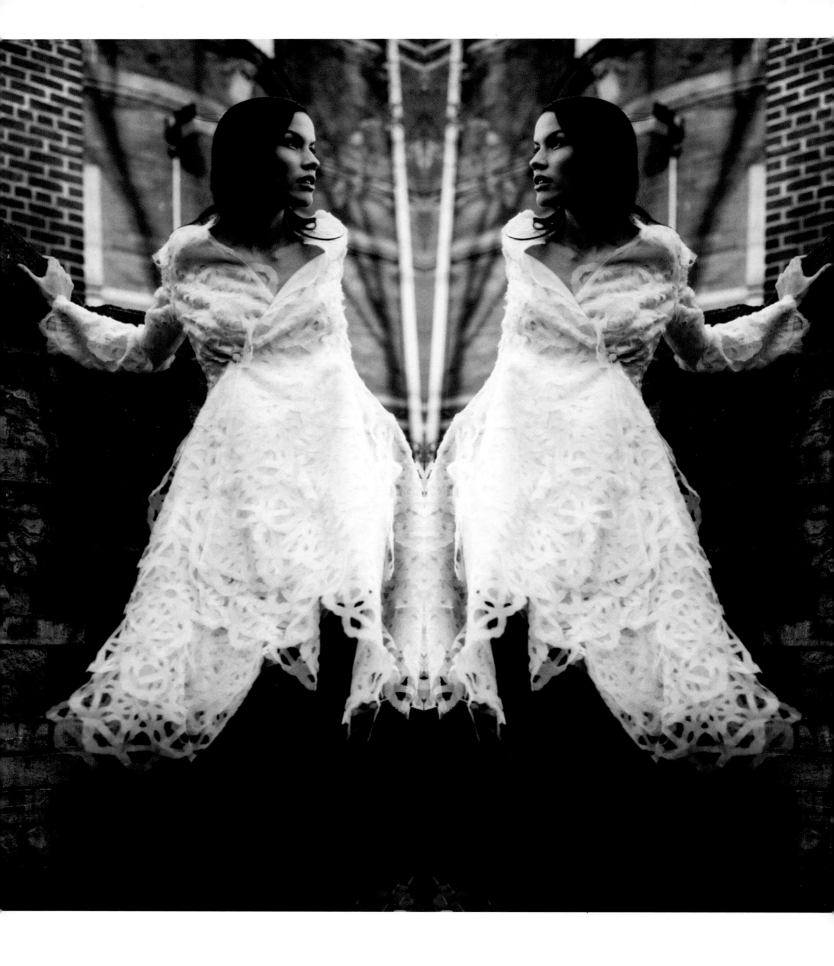

The brief

This was for a spring fashion story called 'Fairy Tale', featuring a dress design called 'Snowflake' by Yumi Eto of Canada. 'With Harper's Bazaar, I will discuss the fashion direction and the photographic direction with the editors via emails and phone conversations,' explains David. 'They have enough trust in me to then leave it to me to create the imagery for the fashion story without outside intervention.'

The location

The idea behind the story was that an ordinary girl had been transformed into a princess in a beautiful dress (a bit like Cinderella). This location was chosen because it looks like the unpretentious backyard of a small house where she might have lived.

Composition

The 'mirror image' was created from a single shot using the computer software Adobe Photoshop. David had planned this from the start and so the pose and composition were judged with this in mind. An alternative would have been to use an actual mirror, but the effect chosen here is more unusual and striking.

Lighting and technique

The dress design was highly detailed and so David wanted directional light that would 'fall off' into shadow to contrast with the white. The brick wall provided the shadow areas and the directional light came from late afternoon sun from the side. A white reflector was also used at a sharp angle to fill in detail.

Fact file

Photographer:	David Anthony
Client:	Harper's Bazaar (Latin American edition)
Model:	Joanne, Next Agency
Location:	Toronto, Canada
Time of day:	Late afternoon, spring

Technical details

Camera:	Pentax 6x7
Lens:	105mm
Film:	Forte Pan 400 rated at ISO 250
Exposure:	1/125sec at f/8

' This story came about from a pig mask I found in a flea market in Mexico City. I showed it to my editors and we discussed the fairy tale idea.'

David Anthony

Sun

White reflector

Medium format camera

The brief

This was taken for Elle magazine in Romania, for which Cosmin shoots a fashion story every month. He never receives much in the way of a brief from them, but works closely with a fashion stylist who shows him the clothes to be featured. It's not easy coming up with new ideas for the same publication on a regular basis. While it's necessary to experiment with new techniques and different locations, it requires a certain amount of courage, and the trust of the client to do so. His plan here was to achieve an overall wash of colour in the image, from which the model would stand out.

The location

Cosmin wanted to find a location that would work with his colour-wash idea. He chose a forest because it's a common and recognisable setting and the green and brown tones would respond well to the blue colour cast he intended for the image.

Composition

The image has a dream-like atmosphere, helped by the reclining pose of the model and her dark, shadowy surroundings. Cosmin tilted the camera to enhance the sense of unreality. The plants in the foreground, in focus and catching the light, create interesting patterns and textures, drawing attention to the contrasting smoothness of the model's skin and the silky fabric of the dress.

Lighting and technique

Although shot at midday, there is no direct sun in the picture because of an overcast sky and thick canopy of trees. Cosmin's main light was a Courtenay 1200 flash head, powered by a 3000w portable gasoline generator. The flash was positioned to the left of the camera and slightly behind the model so as to provide a near backlight effect. Its power was two stops higher than the ambient light to ensure it was the dominant light source. The blue colour cast on the foliage is a result of using tungsten-balanced film in daylight, which has the wrong colour temperature for it. Cosmin wanted the skin tones to look natural, though, so he used a Wratten 85B gel filter in front of the flash. This is an orange conversion filter which takes away the colour cast when tungsten film is used in daylight.

Flash head (slightly behind model)

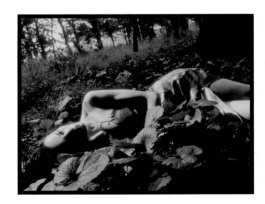

Medium format camera

'Every month I aim to get something distinctive from the shoot.'

Cosmin Bumbut

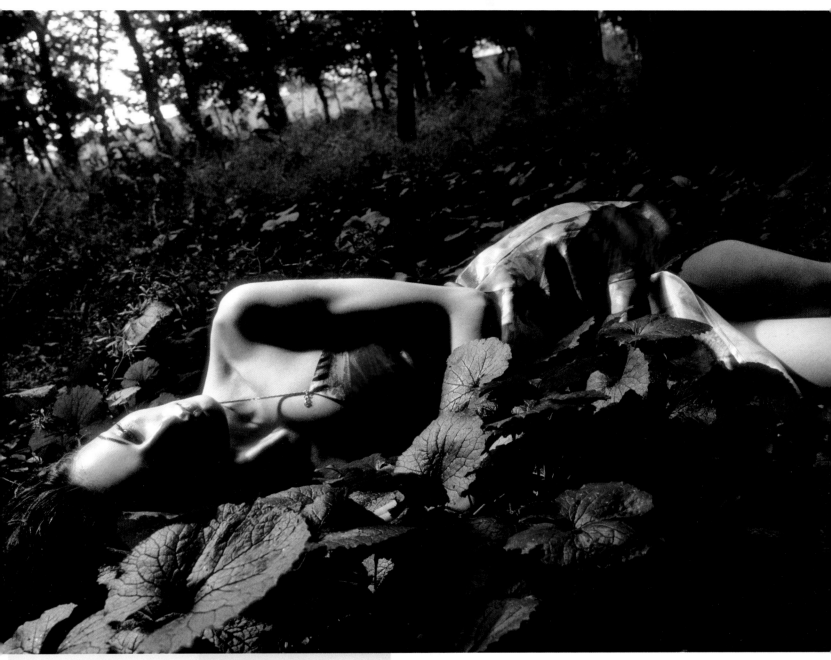

Fact file

Photographer:	Cosmin Bumbut
Client:	Elle (Romania)
Model:	Catrinel, MRA Agency
Location:	Baneasa forest, Bucharest, Romania
Time of day:	Midday, May

Technical details

Camera:	Mamiya RZ 67 Pro 11
Lens:	110mm
Film:	Kodak EPY 120, tungsten
Exposure:	1/30sec at f/8

Fact file

Photographer:	Kenn Lichtenwalter
Client:	Personal work
Model:	Edita
Location:	Prague, Czech Republic
Time of day:	Late afternoon

Technical details

Camera:	Leica R6.2
Lens:	28mm
Film:	Ilford HP5 Plus
Exposure:	1/125sec at f/8

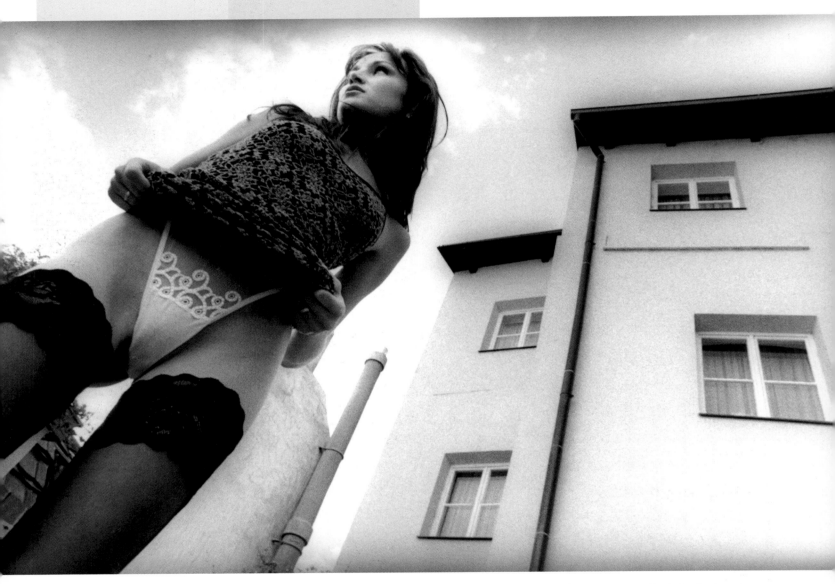

'I always prefer to shoot with just available light, but not in direct sunlight. I work on my own, and like to be able to move around, so prefer not to use flash equipment or reflectors.'

Kenn Lichtenwalter

The location

In Prague, on a personal photographic trip to work with a number of models, Kenn saw the potential of this courtyard behind a bed and breakfast establishment in the old town. 'The light was working really well there at this time of day, with the sun bouncing off the large walls creating a huge, soft light source,' he says.

Composition

'Of all the low angled images I have shot, I particularly like this one with its voyeuristic feel,' says Kenn. 'All of the elements work well together, the buildings with their windows in the background and the model's costume.' The imposing effect of the model seeming to tower over the viewer is exaggerated by a slight tilt of the camera and the model's position in the corner of the frame.

Lighting and technique

Using only available light on a slightly overcast day, the sun was just appearing from behind the clouds at this moment, allowing Kenn to get a sufficient exposure without the contrast becoming too high. The surrounding white buildings acted like giant reflectors, bouncing soft light on to the model.

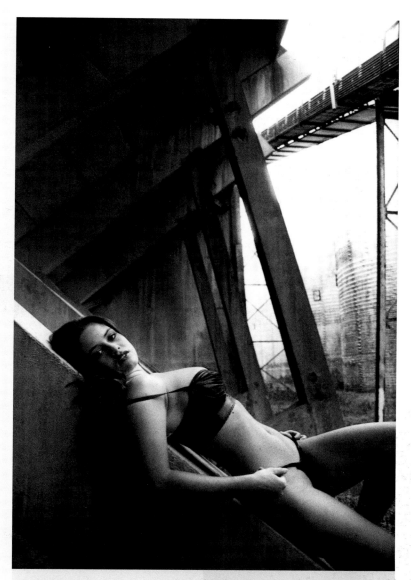

Sun appearing behind clouds

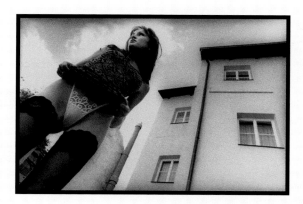

Camera low to ground

Fact file

Photographer:	Kenn Lichtenwalter
Client:	Personal work
Model:	Amy
Location:	Tampa, Florida USA
Time of day:	Late afternoon

Technical details

Camera:	Nikon FM2N
Lens:	28–50mm
Film:	Ilford HP5 Plus
Exposure:	1/60sec at f/5.6

Kenn wanted to increase his experience of working with models and found Amy through a glamour agency on the internet. He travelled to her home town of Tampa in Florida and found this abandoned sugar mill which he thought would lend itself to a strong, graphic composition. 'I asked her to lie on the beam so I could offset her with the many other columns and the conveyer belt in the upper right-hand side,' he says. Although it was a bright day, the model was shaded from direct sunlight by the overhanging structure above. ▲

The brief

Kai Haase was commissioned by a women's magazine to do a fashion shoot on the theme of travel. The photographs needed to convey a sexy, jet-set feeling to suit the clothes and the model, but Kai was given the freedom to interpret this in the way he chose.

The location

Kai wanted the travel theme to be clear in the pictures without it being the dominating factor – it's the clothes that are of most interest to the readership. He chose to use a private airport in Cape Town and also a helipad in the city belonging to a company that does charter flights. With prior permission, both locations allowed him to shoot during quiet periods, using parts of some of the small aircraft as props for the model. It's always worth approaching private companies, especially if the publication can offer to print a small acknowledgement in return for the use of their premises.

Fact file

Photographer:	Kai Haase
Client:	Marie Claire magazine
Model:	Angie Schmidt, Ice, Cape Town
Location:	Cape Town, South Africa
Time of day:	4pm

Technical details

Camera:	Pentax 6x7
Lens:	105mm
Film:	Kodak Portra 160 VC
Exposure:	Not recorded

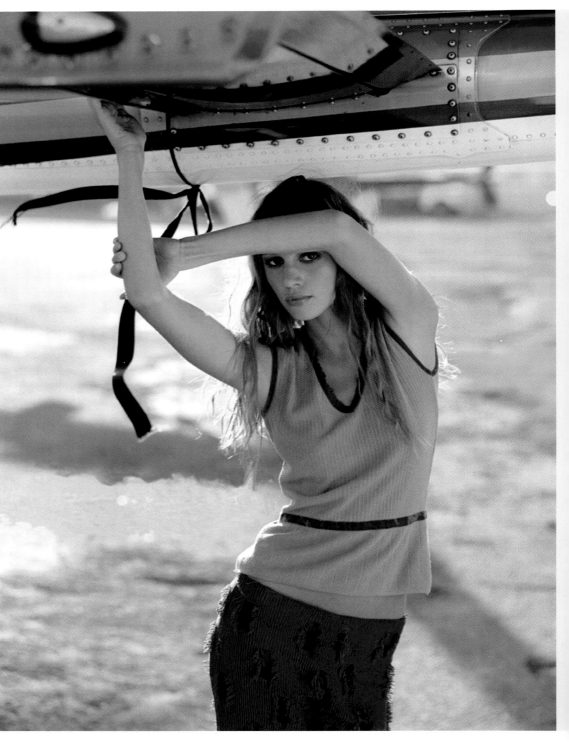

Composition

There is just enough of the aircraft at the top of this picture to provide the link with travel and flying without it being either corny or dominant. The graphic shape of the model's arms echoes the lines of the aircraft while the curve of her body prevents the shot from being too angular. The background does not distract the eye away from the clothes, but the faint hints of colour and the shape of the shadow add subtle interest.

Lighting and technique

The model was backlit by the mid-afternoon sun, which created an attractive rim-light effect on her hair and the edge of her body. A large white reflector held at a slight angle to the side of the camera bounced soft and flattering light on to the front of the model.

As well as tying in to the theme of the shoot, the aeroplane wing was both a useful prop for the model and a graphic element in the composition. This was taken in the warm light very late in the day, with the sun to the left of the photographer and a white reflector filling in the shadows on the other side. ⥥

' I visit the location before the shoot and work out where the light is at various times of the day, taking Polaroids or digital pictures for reference. Then I plan a shoot list – where and when I'll take the different shots. It's a bit like making a movie.'

Kai Haase

Sun

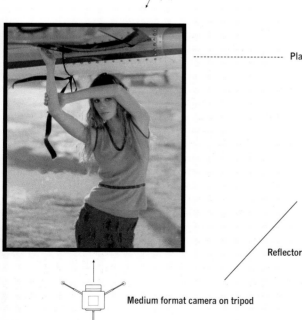

---------------- Plane

Reflector

Medium format camera on tripod

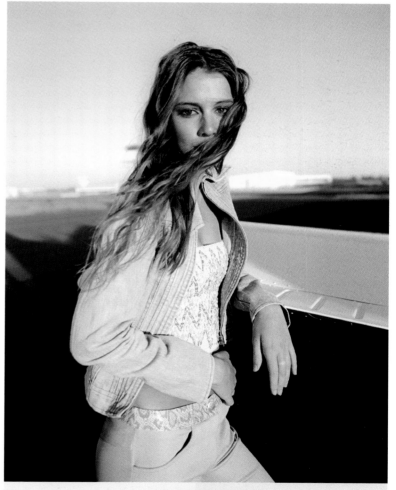

Fact file

Photographer:	Kai Haase
Client:	Marie Claire magazine
Model:	Angie Schmidt, Ice, Cape Town
Location:	Cape Town, South Africa
Time of day:	Evening

Technical details

Camera:	Pentax 6x7
Lens:	105mm
Film:	Kodak Portra 160 VC
Exposure:	Not recorded

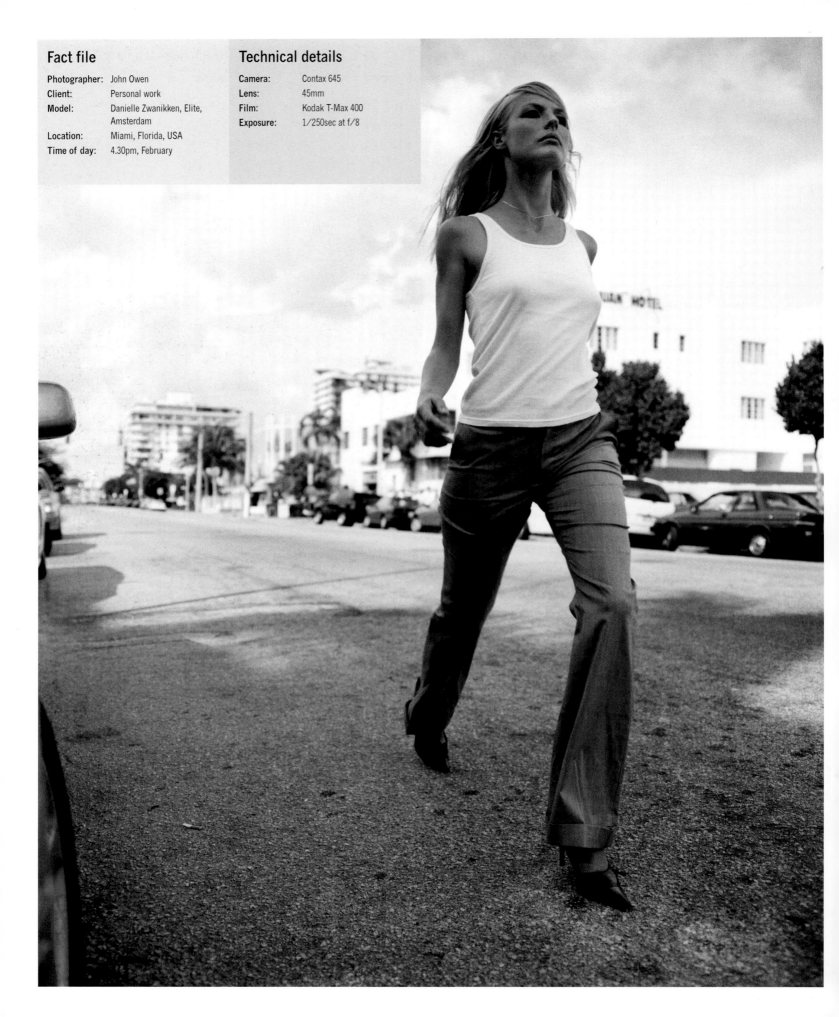

Fact file

Photographer: John Owen
Client: Personal work
Model: Danielle Zwanikken, Elite, Amsterdam
Location: Miami, Florida, USA
Time of day: 4.30pm, February

Technical details

Camera: Contax 645
Lens: 45mm
Film: Kodak T-Max 400
Exposure: 1/250sec at f/8

The brief

John was working in Miami on a catalogue shoot for a mail order company. After they had finished for the day, he spent a couple of hours with the model, following his own idea for a black-and-white fashion story with an edgy, reportage feel.

The location

John used a number of street locations for the story, including outside cafe bars, where the model mingled with the customers. Although based in England, he knows Miami quite well, having worked there on many occasions, so it didn't take him long to find this location. He picked it because he liked the broad sweep of the avenue, with the perspective of the cars lining up into the distance.

Composition

Taken from a low viewpoint with a wide-angle lens, it almost looks like the model is striding out of the frame, towards the viewer. The contrast between her purposeful movement and the deserted street works well, as does her position in the frame, just off-centre with plenty of space around her.

Lighting and technique

The light was still quite bright at 4.30pm but the open shade, provided by the shadow of a building, reduced the contrast on the model – as well as adding to the composition. John hand-held the camera and used a shutter speed of 1/250sec which was fast enough to ensure she was generally sharp, but not totally frozen, as she walked past him.

Sun

Medium format camera

Fact file

Photographer:	John Owen
Client:	Personal work
Model:	Danielle Zwanikken, Elite, Amsterdam
Location:	Miami, Florida, USA
Time of day:	6pm, February

Technical details

Camera:	Contax 645
Lens:	45mm
Film:	Kodak T-Max 400
Exposure:	1/250sec at f/5.6

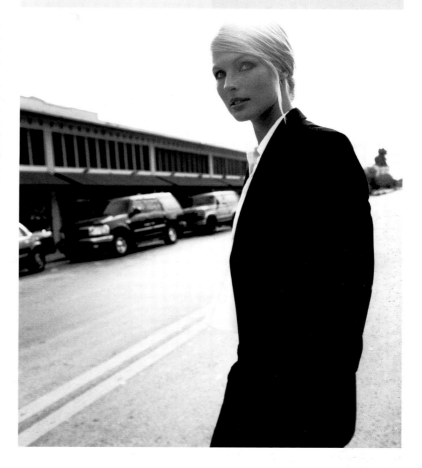

This composition makes even greater play of the strong perspective in the background, cut through by the upright form of the figure for a very graphic image that works superbly well in black and white. The model was backlit by the early evening sun and no reflectors or flash were used. ▲

' She was walking really quickly and it was hard to catch her in just the right position. I took several rolls of film as she did it over and over again, and this was the only shot that I felt worked well.'

John Owen

Fact file		Technical details	
Photographer:	Sam Short	Camera:	Canon EOS 3
Client:	Vancouver magazine	Lens:	28mm
Model:	Chen	Film:	Agfachrome ISO 100
Location:	Sea to Sky Highway, Vancouver, Canada	Exposure:	1/30sec at f/8
Time of day:	Late afternoon, early spring		

The brief

For an editorial spread for a magazine or newspaper, the photographer will usually have a discussion before the shoot with the art or fashion editor to establish the number of pictures needed, the items of clothing to be featured and possible locations. In this case, Sam was also given a proposed layout so she knew how many horizontal and vertical pictures would be required and she could start thinking of ideas.

The location

Sam scouted for locations before the shoot, deciding which would best suit the outfit for each picture. Sometimes the best-laid plans have to be changed, however, and this bridge was not Sam's original choice. 'It was the last shot of the day, very cold and windy, and I was losing light. I decided to use the bridge because it was closer than the location I had planned, and in the end it turned out better. I like the horizontal lines of the railings because they work with the lines of the dress.'

Composition

Sam was lying on her stomach, shooting upwards to take this shot. This angle, together with a 28mm wide-angle lens gives the model an elongated and statuesque appearance that suits the long lines of the dress. It also makes use of the sky as a background, which is less distracting than details in the landscape.

Lighting and technique

Making the most of the remaining light, Sam faced the model into it, looking upwards, thereby ensuring her face and neck were nicely highlighted. She used a shutter speed of 1/30sec, with the camera hand-held, which was just slow enough to show the movement of the dress in the wind, adding life to the shot.

Sun

Medium format camera

' I was losing light rapidly as storm clouds were moving in fast and the model was extremely cold. I shot off one roll of film in a very short time.'

Sam Short

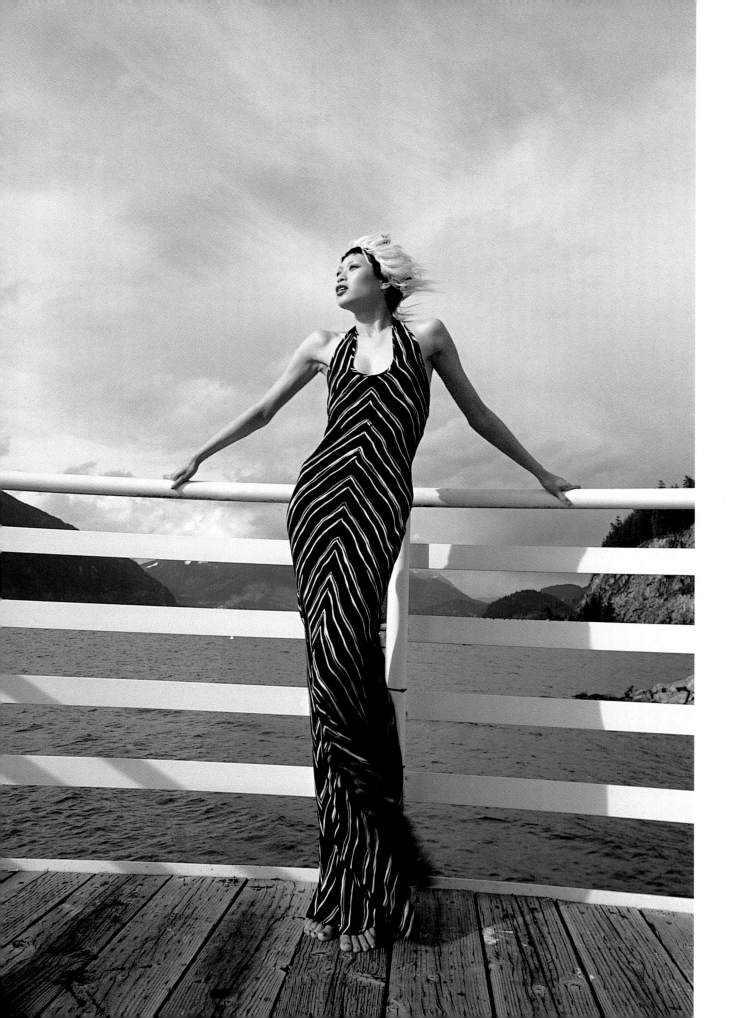

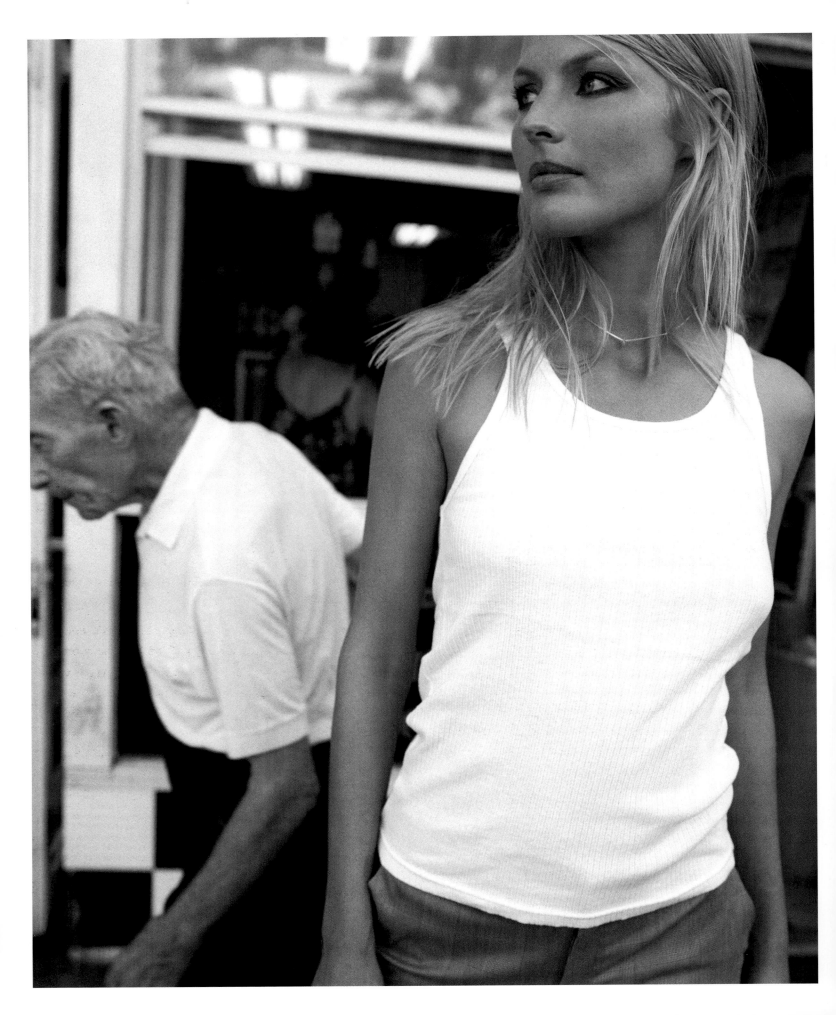

Chapter 2: **Timing the shoot**

Fashion is dictated by the seasons and because of long production schedules in advertising and editorial, this can often mean shooting snow scenes or golden beaches months before there's any sign of the white stuff or need for the sun cream. If the budget allows, the right weather can always be found on the other side of the world. Otherwise a few tricks in the way of lighting, filtration, composition or substantial forward planning will be called for.

It isn't just the month of the year that will impact on a shot, but the hour of the day, as the colour of daylight and the direction of the sun changes. Unlike the studio, where you can take as long as you like to tinker with the light, outdoor photography requires fast work by the entire team to get the shot in the bag before the sun retires behind clouds or disappears altogether below the horizon. Then you're in the realms of low-light photography, which can also be used to stunning effect.

The location

'The west of San Francisco has abundant natural beauty and all around the Palace of the Legion of Honor you have stunning vistas, trees, deep green grass and views of the Golden Gate Bridge,' explains Roddie. 'I looked north as the ground falls away to the golf course below. On a typically foggy San Francisco afternoon, the eucalyptus trees looked beautifully shrouded.'

Composition

Patrick prefers not to direct his models too much, but he placed Mitra on the right-hand side of the frame, leaving plenty of negative space to the left. 'She's an exotic, curvy woman and I saw her as a great complement to the ghostly, fog-shrouded trees. The reds in her dress contrasted with the cool tones of the background.'

Lighting and technique

The blue light of a very overcast or foggy day is not desirable in all pictures but is beautifully atmospheric in this wintry shot. Patrick lay flat on the ground so a few tufts of green grass were visible in the bottom of the frame to add a little contrasting vibrant colour. With the camera firmly supported in this position, Patrick was able to use a slow shutter speed without fear of camera shake, allowing him to close down the aperture from f/1.4 to f/2.8 and therefore capture the trees in sharper focus.

Sun hidden behind clouds

35mm camera

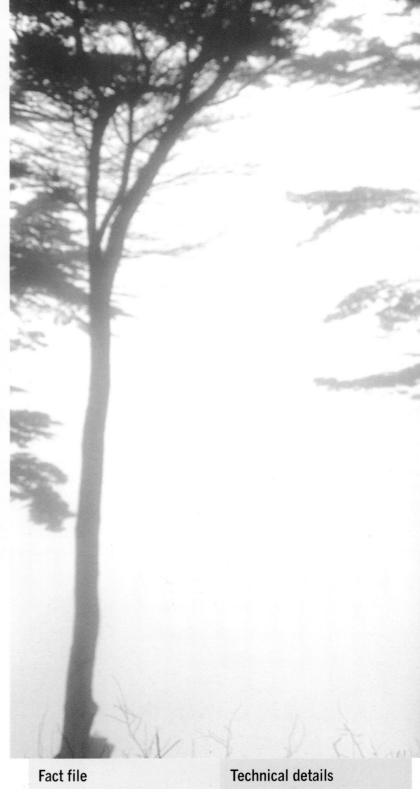

Fact file

Photographer:	Patrick Roddie
Client:	Photographer's portfolio
Model:	Mitra Ahani
Location:	San Francisco, USA
Time of day:	Late afternoon, March

Technical details

Camera:	Nikon F100
Lens:	50mm f/1.4
Film:	Fuji Velvia rated at ISO 40
Exposure:	1/30sec at f/2.8

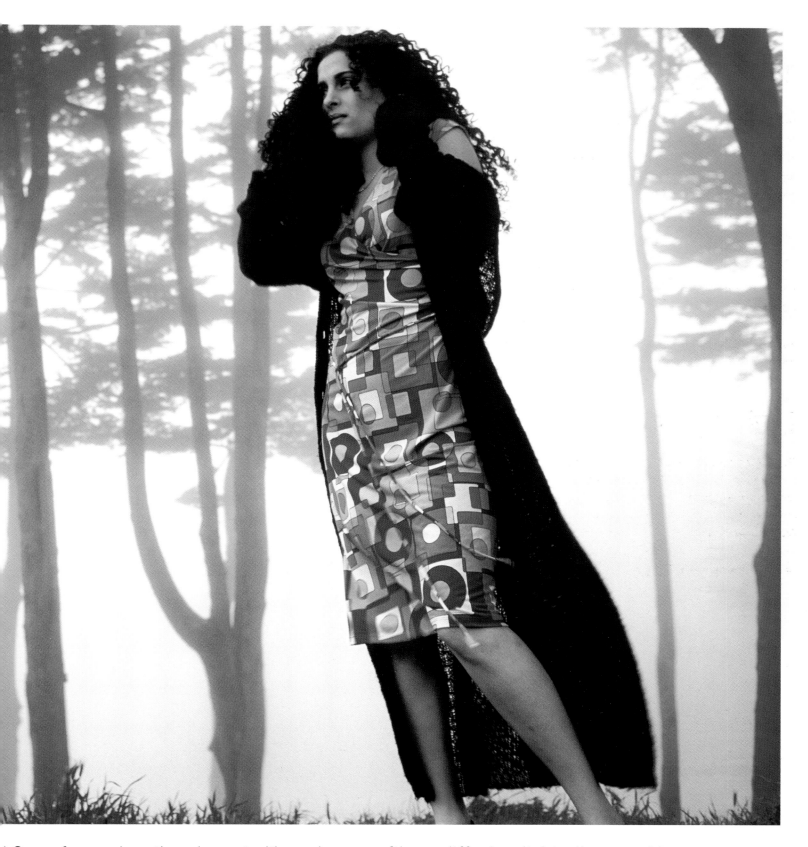

'On a foggy day, the sky acts like a huge softbox, diffusing light all around.'
Patrick Roddie

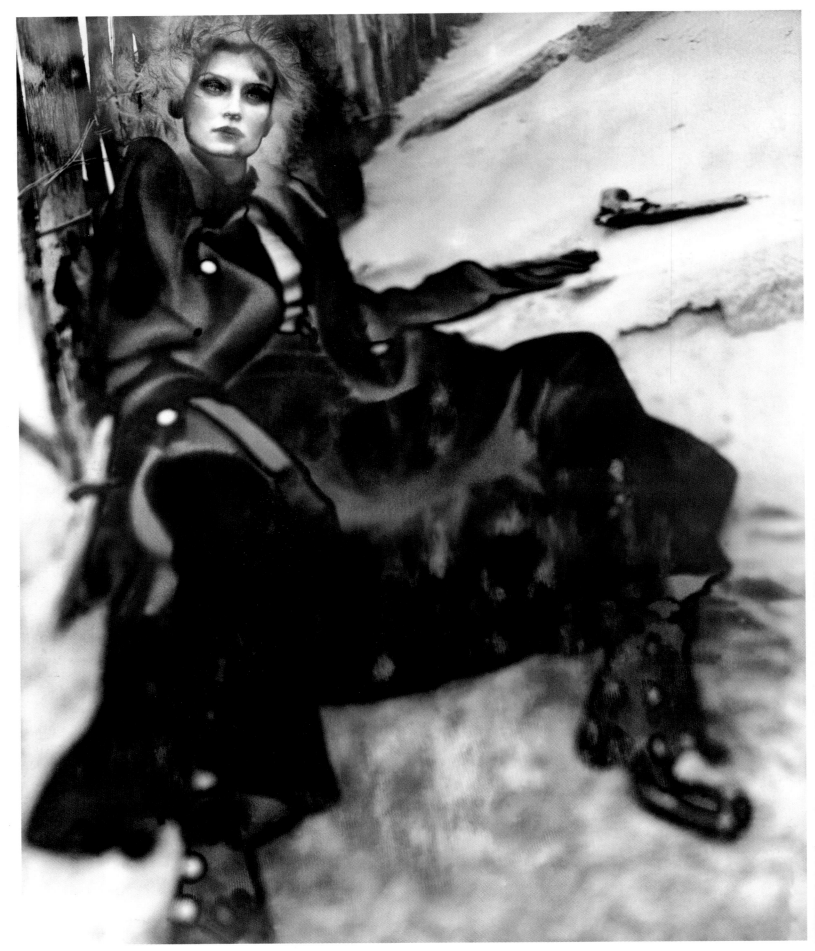

The brief

This is one of seven photographs commissioned from Gry Garness by Scene magazine to show military-style fashion, such as double-breasted coats and big boots. The magazine, and the stylist, Alison Fitzpatrick, wanted the images to form a story about a lost Confederate soldier and Gry was given free interpretation of this brief. 'I suggested a slightly aged, solarised look to the images,' she recalls. 'The model is looking battle-ragged, and I thought that aspect would be emphasised by the Polaroid markings and the solarisation technique. I preferred that effect to the clichéd sepia-toned, old-fashioned look.'

The location

The pictures in this series had to convey the kind of stormy weather and rugged landscape in which this type of clothing would be worn. Camber Sands, on the south coast of England, has several useful compositional elements in one area – the sea, large stretches of sandy open space and grassland.

Composition

Gry wanted to convey the idea that the 'soldier' has slumped down, exhausted and she's managed to achieve this, while still bringing out the elegance and femininity of the model's head and shoulders. She forms a triangular shape in the frame, echoed by the smaller triangle of the wooden fence behind her.

Lighting and technique

'We had beautiful soft light earlier in the day, but when we came to do this shot at around 4pm, the light faded suddenly, the temperature dropped from 15°c to 10°c, and it started to rain. The light was now flat and dull, but coming mostly from the left of the camera. We used a reflector on the opposite side to brighten up this area a little.' The overall look of the image is affected by the solarisation technique, which is explained on the following page.

' I like the dark feeling of the shot. She's supposed to look beaten and she does.'

Gry Garness

Fact file

Photographer:	Gry Garness
Client:	Scene magazine
Model:	Che Ledbetter, Models 1
Location:	Camber Sands, Kent, UK
Time of day:	4pm, October

Technical details

Camera:	Sinar F1 5x4
Lens:	90mm Super Angulon f/8
Film:	Polaroid Type 55
Exposure:	1/2sec at f/8

Reflector

5x4 large format camera

Sun diffused by clouds

Fact file

Photographer: Gry Garness
Client: Scene magazine
Model: Che Ledbetter, Models 1
Location: Camber Sands, Kent, UK
Time of day: 11am, October

Technical details

Camera: Sinar F1 5x4
Lens: 90mm Super Angulon f/8
Film: Polaroid Type 55
Exposure: 1/125sec at f/11

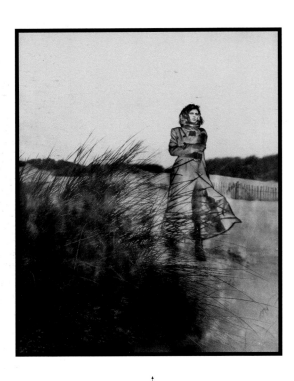

Sun diffused by clouds

5x4 large format camera

The brief

This was part of the same fashion story as the image on the previous page, featuring military-style winter clothing, using the theme of a lost Confederate soldier.

Composition

Gry composes her pictures by intuition, rather than following any rule book, and the composition is quite unusual here. The model is relatively small in the frame for a fashion shot and large areas are taken up with sky and the long grass in the foreground. The effect of this, together with the use of black and white, is to make the shot look more like a piece of reportage than staged fashion, which really helps bring the invented story of the lost soldier to life.

Lighting and technique

On an autumn morning, the light was quite bright, but very soft, with cloud cover acting as a huge softbox. Gry had no need to modify the light at all since the sand the model was standing on, and the sea in front of her, bounced light on to her face and coat. The image was printed on to fibre-based Ilford multigrade paper and slightly bleached with potassium ferrycyanide. After scanning it into the computer, Gry balanced the tones further than she could in the darkroom and split-toned the image using Photoshop software, to give slightly yellowish highlights and blue-red shadows.

Solarisation

The distinctive, quite ghostly appearance of this shot, and the one on the previous page, was created by the solarisation technique. Gry explains her method: 'Using Polaroid Type 55 film in an instant film back on my 5x4 camera, I cut the Polaroid processing time in half, revealing the Polaroid negative after 10–15 seconds. I then flashed it with a Vivitar 283 flashgun. The Polaroid negative went into a black, light-tight container for two minutes to let development and solarisation take place. I then put the negative into a solution of sodium sulphate to clear, which gives me a solarised negative. The effect is "fluffy", especially in soft focus, dark areas, and it inverts the darkest tones to almost white. The complete process is done at the location.'

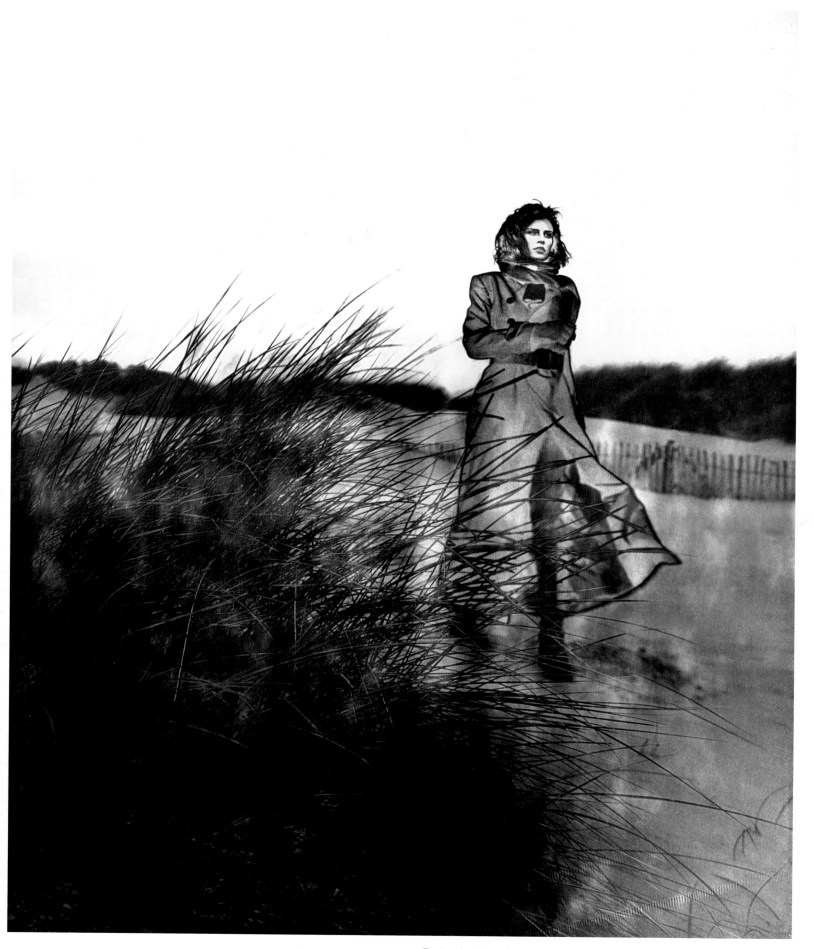

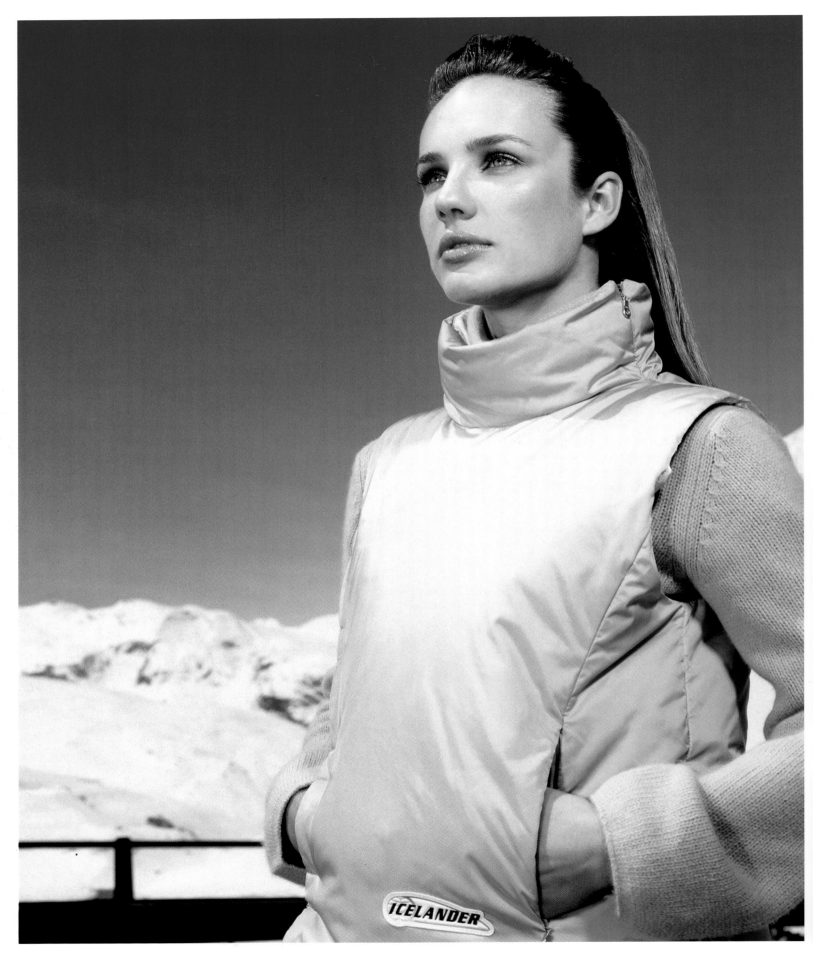

The brief

The Swiss fashion magazine, Meyer's, commissioned Christian Dietrich to produce an eight-page editorial entitled 'Icebreaker', featuring apres-ski wear. Seasonal stories like these involve a great deal of forward planning. Christian's pictures were due to be published at the end of November, as the skiing season picked up. To ensure snow in the pictures, and still give the magazine the production time it needed, the shoot had to take place at the end of the previous ski season, in April.

The location

This picture was taken quite high up in the mountains of the Swiss Alps, to ensure a good covering of snow and a magnificent view. Fortunately it snowed the day before but cleared up in time for the shoot.

The blue cast is the effect of the fading light, just after sunset on a December evening, when the warm rays of the previous hour had vanished. Shooting at just the right time of day is an effective way of portraying an atmospheric wintry feel. ▼

Composition

The lighting and the pose were designed to give the clearest view of the clothing featured. Christian shot the picture from a lower angle, looking up at the model, which makes her look imposing and glamorous. It also allowed him to include plenty of the clear blue sky, which makes her stand out from the background.

Lighting and technique

Because of the height of the location and the reflective qualities of the snow, the sunlight was extremely bright, coming from the left of the camera. To achieve the shadowless, almost luminous, quality of light on the model and jacket, Christian combined flash with the existing light. The main unit was placed next to the camera on the right, slightly higher than the model's head. The second unit was used as fill-in on the left side. Both flash heads were aimed directly at the model, with only a small reflector and no diffuser attached. Each light was powered by its own Broncolor 1200 J battery-pack, used at full strength.

Fact file

Photographer: Patrick Roddie
Client: Photographer's portfolio
Model: Erin Mahoney
Location: San Francisco Bay, USA
Time of day: After sunset, December

Technical details

Camera: Nikon F100
Lens: 50mm f/1.4
Film: Fuji Velvia
Exposure: 1/60sec at f/2.8

Fact file

Photographer: Christian Dietrich
Client: Meyer's magazine
Model: Olga, Fotogen, Zurich
Location: Swiss Alps
Time of day: 11am, April

Technical details

Camera: Mamiya RZ Pro 11
Lens: 110mm
Film: Fuji Provia 100
Exposure: f/22

Sun

Fill-in flash head

Medium format camera

Main flash head

' I believe you should crop out what isn't absolutely essential to the image. This is clearly a beautiful, quirkily dressed young woman. It doesn't matter that you can't see her face.'

Patrick Roddie

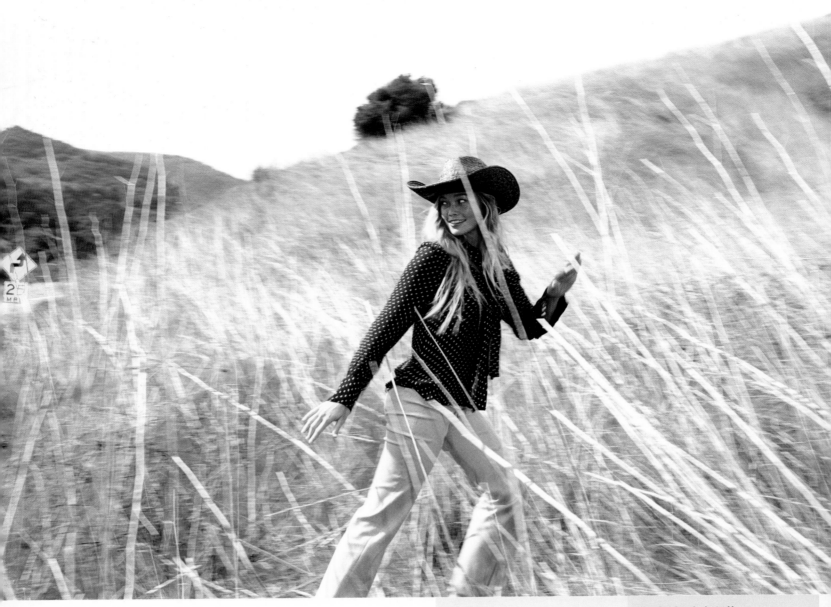

'Out of 30 frames, I only had two perfect shots of this. It's the kind of set-up where you don't know if you have it until the film is developed, but since it was for my portfolio, I wanted to experiment.'

Dorit Thies

Fact file

Photographer:	Dorit Thies
Client:	Photographer's portfolio
Model:	Lana Papke, jetsetmodels.com
Location:	Malibu Canyon, LA, USA
Time of day:	5pm, June

Technical details

Camera:	Mamiya 645
Lens:	55mm
Film:	Kodak Portra VC 160
Exposure:	1/125sec at f/22

The location

Every location will look completely different depending on what the light is doing at certain times of the day. When shooting for a portfolio, it's worth using a handful of places that you can familiarise yourself with really well so you can pre-plan the shoot to a certain extent. This was taken in Malibu Canyon, west of Los Angeles, not far from Dorit's studio. She loved the idea of using the long, dry grass in the summer time and knew that in late afternoon the sun would hit it, turning it a white/silver colour.

Composition

Dorit chose her viewpoint so that the long blades of grass would be between the lens and the model, which gives a sense of atmosphere, texture and movement, since these are blurred by the panning action of the camera. The trees and hills in the background form a good colour contrast to the overall softness of the grass.

Lighting and technique

Dorit wanted this exact angle and background but it meant that the model's face was in shadow. To lighten it up, Dorit's assistant aimed a Profoto flash head at her and followed her movement with it. Using a shutter speed of 1/125sec, the camera was also panned as the model walked, so she is sharp but the grass around her is nicely blurred.

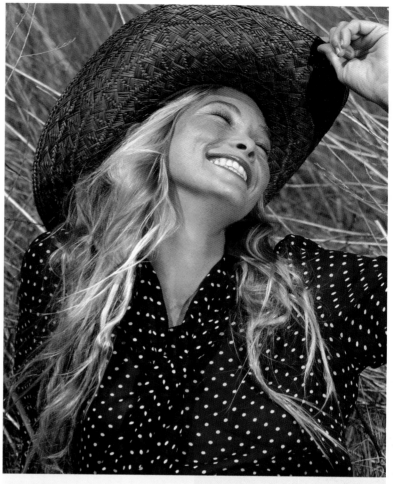

Fact file

Photographer:	Dorit Thies
Client:	Photographer's portfolio
Model:	Lana Papke, jetsetmodels.com
Location:	Malibu Canyon, USA
Time of day:	5.30pm, June

Technical details

Camera:	Mamiya 645
Lens:	150mm
Film:	Kodak Portra VC 160
Exposure:	1/125sec at f/11

Sun

Dorit wanted to supplement the light on the model's face and hair and soften the shadows created by the directional side-light of the sun. She used a Profoto flash head on a stand next to the camera and set it half a stop brighter than the ambient light to create quite a subtle effect. The 1SO 160 film was rated at ISO 80 to boost the colour. ▲

Flash head

Medium format camera

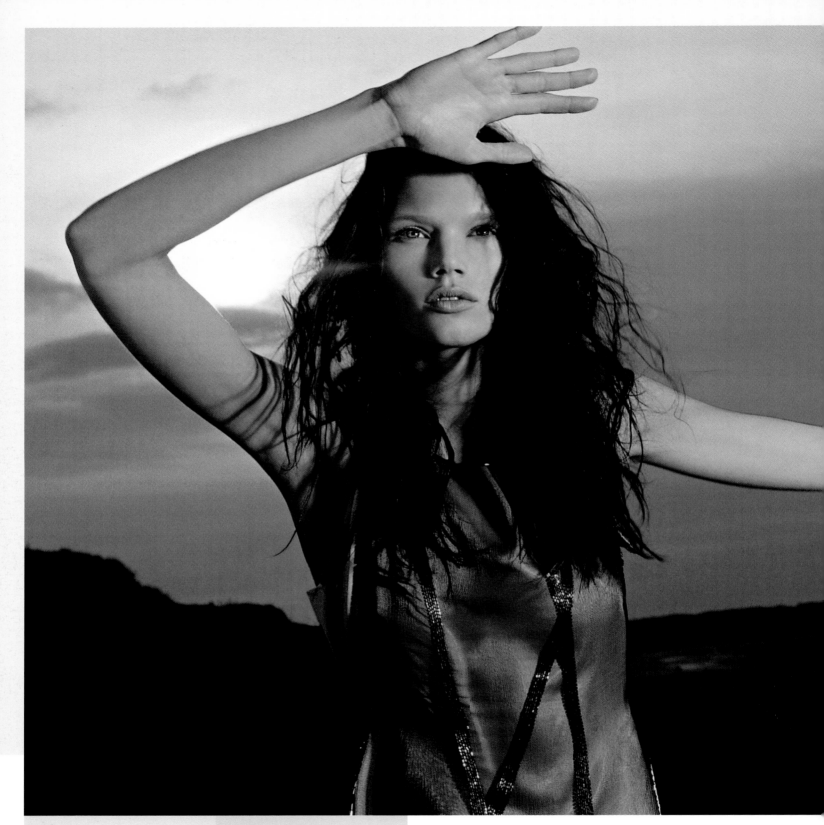

Fact file

Photographer: Fabien Dettori
Client: Model's portfolio
Model: Diana Gartner, Marilyn, Paris
Location: North of France
Time of day: Late afternoon, October

Technical details

Camera: Pentax 6x7
Lens: 105mm
Film: Kodak Portra 160 VC
Exposure: 1/125sec at f/11

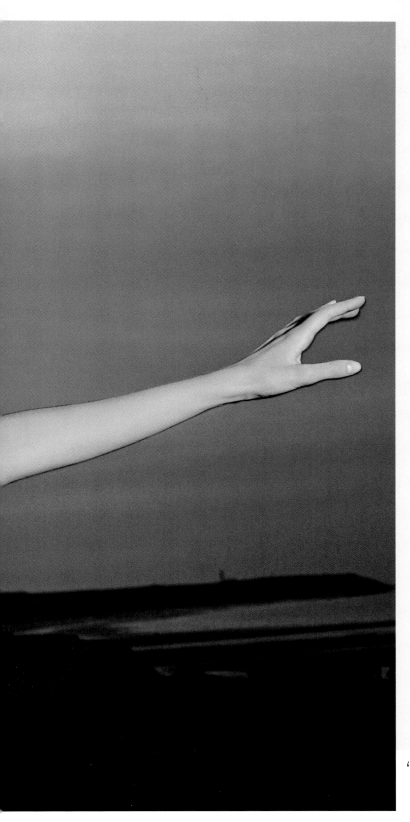

The brief

The model's agency asked Fabien to take some test shots of her for her portfolio. The aim of this kind of work is to show the range, potential and distinctive qualities of a model and it's a good chance for both her and the photographer to experiment with ideas.

The location

Fabien chose a beach in the north of France principally to achieve the kind of lighting that he wanted. The background is natural and wild-looking, without stealing attention away from the model. Because of the sand dunes and rocks, it also allowed him to shoot from different angles.

Composition

Although the model is photographed only to waist level, she fills every part of the frame here because of the position of her arms, which follow the line of the horizon. The background is not dominant but it's an important part of the composition, adding interest and a contrasting texture to the fine fabric of the Dries Van Noten top and the smoothness of the skin.

Lighting and technique

Fabien wanted the model to be lit from behind by the sun and from the front by flash but the sun needed to be fairly weak to produce the atmosphere he was after. He had to wait until late on an autumn afternoon until the sun had paled to a soft glow behind the clouds. He had to follow the flash-sync speed on his Pentax camera, which was 1/125sec. This gave him an aperture of f/11 and he cut down the light by a further two stops using a neutral density filter on the lens, resulting in a darker sky and a good contrast between the model and the background. The Norman flash unit was set at maximum power and held above Fabien's head by an assistant. The right balance of tones was very important here and checked prior to shooting with Polaroids.

'For this kind of shot you must know your technique perfectly as the sun is not waiting for you. For me the most important part of a fashion picture is the emotion you create.'

Fabien Dettori

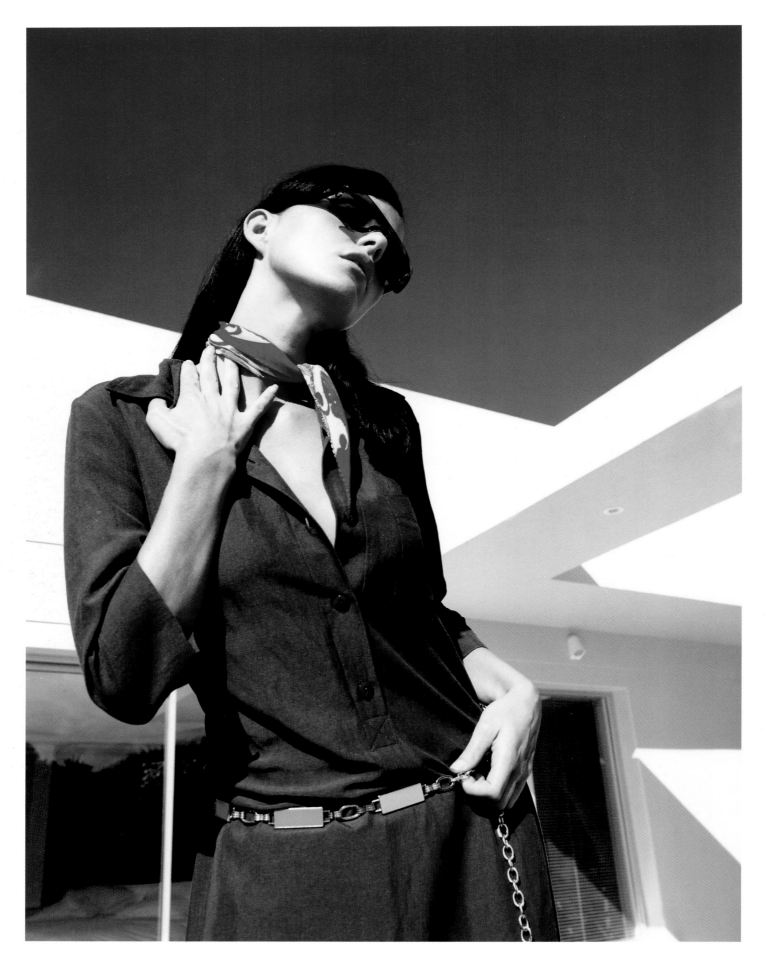

The brief

Kai was asked to take the pictures for an eight-page fashion feature for Femina magazine. The unifying theme was the location and Kai planned the shoot according to how the light affected it at different times of the day and, working with the stylist, which outfits would best suit the various settings.

Composition

One of the important skills of photography is to judge the best angle of view for the composition. A background that can look quite boring at eye level can suddenly appear dramatic seen from higher up, lower down or obliquely. A low angle gives the shot impact here. It makes the model seem taller, catches the light on her face and sets it against the vibrant blue. The angles of the building, and the shadows falling on it, add a strong, graphic element to the composition.

Lighting and technique

Taken in mid-afternoon, the light is still very strong here, but the effect is more directional than if it had been shot three hours earlier when the sun was directly overhead. This was also the best time of day to catch the sky at its deepest colour. Kai didn't use flash or reflectors to modify it but light bounced off the surrounding white walls, filling in details in the shadier areas of the dress.

Location

This particular house in Cape Town is well-known in the fashion world as a good outdoor location and it's available for hire. It has white walls, plenty of glass and interesting, modern, architectural features that can be used creatively in many different ways.

Fact file

Photographer:	Kai Haase
Client:	Femina magazine, South Africa
Model:	Ana Stojanovic, Next, LA
Location:	Cape Town, South Africa
Time of day:	3–4pm, spring

Technical details

Camera:	Pentax 6x7
Lens:	55mm
Film:	Kodak Portra 160VC
Exposure:	Not recorded

Fact file

Photographer:	Kai Haase
Client:	Femina magazine, South Africa
Model:	Anna Paula
Location:	Hotel, South Africa
Time of day:	Early afternoon, July

Technical details

Camera:	Pentax 6x7
Lens:	55mm
Film:	Kodak Portra 160VC
Exposure:	Not recorded

This was taken for a summer edition of a woman's magazine but photographed in winter, which the South African climate allows for. The sun was behind the model's shoulder and, as you can see from the reflection in her sunglasses, a white reflector provided the lighting to her front. ▲

' I love the sky in Cape Town. When it's blue, it's really dark blue.'

Kai Haase

The brief

This was part of a story for an autumn/winter edition of Harper's Bazaar, Latin Americian edition. The idea for the horse came from David, who obviously enjoys a challenge! When working for regular clients, he is given the freedom – and responsibility – to come up with a theme that will work well with the fashion to be featured.

Composition

This is a romantic and sensual image with the white horse providing a striking foil for the model. Her reclining pose is echoed by the long back of the horse behind her and the limited colour stands out against the sombre ground and background. David has given a mood and a story to the image while, essentially, keeping it very simple.

Lighting and technique

Very early in the morning the light was fairly low and there was still mist on the bluffs. This gave a cool quality to the light which suited the winter publication date, even though it was shot in June. Small silver and white reflectors were placed, alternating, on the ground in front of the model, making a fan shape, in order to bounce light on to her and bring out the detail of the dress.

Location

Scarborough Bluffs – an unusual stretch of cliffs above Lake Ontario – provide the feeling of wild remoteness in this image, even though it's a very well known area, and only a short distance from the city of Toronto. By being very selective with his viewpoint, David was able to use this one location in a number of ways for this fashion story. Another image from the same shoot, on pages 86–87, uses the lake instead of the bluffs as the backdrop.

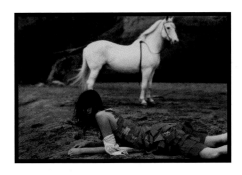

Sun through mist

Reflectors

Medium format camera

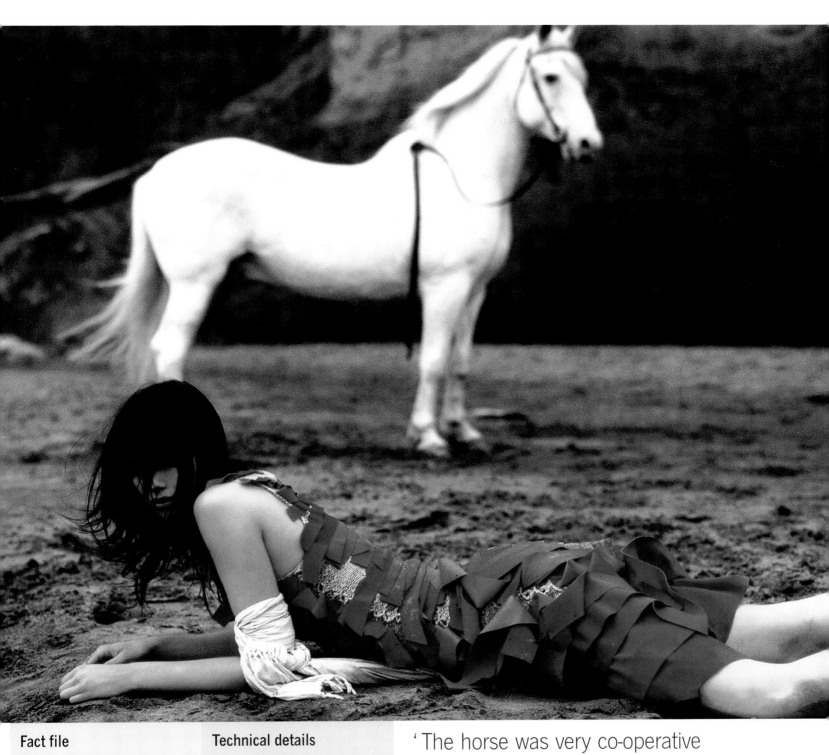

Fact file

Photographer: David Anthony
Client: Harper's Bazaar magazine
(Latin American edition)
Model: Martine, Next Agency
Location: Scarborough Bluffs,
Lake Ontario, Canada
Time of day: Early morning, June

Technical details

Camera: Pentax 6x7
Lens: 75mm
Film: Kodak E100VS
Exposure: 1/30sec at f/5.6

'The horse was very co-operative throughout the shoot, as long as he was getting snacks.'

David Anthony

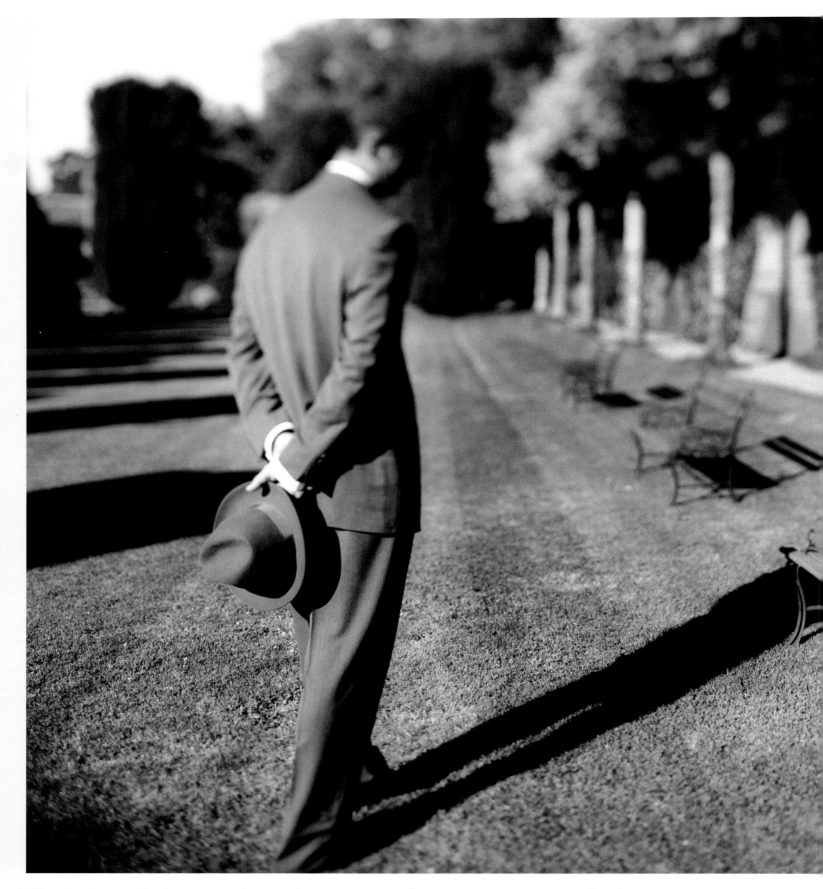

'The history of photography and painting is the greatest source of information, as well as inspiration.'

David Maisel

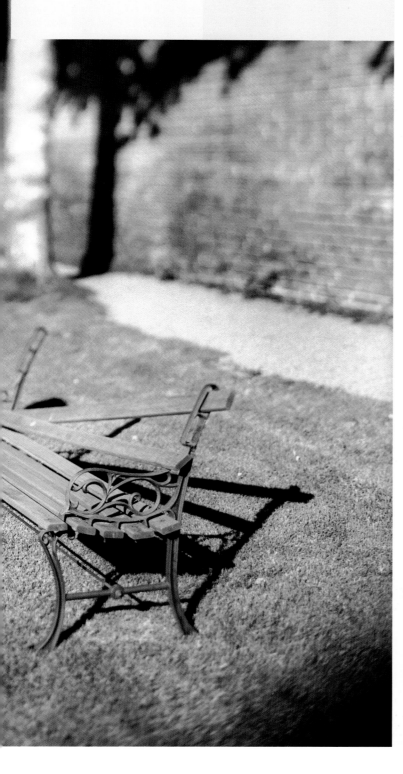

The brief

This was one of six shots commissioned from David by an advertising agency, for an international identity campaign for the St Paul Insurance Company. 'Stylistically, the creative director and I were interested in using the history of photography, and we looked at classic images by Strand, Atget and Kertesz,' explains David.

Composition

Earlier in the day, when the sun was higher in the sky, this shot wouldn't have been anything like as successful. It's the long, clearly defined shadows of late afternoon summer sun that give the image its drama – a bit like an old black-and-white movie. The perspective is important here too, with the benches and trees behind them leading the eye diagonally towards the vanishing point.

Lighting and technique

'This was simple, simple, simple,' says David. 'It was just natural daylight with a reflector to provide a bit of fill for the shadows on the model's suit. We wanted him to be somewhat anonymous – an Everyman figure – so I intentionally let his face fall into shadow.'

The Location

David wanted the shot to have a timeless feel about it and this well-kept and rather refined park setting could have looked just the same 100 years ago as it does today – there are no revealing clues to the 21st century.

Sun

Reflector

Medium format camera

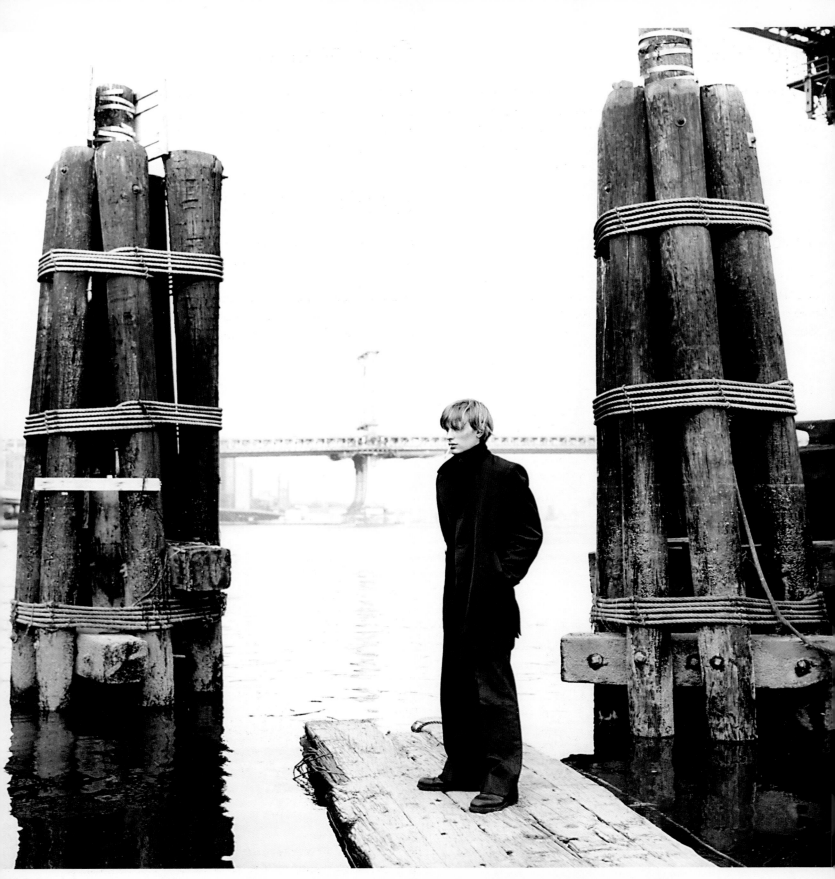

'After my days at Playboy with their 40 flash heads and tons of stands, I just had enough. The "KISS" method works for me – keep it simple stupid. I make less mistakes that way.'

Baldur Bragason

The brief

'I was about to move back to Iceland having spent two years in New York working as an assistant to fashion photographers. My connections meant I'd been able to use the best studios and equipment for free, but I realised I didn't have any New York location shots for my book,' explains Baldur Bragason. 'I called up my Icelandic friend Geir, a professional model, and we went out with a borrowed Hasselblad and took a whole series of pictures.'

The location

This was taken under Brooklyn Bridge, on the Manhattan side, which is a place close to Baldur's heart. 'When I was living in downtown Brooklyn and was too broke to afford the subway, I would walk into the city over the bridge and just soak up the stunning city view. The memory of it never dulls or fades away.'

Composition

Baldur loves architecture and enjoys lining up structures in a composition to emphasise the subject. The use of symmetry and range of tones create a graphic effect here. Geir's clothing contrasts dramatically with the high key background, which still retains a hint of detail in the bridge and buildings in the distance.

Lighting and technique

As well as providing scope for an interesting composition, the location was chosen because of the light. The bridge shaded the model from the direct brightness of the sun, behind and to the right of him, but there was also natural reflection from the water, which helped fill in detail in the shadows. 'This was the final set-up of the day and I only shot one frame,' recalls Baldur. 'I worried all night that something had gone wrong, but it turned out to be my favourite picture of the series.'

Fact file

Photographer: Baldur Bragason
Client: Photographer's portfolio
Model: Geir
Location: Manhattan, New York, USA
Time of day: 2pm, May

Technical details

Camera: Hasselblad 500CM
Lens: 80mm
Film: Kodak Tri X 320
Exposure: 1/125sec at f/8

Sun

Bridge

Medium format camera

Fact file

Photographer: Marco Girolami
Client: Personal work
Model: Ricardo, Model Plan, Milan
Location: Lake Como, Italy
Time of day: 3pm, March

Technical details

Camera: Mamiya RZ 67
Lens: 100mm f/2.8
Film: Agfapan APX 100
Exposure: 1/125sec at f/5.6

The blue light of an overcast day is perfect for black and white, whereas it can kill the mood of a colour image. If the light appears too flat, it can be transformed by the use of reflectors. Marco used two white ones here, one on either side of the model, to help separate him from the background. The result is a moody and atmospheric portrait. ▲

The brief

This was Baldur's own idea. He 'borrowed' two models from an agency and planned a shoot with Scatha Allison, an American artist and stylist. Several Icelandic designers lent her some clothing and make-up artists also got involved. It was a team effort from which everyone would benefit with some special images for their books. It turned out that they all got paid because the shots were published soon afterwards as a six page story in Nytt Lif Magazine, the largest women's magazine in Iceland.

The location

Baldur had his eye on a new car park in Reykjavik for about a year, as it was being built, and had been there several times to take test shots. He found out that the best time to use it would be after sunset in autumn, when the sky turns indigo blue in Iceland and stays that way for a long time. He hadn't planned to use it on this occasion, however. 'We were on our way out of town to shoot under some power line structures when it started raining,' he explains. 'The weather in Iceland is extremely unpredictable and you always have to have a back-up plan – in this case the car park. It turned out to be a blessing in disguise as we were very pleased with this image.'

Composition

The rain was an unexpected bonus here, because it made the surface of the ground and walls shimmer in the light, complementing the shiny texture of the model's top and boots. The background structure forms a graphic design of lines and shapes, set off by the contrasting deep blue triangle of sky.

Lighting and technique

Baldur used a Bowens Esprit 500w flash head with a 60x100cm softbox. He placed this on a stand right next to the tripod so that the lower edge of the softbox lay on top of the lens. This gives a similar, but softer, effect to ring flash. The flash and ambient light were balanced, with the flash used at a low power setting and the camera set to a slow exposure of 1/4sec.

Fact file

Photographer:	Baldur Bragason
Client:	Portfolio shoot
Model:	Edda, Eskimo Models, Iceland
Location:	Reykjavik, Iceland
Time of day:	10pm, September

Technical details

Camera:	Mamiya RZ 67 Pro 11
Lens:	110mm f/2.8
Film:	Kodak Portra 400 VC
Exposure:	1/4sec at f/5.6

Medium format camera under softbox

Fact file

Photographer:	Marco Girolami
Client:	Smogh fashion catalogue
Location:	Warner Village, Rome
Time of day:	10pm, June

Technical details

Camera:	Nikon F3
Lens:	85mm F/1.4
Film:	Fujichrome Provia 100
Exposure:	1/30sec at f/2.8

Taken outside a cinema multicomplex, there was still quite a lot of ambient light at 10pm as well as plenty of people in the background. Marco used an Elinchrom 500 flash unit with a softbox on full power so that only the bright neon signs would register and the rest of the background would turn black. A white reflector bounced additional light from the flash on to the model to ensure she stood out. ▲

'Using just one light made the shoot go very fast. I took six pictures in an hour and 40 minutes.'

Baldur Bragason

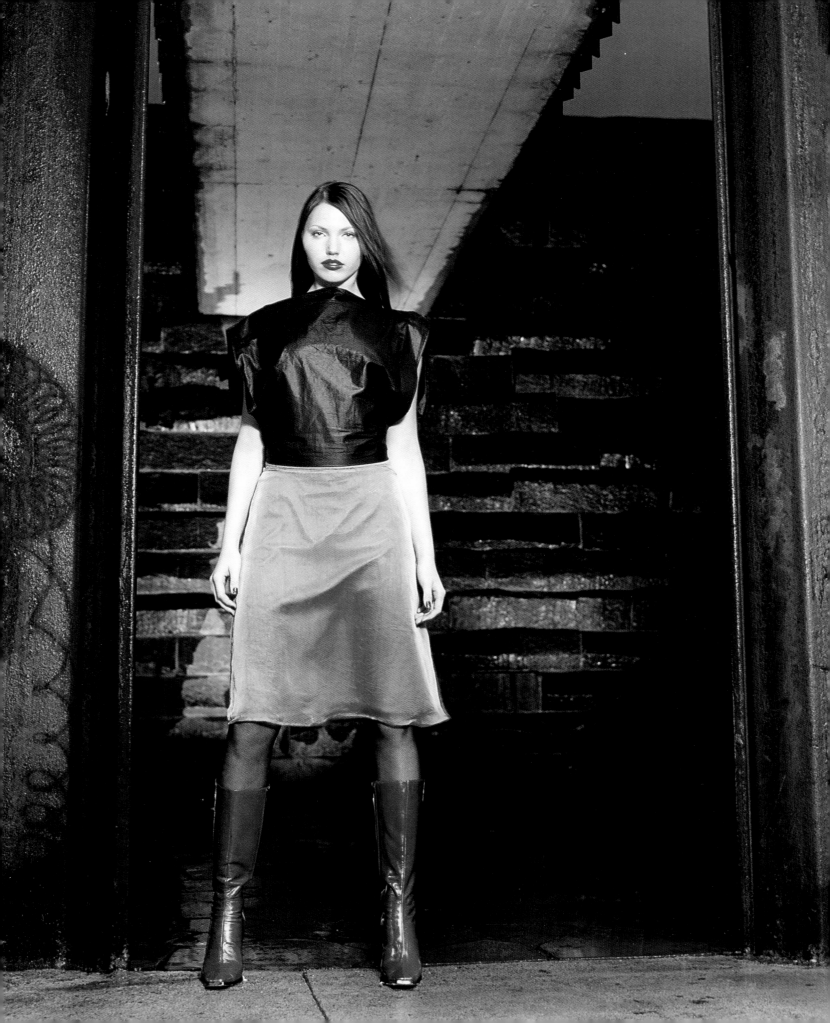

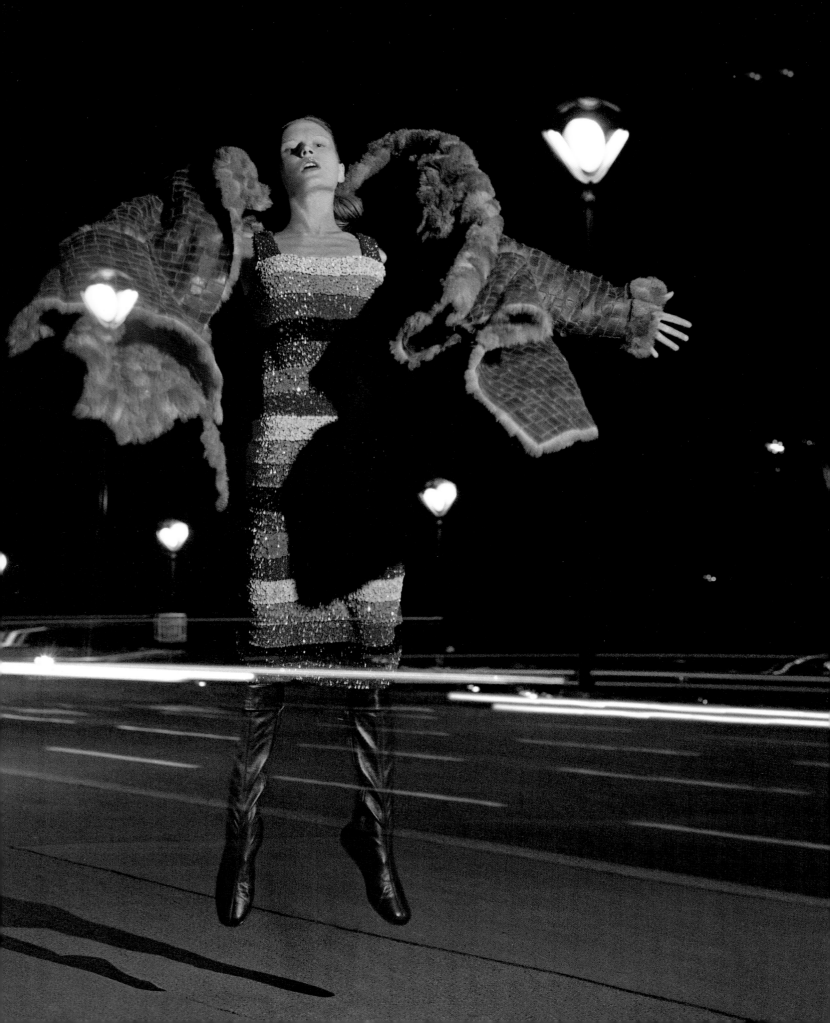

'I prepare a lot of my shots, by doing drawings and making technical notes, to have more time on the set to create an atmosphere with the model.'

Fabien Dettori

The brief

The Spanish edition of Vogue magazine commissioned a winter fashion story from Fabien, though this particular shot was not published. The model was dressed in a Jean-Paul Gaultier fur coat, a dress by Sonia Rikyel and boots by Chanel. The idea was to create a dynamic image showing all these items, but particularly the fur inside the coat.

The location

Having decided to do a night-time shot, Fabien needed a road that would be generally dark and quite heavy with traffic to record the lights of the cars in this way. He picked this location in Paris because it had the added advantage of the distinctive street lamps in the background.

Composition

Fabien hit upon the idea of the model leaping in the air as a way of showing the coat stretched out with the fur visible. If she had been standing still and opening the coat it would have looked like a very artificial pose. As it is the image is dramatic and distinctive, especially the way the streaks of light and the street lamp seem to be superimposed on the model, a trick which engages the viewer's attention.

Lighting and technique

This image was made using the open flash technique. Fabien supported the camera, fitted with a cable release, on a tripod and set the shutter speed to the B setting. Once the cable release was pressed, the camera shutter remained open until he let the release go – in this case, six seconds later. At the beginning of the exposure, Ashley made her quick leap into the air, then ran out of the frame. A burst of flash from a Norman unit, fired manually, froze her in action but the front and rear lights of the passing cars, as well as the street lights, continued to be recorded on the film for the remainder of the exposure. The technique is not an exact science with a moving subject, and it's worthwhile experimenting with different exposure times and, ideally, doing some Polaroid tests.

Although this was taken on a summer afternoon, there was very little natural light falling on the model because of the dense shade from the tree. Yanick wanted to use this shade to act as a dramatic contrast to the well-lit areas of the model's face and body, which he created artificially. A Nikon SB24 flashgun was used to one side of her, set at one and a half stops greater than the daylight in the background and around five stops greater than the light falling on the model. A Vivitar 285 flashgun was used as a backlight and this was one stop lower than the Nikon flash. ▲

The brief

After working all day on a fashion shoot for a catalogue company, John, the model, and some other members of the team decided to make the most of the evening sky to take some shots for their books. 'Nikki had her own swimsuit with her, and an amazing body, and I needed some swimwear shots for my book,' says John. 'Often you just don't have the time to do your own thing after a job but occasionally it's a good chance to try something a little different.'

The location

Taken by Miami beach, John was attracted by the railings, the palm tree and the view of the city over the water.

Composition

The railings, brightly lit by the flash, act as a good contrast with the purple and black tones in the background, as well as providing a prop for the model. The night sky provides an interesting variation on the usual bright blue sky or sandy beach that often feature in swimwear shots.

Lighting and technique

The sun had disappeared about 45 minutes before this was taken but there was still some reflected light in the sky, making the clouds look dramatic. John used a ring flash, softened with diffusing material, round the lens of the camera, which is the sole provider of light on the model and railings. He supported the camera on a tripod and used a slow exposure of 1/8sec, to ensure that some of the background detail was recorded. A wind machine was responsible for the blowing hair, which adds life and movement to the picture.

Fact file

Photographer:	John Owen
Client:	Portfolio shoot
Model:	Nikki Novak, Elite, New York
Location:	Miami, Florida, USA
Time of day:	Dusk, February

Technical details

Camera:	Contax 645
Lens:	80mm
Film:	Kodak Ektachrome 100S
Exposure:	1/8sec at f/5.6

' The ring flash makes everything zingy, sharp and edgy. It's quite a hard light but it's slightly softened here.'

John Owen

Medium format camera with ring flash

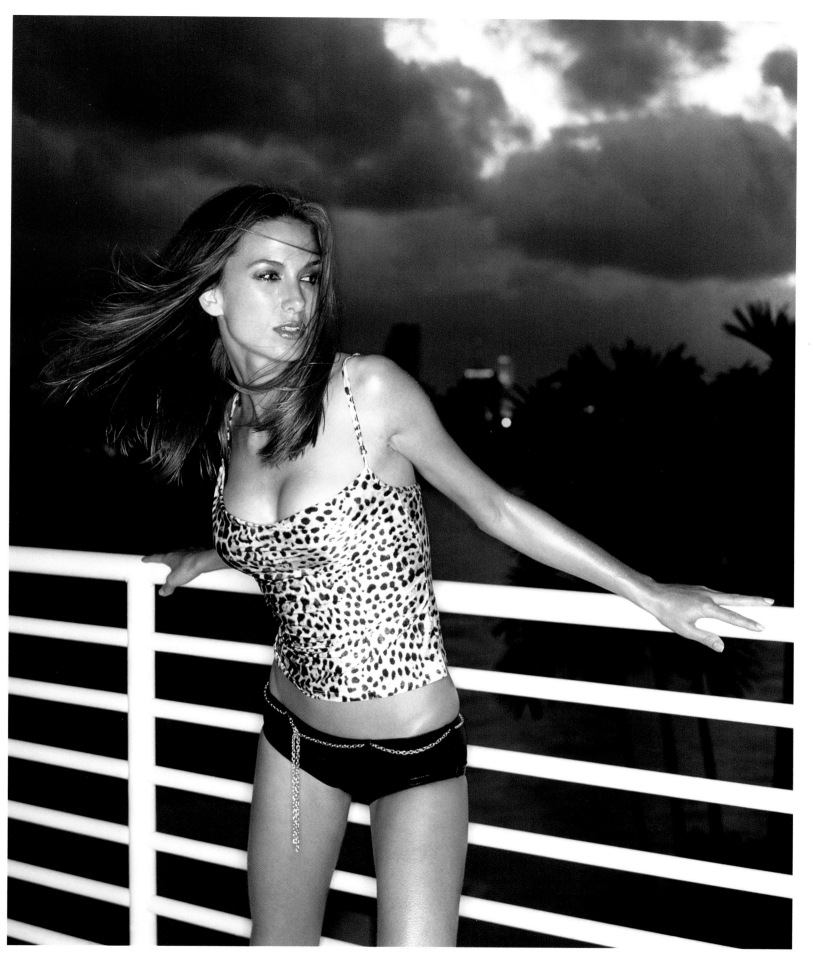

Chapter 3: **Creating a mood**

The kind of mood you create is central to fashion and glamour photography and, if there is a client involved, they will no doubt give some direction as to the kind of look they are after. It will depend on such things as the look of the model and what she is wearing, the timing of publication and the kind of readership or audience it is aiming for. Translating such an abstract notion as 'mood' or 'feeling' into a two-dimensional image will then be down to you.

This is where the natural variations of daylight come into play. Hard, overhead sun may be inappropriate for a lingerie advert but perfect for vibrant street fashion. Soft light from an overcast sky can be flattering and easy on the eye, though it can have a cool tone, while the warm late afternoon sunshine lends itself to romance.

This chapter also looks at how black-and-white film, texture and the use of colour affect the mood of images and how all these can be enhanced by different types of lighting.

'My idea for the shoot that day was that the girls and the guy were all kind of innocent but felt an attraction between them.'

Dorit Thies

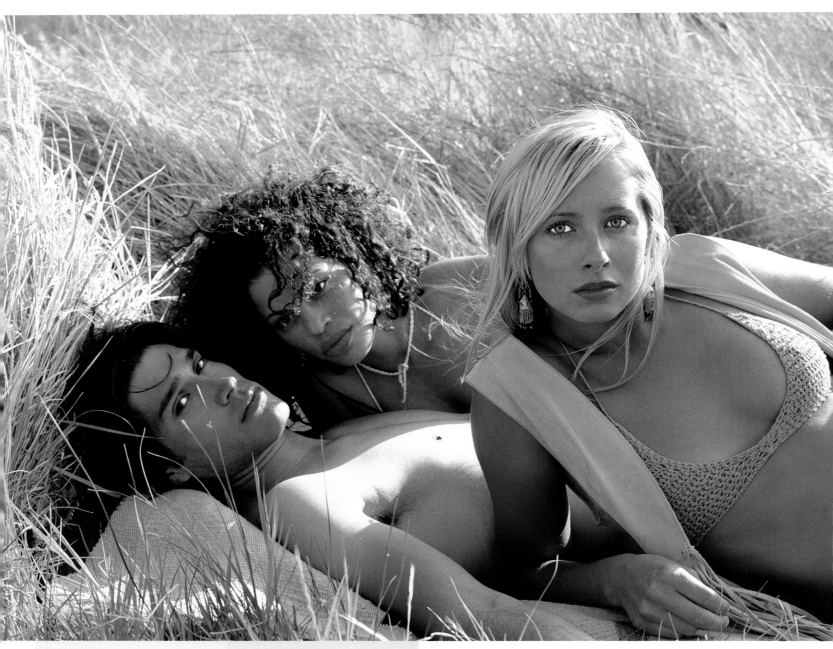

Fact file

Photographer: Dorit Thies
Client: Photographer's portfolio
Models: Jesse and Luis, LA Management; Jaylin, Ford Agency, LA
Location: California, USA
Time of day: 4.30pm, June

Technical details

Camera: Mamiya 645
Lens: 80mm
Film: Kodak Portra VC 160
Exposure: 1/125sec at f/5.6

The brief

Dorit wanted to create some atmospheric, romantic shots for her portfolio and so she hired three models for the day and took a variety of shots using them individually, in pairs and in this case, as a group.

The Location

Dorit is based in Los Angeles and this location is about a two-and-a-half hour drive north east of the city. It's a remote spot near a river bed and she could work undisturbed, using the grassland and the river in a variety of ways.

Composition

'Half the task in working with a group is making everyone feel comfortable because any unease on the models' part will show in the pictures. The eye contact between two of the models and the viewer strengthens the image and the third, middle figure, balances out the composition, giving a pleasing rounded shape to the group.'

Lighting and technique

Dorit avoided the middle of the day when the sun would have been too high and the shadows too harsh. The light is still bright here, coming from the side, but has a warmer tone. Dorit took a meter reading from the models' faces, which were in the shade, and then opened up the lens by half a stop from f/8 to f/5.6 to add a little more light.

Sun

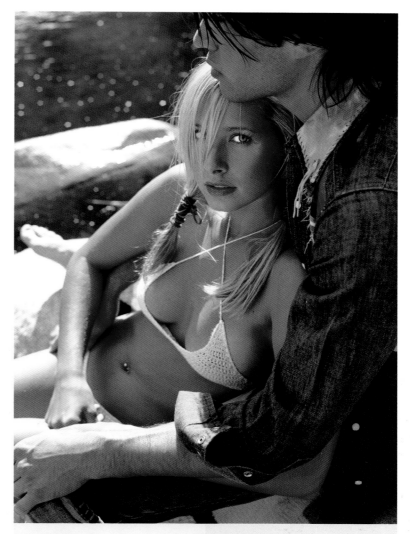

Fact file

Photographer:	Dorit Thies
Client:	Photographer's portfolio
Models:	Jesse and Luis, LA Management
Location:	California, USA
Time of day:	3.30pm, June

Technical details

Camera:	Mamiya 645
Lens:	80mm
Film:	Kodak Portra VC 160
Exposure:	1/125sec at f/16

Taken in strong sunshine, behind and to the left of the models, there was also some natural reflection from the river and the rocks, helping to retain details in the shadier areas. You can almost feel the warmth of the sun on their skin, which adds to the overall sense of romance. ▲

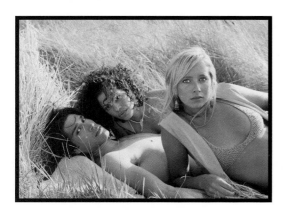

Medium format camera

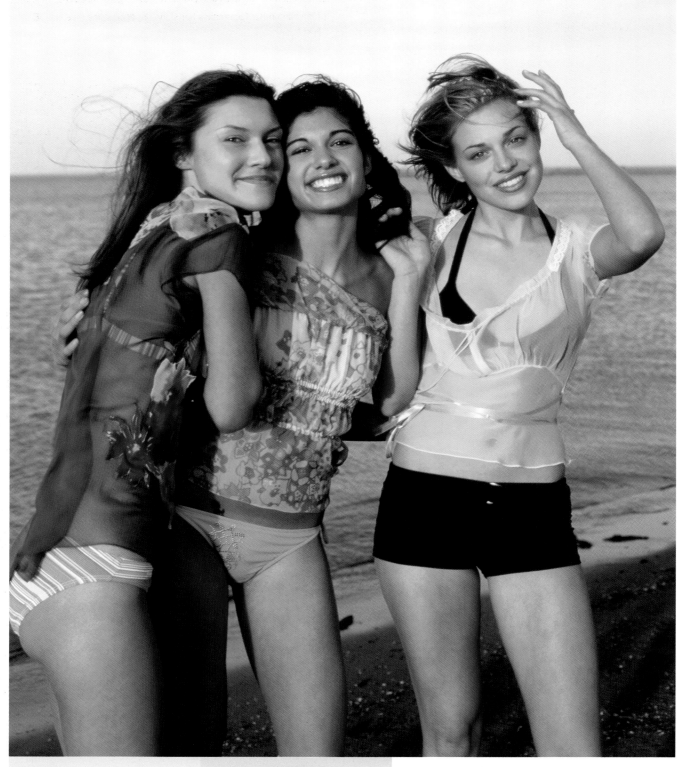

Fact file

Photographer: David Anthony
Client: Marie Claire (Spain)
Models: Kylie, Ford Agency; Jessica and Erica, Aria Agency
Location: Montrose Beach, Chicago, USA
Time of day: Late afternoon, May

Technical details

Camera: Pentax 6x7
Lens: 165mm
Film: Kodak EPN100 rated at ISO 80
Exposure: 1/500sec at f/8

The brief

Marie Claire wanted a 'clean, fresh look' for its summer beauty story but left the interpretation of this up to David.

The Location

Montrose Beach in Chicago, with a clear view of Lake Michigan in the background, was chosen as a suitable summer setting. David wanted to avoid unnecessary detail to keep the look 'clean' as the client wanted. Blue sky and water were all that were required to generate the feeling of health and well-being.

Composition

This tight group shot looks like the three girls are posing casually for a friend rather than for a set up fashion shot. The linking of arms is a good way of drawing them together and the way the model on the left is leaning in gives a feeling of intimacy and prevents them looking as though they are standing in line like sentries. For three or more subjects, photographers often place the tallest in the middle, but that triangular shape would have looked too obviously posed here.

Lighting and technique

Strong, direct sunlight is often avoided for people pictures but David has capitalised on it here to give the feeling of summer heat. 'I used the sun like a giant strobe head and positioned the models to take advantage of the harder light,' he explains. 'Absolutely no reflectors or additional light were used. Instead I placed large, black, foam core boards on each side of the models to create a soft shadow outline and bring out the texture of the fabrics.'

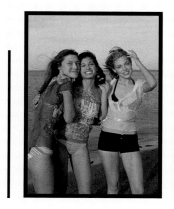

Black foam core boards

Sun

Medium format camera

Taken on the same shoot, this again shows the impact that hard lighting can have. The shadow on the neck and stomach provide good modelling while the full strength of the sun on her face makes her shine out against the blue sky. ▼

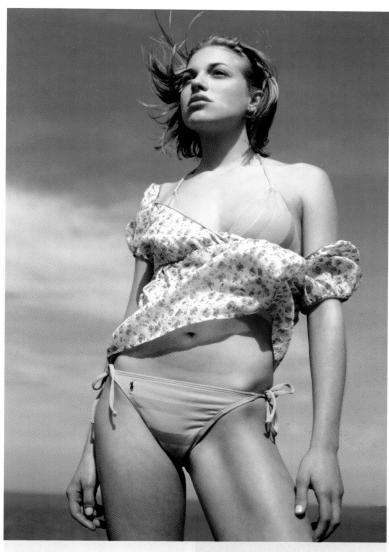

Fact file

Photographer:	David Anthony
Client:	Marie Claire (Spain)
Model:	Kylie Rowe, Ford Agency
Location:	Montrose Beach, Chicago, USA
Time of day:	Mid-afternoon, May

Technical details

Camera:	Pentax 6x7
Lens:	105mm
Film:	Kodak EPN100, rated at ISO 80
Exposure:	1/500sec at f/8

'One of the enjoyable aspects of this shoot was that I had taken the three models' very first test photos only weeks before.'

David Anthony

Fact file

Photographer: Marco Girolami
Client: Smogh fashion catalogue
Model: Roberta, Zoe Model
Management, Rome
Location: Rome, Italy
Time of day: Midday, June

Technical details

Camera: Nikon F3
Lens: 80–200mm f/2.8
Film: Fuji Provia 100
Exposure: 1/250sec at f/4

'I love shooting
in this hard,
bright light.
You can find it
in Rome on plenty
of occasions
during the year.'

Marco Girolami

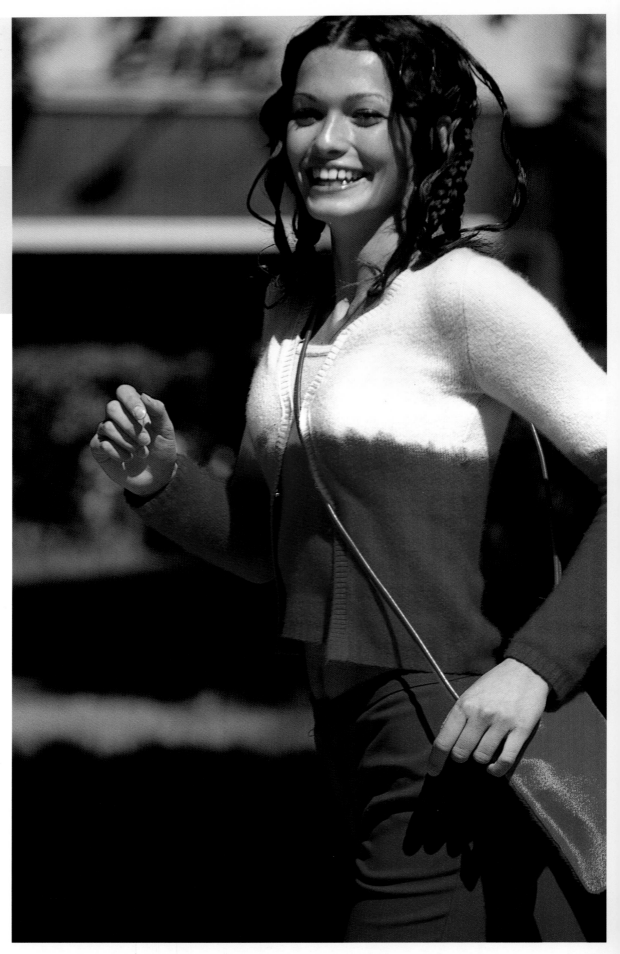

The brief

Marco works closely with the art director on a catalogue shoot, rather than the client directly. The two of them discuss the mood of the images, the casting and the locations, balancing the requirements of the client with Marco's own style. The brightly-coloured clothing featured here required a strong image with a youthful, vibrant feel.

The Location

Despite the risk of passers-by stopping to stare or getting in the way of the shot, Marco took this in Rome. He wanted an urban atmosphere and vivid colours in the background, which are easily found in the city.

Composition

Marco used a fairly wide aperture to ensure the background wasn't too sharp and distracting from the model. It plays an important role, however, with the shadow areas, relieved by strips of green and blue, forming an abstract picture behind her. Tight framing with a zoom lens gives a clear view of the fashion items that the photograph is advertising.

Lighting and technique

At midday, the sun was high in the sky giving very hard lighting with plenty of contrast. Marco positioned the model carefully to ensure the light hit the important details in the shot – her face, tops, skirt and bag – while allowing the rest to fall into shadow. He ensured his subject was accurately exposed by taking an incident light reading with a hand-held meter to measure the light falling on her.

Taken during the same shoot, Marco has again taken advantage of the hard, overhead sunlight to illuminate the model's face and give rich, punchy colours. The disadvantage, for a close-up, is that ugly shadows on the face can arise. Marco used a gold reflector panel to fill these in and add warmth to the skin tone. ▲

Sun

35mm camera

Fact file

Photographer:	Marco Girolami
Client:	Smogh fashion catalogue
Model:	Roberta, Zoe Model Management, Rome
Location:	Rome, Italy
Time of day:	11am, June

Technical details

Camera:	Nikon F3
Lens:	135mm f/2
Film:	Fuji Provia 100
Exposure:	1/250sec at f/4

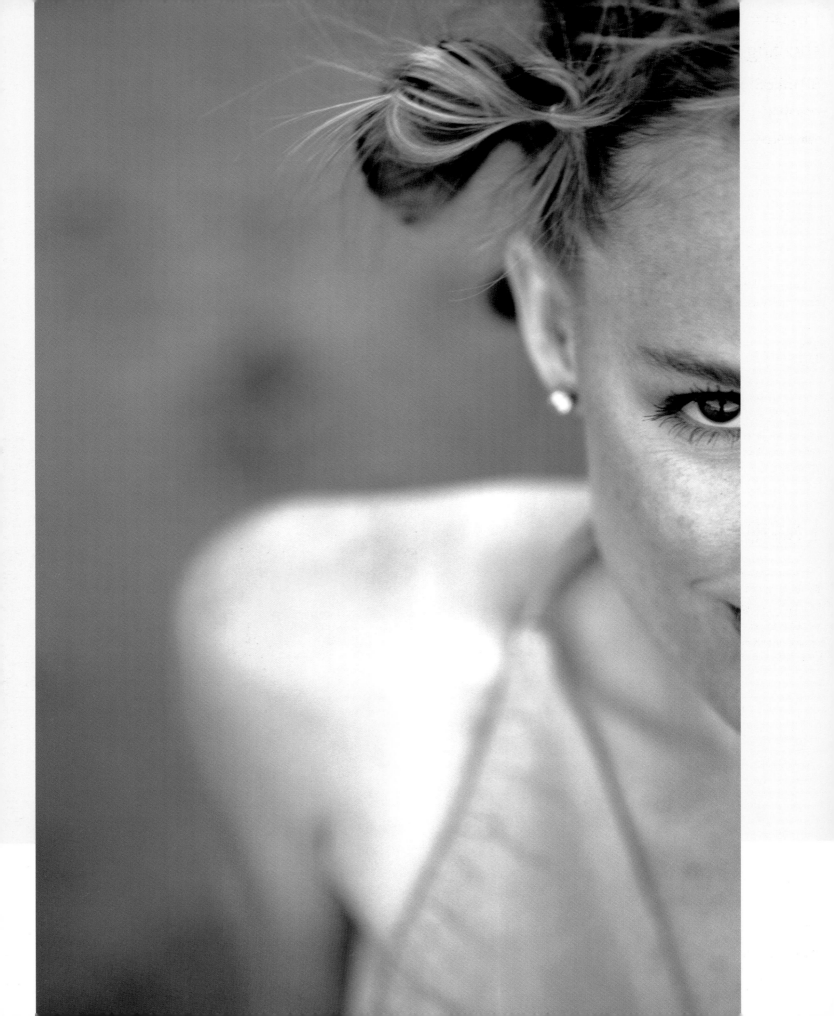

'I believe that less is more when you're shooting people. I try to photograph the smallest part of a person while still capturing the essence of the whole.'

Patrick Roddie

The location

'The Palace of the Legion of Honor is a classical Roman/Greek museum, typically overrun with newlyweds and Hassleblad-toting photographers,' says Patrick Roddie. 'I often shoot there for perspective shots of pillars and Rodin sculptures. In this case I merely used it as an applebox to shoot down on Kay.'

Composition

'I'm a major advocate of using minimal depth of field to isolate and draw the viewer's attention to a detail,' explains Patrick. 'When I'm looking at people, I don't take a wide view but scan different parts of them – eyes, hair, whatever – and combine those mental snapshots into a complete picture of the whole. When I'm taking photos, I capture what I see, not the entire mental image.'

Lighting and technique

The late afternoon sun was directly behind Patrick, hidden behind a tall wall of the museum building. This blocked the reddish tones of the direct light, leaving the blue sky as the light source. Patrick asked Kay to kneel to make her more stable, while he leant against the wall for support. She was pretty close to the camera's minimum focusing distance, which accentuates the very small depth of field.

Fact file

Photographer: Patrick Roddie
Client: Photographer's portfolio
Model: Kay Hill
Location: Palace of the Legion of Honor, San Francisco, USA
Time of day: Before sunset, July

Technical details

Camera: Nikon F100
Lens: 50mm f/1.4
Film: Fuji Velvia
Exposure: 1/30sec at f/1.4

Fact file

Photographer: Patrick Roddie
Client: Photographer's portfolio
Model: Kay Hill
Location: Palace of the Legion of Honor, San Francisco, USA
Time of day: Before sunset, July

Technical details

Camera: Nikon F100
Lens: 105mm f/2.8 Micro
Film: Fuji Velvia
Exposure: 1/125sec at f/4

Patrick continued his theme of tight depth of field drawing attention to the right eye, only this is more extreme than usual. Kay peeked out at him from behind a pillar, while he braced himself on the opposite side of it to minimise camera shake. The sun was behind the museum building to the left of him but there was enough open space between the pillar and the building to allow some of the warm tones of light to reach Kay's face. ▲

35mm camera

Sun

Wall

Creating a mood: Soft light 63

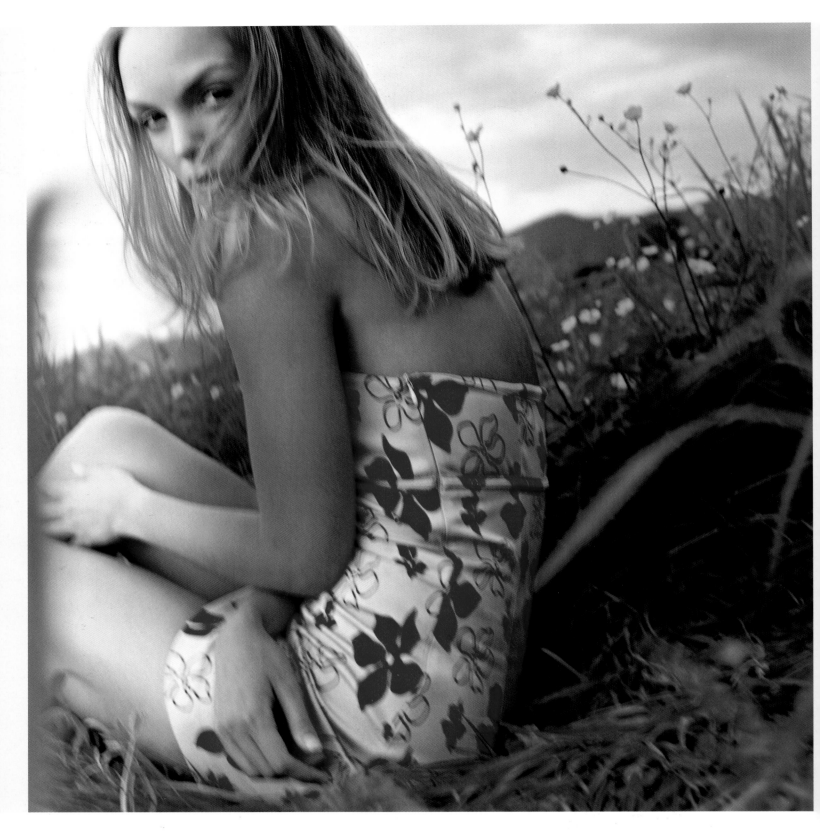

' I like to be spontaneous when I shoot so I never use fill-in flash and very rarely use reflectors. Instead, I've adapted the way I expose and process so that I can shoot at any time of day, anywhere, without having to be stationary.'

Barry Gnyp

The brief

This was one of a series of pictures commissioned by the model's agent. 'I was asked to add some life to her portfolio – something that would get her noticed,' says Barry. 'I just tried to capture her beauty through her energy.'

The Location

'This was a spontaneous thing,' he explains. 'We were driving around looking for locations in the rural area around the model's home. After seeing the clothing, this beautiful yellow and green field seemed like the perfect place to get nice colours, and also allow her the space to run around.'

Composition

Barry rarely plans his compositions but says that he is always looking for new ways to fill the frame. He's made great use of the square format here with an almost half-and-half balance between the model and her surroundings – much more effective and natural-looking than if he had tried to place her in the middle of the frame.

Lighting and technique

The sky was overcast in the late afternoon and the light was very flat. Barry wanted to boost the contrast in the image to give it more life and impact so he exposed the film at the normal speed and according to the correct meter reading and then push-processed the film (gave it extra development time) by one stop. Usually the technique also involves underexposing the film by, for example, rating a 400 ISO film at 800 ISO. As well as adding contrast, it makes the image a little more grainy, which adds to the overall mood here.

Sun behind clouds

Medium format camera

Fact file		Technical details	
Photographer:	Barry Gnyp	**Camera:**	Zeiss-Ikon Nettar
Client:	Model's portfolio	**Lens:**	75mm f/1.4
Model:	Tanya, Richard's Model Management, Vancouver	**Film:**	Fuji NPH 400
		Exposure:	1/75sec at f/8.5
Location:	Maple Ridge, British Columbia, Canada		
Time of day:	Late afternoon, August		

Albert wanted to capture the gracefulness of the clothing and the beauty of the location. The sun was setting behind the models and was about 20 minutes from falling behind the horizon. It meant he had to work quickly, but also gave him soft warmth in the lighting which makes the colours glow. ⏬

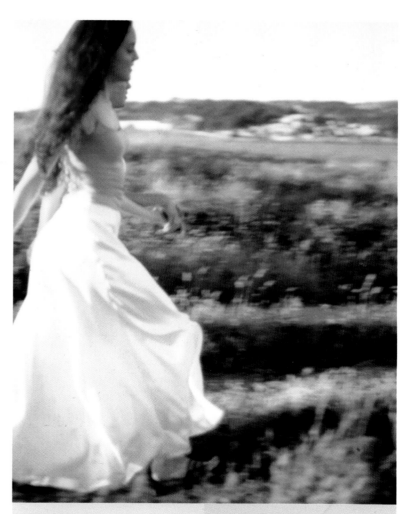

Fact file		Technical details	
Photographer:	Albert Lewis	**Camera:**	Mamiya 534 pro
Client:	Portfolio shoot	**Lens:**	85mm
Model:	Austen Beverly, Stars Agency, San Francisco	**Film:**	Kodak Ektachrome 100S
		Exposure:	1/60sec at f/5.6
Location:	Berkeley, California, USA		
Time of day:	5.30pm, September		

Flash 1

Sun behind clouds

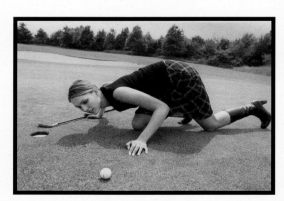

Flash 2

Medium format camera
at low angle

Fact file

Photographer:	André Schuster
Client:	Photographer's portfolio
Model:	Lisa, ModelPool, Dusseldorf
Location:	Golf course, Germany
Time of day:	2pm, April

Technical details

Camera:	Canon EOS 3
Lens:	50mm
Film:	Kodak Portra 160VC
Exposure:	1/125sec

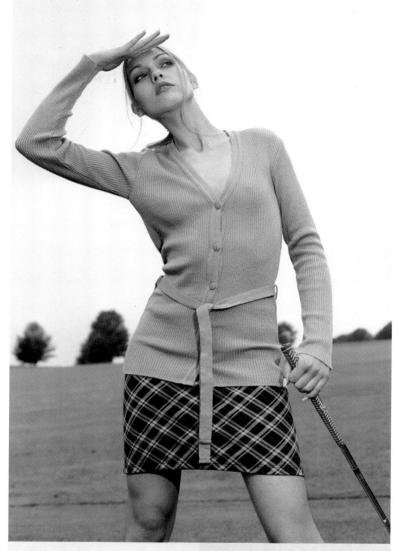

The Location

André thought a golf course would have plenty of potential for the ironic style of shots he was after for his portfolio. He had to call the golf club several times to get permission to shoot on the green. 'They promised that they would block off the whole area where we were taking pictures, but after a few minutes there were balls flying over our heads. It was quite a dangerous location!'

Composition

'One of the course officials saw the model with her boots on the putting green and told us that high heels were banned,' recalls André. 'We had to improvise, and ended up with Lisa watching the ball on her knees. It worked out well because it's obviously not the sort of thing real golfers would normally do, but it sends up people's notions of them.'

Lighting and technique

On an overcast day, André used two flash units here, one hidden behind the model and a smaller one to the left of the camera. The flash was intensive enough for the effect to be noticeably artificial and quite surreal.

Fact file

Photographer:	André Schuster
Client:	Photographer's portfolio
Model:	Lisa, ModelPool, Dusseldorf
Location:	Golf course, Germany
Time of day:	2pm, April

Technical details

Camera:	Canon EOS 3
Lens:	85mm
Film:	Kodak Portra 160VC
Exposure:	Not recorded

' I wanted the photos to be ironic and funny so the poses and the light are meant to look unrealistic.'

André Schuster

André directed the model to this cliched classic golfing pose and included plenty of sky in the background as though she was watching her ball fly through the air. Again the daylight was artificially enhanced using flash, at a greater power than for fill-in, from the right of the camera. ▲

Sun

Medium format camera
at low angle

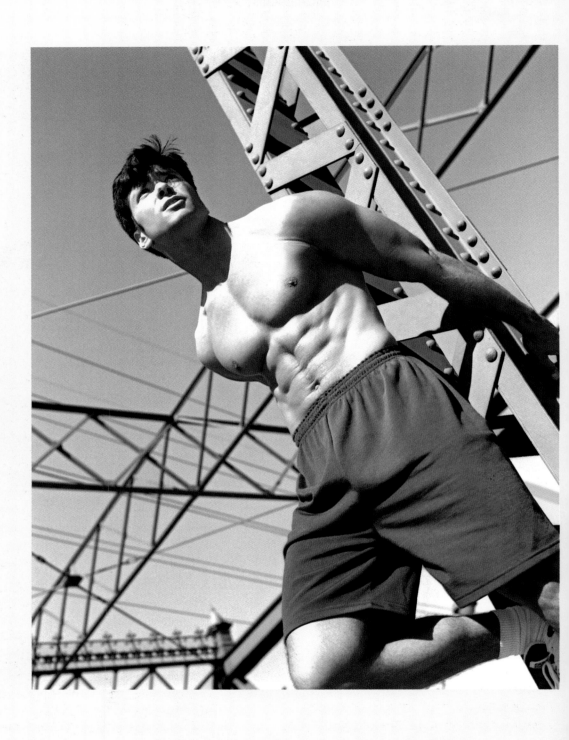

'The client wanted large blocks of solid black and white for the poster production technique. I'm wary of shooting with no shadow detail at all, because there's no way to bring it back. With black and white, if I allow for just a little detail, it's much easier to keep it or lose it in the print.'

Chuck Smith

Fact file

Photographer:	Chuck Smith
Client:	Target Stores
Model:	Steve Johnson, Meredith Model & Talent
Location:	Minneapolis, USA
Time of day:	Midday, September

Technical details

Camera:	Pentax 6x7
Lens:	165mm f/4
Film:	Kodak T-Max 100
Exposure:	1/250sec at f/11

The Brief

This image was taken as part of an advertising campaign for Target Stores called 'New Year, New Gear'. These would be large posters hanging from the ceiling throughout the store and needed to be bold, graphic, high-contrast images that would be screened in one of several strong colours. Chuck's assignment was to shoot a wide variety of images conveying a 'get fit, stay healthy and buy it all at Target' theme. 'We had two days to shoot two models in every kind of athletic effort we could think of.'

The Location

Finding a compact location with lots of different possibilities was essential and an area along downtown Minneapolis' river front was chosen. 'It offered it all – a mix of old historic structures, new architecture, miles of landscaped cycle and jogging paths, an outdoor gym and various bridges crossing the Mississippi.' Explains Chuck. 'This particular image was taken on an old train crossing bridge, only used for light traffic. The bare metal steelwork is a great example of strength, just like the model's physique.'

Composition

'The structure of the bridge offered so many wonderful possibilities, with criss-crossing patterns of steel interacting differently from every angle,' recalls Chuck. 'I liked the graphic nature of the bare structure against the sky, and there were only a few spots where I could shoot with no buildings or trees obstructing the background.' Chuck needed to shoot from a low angle to avoid these obstructions. This adds to the visual impact and feeling of strength, by making the model appear monumental in the composition.

Lighting and technique

Because the image was ultimately to be printed as high contrast duo tones, Chuck could shoot with much higher contrast than a typical fashion shoot. 'The sun was near its high point when this shot was taken and the model's poses were directed to maximise the effect of the sun's directional rays to define his muscle tone,' he says. Although he had been prepared to use white or foil reflectors to fill in shadow detail, Chuck didn't need them here.

Fact file

Photographer:	Marco Girolami
Client:	Max magazine
Model:	Carole Bouquet (actress)
Location:	Hotel Martinez, Cannes, France
Time of day:	10.30am, June

Technical details

Camera:	Mamiya RZ67
Lens:	180mm, f/4.5
Film:	Kodak T-Max 400
Exposure:	1/125sec at f/8

Marco took this portrait of the French actress Carole Bouquet for an Italian magazine during the Cannes Film Festival. To avoid strong contrast from the bright sun, he positioned her under a large canopy outside the hotel to serve as open shade. A silver reflecting panel placed underneath her chin, just out of the frame, lifted the light on her face and evened out the tones for a flattering result. ▲

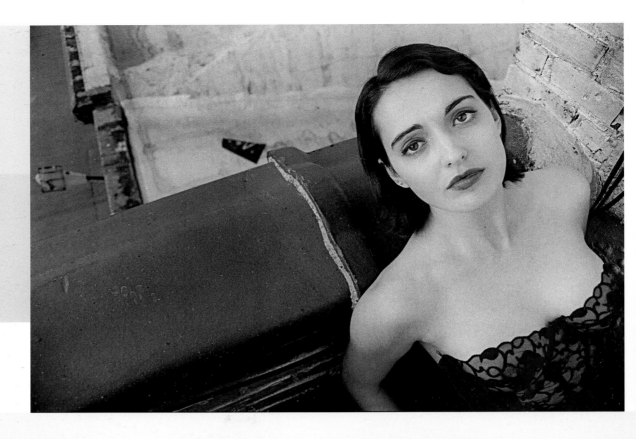

Fact file

Photographer:	Kenn Lichtenwalter
Client:	Personal work
Model:	Carmel
Location:	New York, USA
Time of day:	Late afternoon

Technical details

Camera:	Nikon FM2N
Lens:	28–50mm
Film:	Ilford HP5 Plus
Exposure:	1/125sec at f/5.6

The location

Part of Kenn's distinctive style in his personal work is his use of fairly stark urban locations, which work particularly well in black and white. For him, the fact that a semi-clothed woman is seen in an incongruous setting gives the image a story, as well as being a compositional device to incorporate graphic shapes and angles. This shot was taken on the rooftop of the model's apartment block in Brooklyn, New York.

Composition

'Having tried out various positions, I came up with the idea of Carmel sitting in the corner of the rooftop space. This enabled me to shoot from an angle above her, as well as including part of the rooftop and street below,' explains Kenn. 'What I like most about this image are all the different textures – her skin tone, the brick, the surface she is leaning on and the rooftop below.'

Lighting and technique

This was the kind of lighting Kenn aims for when shooting models. The sky was bright, but the sun hidden behind light cloud cover, giving a broad diffused light source. With Carmel leaning back, looking up towards the sky, she is uniformly lit which accentuates the smoothness of her skin.

35mm camera

Sun behind clouds

Kenn was selling prints of his work on the streets of Soho, New York when Ima, the model here, commissioned him to take her portrait. They met at her cousin's Soho apartment and, once again, Kenn was drawn to the building's rooftop, shooting from above to include the buildings below. The sun was just coming out from behind a cloud, which provided a directional light source, without the full strength of the sun. ⍖

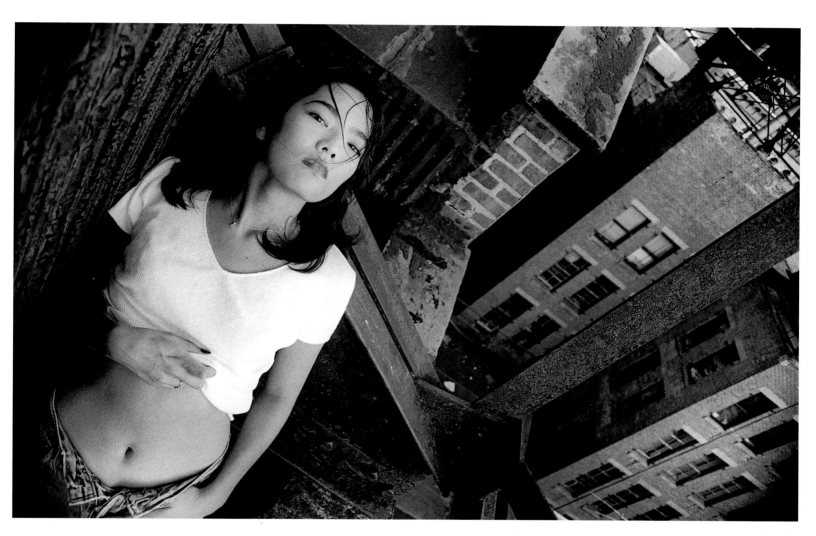

'This is a personal favourite. I like the way the buildings appear to be falling out of the frame, with the model floating above.'

Kenn Lichtenwalter

Fact file

Photographer:	Kenn Lichtenwalter
Client:	Personal work
Model:	Ima
Location:	Manhattan, USA
Time of day:	Not recorded

Technical details

Camera:	Nikon FM2N
Lens:	28–50mm
Film:	Ilford HP5 Plus
Exposure:	Not recorded

> ' I use black and white or colour depending on the "feel" I want the image to have. I don't have a preference for one or the other – they are equally important.'
>
> David Anthony

The Brief

The Parisian fashion designer, Marisa Mone, commissioned David to shoot an image catalogue featuring her designs. 'The fabrics were sheer and had a 17th-century feel to them so I decided to create a Marie Antoinette period in the photographs.'

The location

New Orleans was chosen for the shoot because it has the right kind of period atmosphere that David and Marisa were after. This picture was taken in an old dilapidated mansion that had lost part of its roof. The roughness of the bricks contrasted well with the fine texture of the fabrics.

Composition

The posing of the models is interesting here, with the third figure seen only from the back. There was good reason for this as David needed to show the main detail of that dress which was on the back and sides. He wanted to find a way of drawing attention to it, and yet still tell a story with the picture. It works well because the third, unseen, figure is apparently looking down on the other two, who are in turn glancing up at her rather disdainfully.

Lighting and technique

The day of the shoot was fairly overcast with intermittent sunny spells and then a huge downpour of rain. David squeezed this shot in during one of the brighter moments when the sun was lighting the models from above. This was bounced by a silver reflector in front of the models at a 45 degree angle. Another reflector, which was actually a mirror sprayed with a dulling solution, was held at 45 degrees on the right side of the camera. These helped to create directional light and to bring out the texture of the delicate fabrics. David took pictures for the catalogue in both colour and black and white. The latter works well here because of the monotone nature of the costumes. A green filter on the lens deepened the blacks to heighten the contrast.

Fact file

Photographer:	David Anthony
Client:	Marisa Mone
Models:	Karen, Elite Agency, Chicago and Tara, Aria Agency, Chicago
Location:	New Orleans
Time of day:	10–11am, spring

Technical details

Camera:	Pentax 6x7
Lens:	105mm
Film:	Kodak Tri X 400, rated at ISO 320
Exposure:	1/15sec at f/8

Sun

Silver reflector

Silver reflector

35mm camera

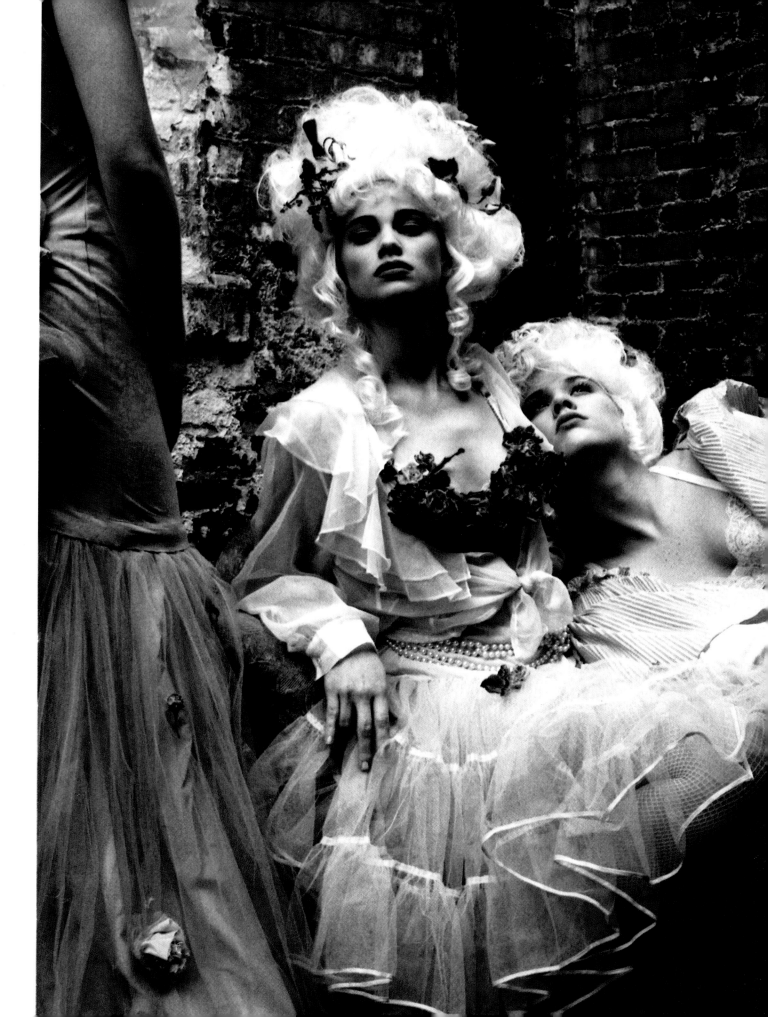

The brief

Stefano Oppo was commissioned by a travel magazine, Gulliver, to take a series of photographs using a model, to accompany editorial on the beauty farms and a spa in Provence in southern France. The client gave him no specific brief about the images required.

The location

When he is given a free reign over the pictures, Stefano's first task is to look for promising places to glean some ideas. Provence is famous for its lavender and at the time of the shoot in July, it was in full flower, providing a stunning setting for the model and a useful theme to his shots, linking the notions of health and beauty with the location.

Composition

This image has been cropped to a panoramic format from 35mm to show the broad sweep of the lavender field without including the sky, which would detract from the colour. The model is standing slightly off-centre and her relaxed pose contributes to the naturalness of the image.

Lighting and technique

Taken late in the day, the sun was setting in front of the model, producing the warm light characteristic of a summer's evening. The vibrant colours of the lavender and the model's hair have been boosted by the cross-processing technique of putting an E6 slide through the C-41 process usually used for colour negative film. This is a technique often used by fashion and portrait photographers because it tends to make skin tones look light and smooth as well as increasing contrast and making colours more vivid.

'When I don't have a specific brief from the client, the location provides inspiration.'
Stefano Oppo

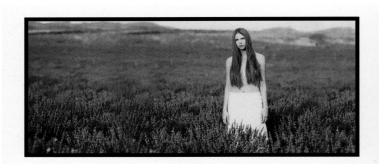

Hand-held 35mm camera

Setting sun

Fact file

Photographer: Stefano Oppo
Client: Gulliver magazine
Model: Hannah, Ice, Milan
Location: Provence, South of France
Time of day: Sunset, July

Technical details

Camera: Nikon F100
Lens: 85mm f/1.4
Film: Kodak Ektachrome 64
Exposure: 1/125sec at f/5.6

Fact file

Photographer:	Stefano Oppo
Client:	Gulliver magazine
Model:	Hannah, Ice, Milan
Location:	Provence, South of France
Time of day:	10am, July

Technical details

Camera:	Nikon F100
Lens:	85mm
Film:	Kodak Ektachrome 64
Exposure:	1/125sec at f/5.6

Fact file

Photographer:	Stefano Oppo
Client:	Gulliver magazine
Model:	Hannah, Ice, Milan
Location:	Provence, South of France
Time of day:	11am, July

Technical details

Camera:	Pentax 645
Lens:	200mm
Film:	Fuji Provia
Exposure:	1/500sec at f/5.6

This was part of the same shoot but taken earlier in the day when the sun was strong and bright. Stefano placed the model against the sun and used two portable Lumedyne flashlights, one on either side, to provide fill-in light on the front of the model, which would have otherwise been in shadow. The flash was used on 1/4 power to prevent it appearing too dominant. ▲

The lavender theme is continued in this subtle close-up. Stefano was attracted by the way the light was falling on his hotel swimming pool and so he asked the model to stand in it and scattered flowers around her. The direct sunlight above her would have been too harsh so an assistant held a reflector over her head to act as a screen. The light on her face and body is purely the effect of the water acting as a giant reflector. ▲

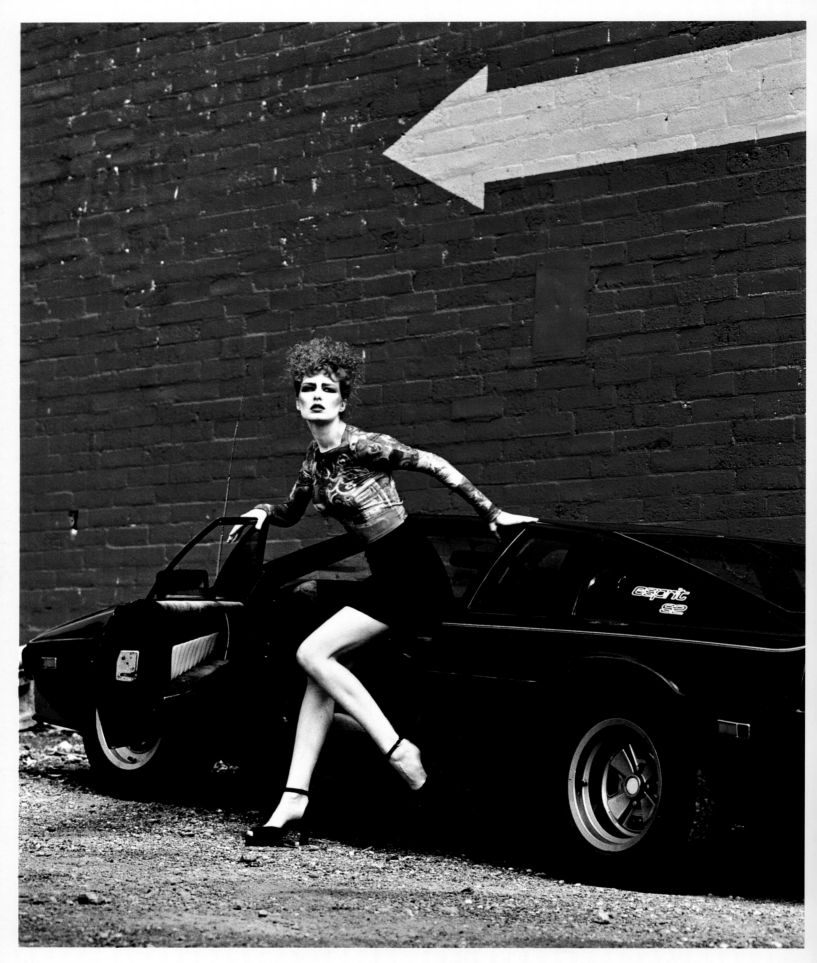

The location

Sam had noticed this area of a car park near her home on many previous occasions and felt that the colourful bricks and graphic yellow arrow would make a great location for a vibrant, urban shot. Rather than wait for a commission to use it, she set the shot up herself to show on her website, and for the model's portfolio.

Composition

The car was positioned parallel to the angle of the arrow and the model's angular shape contrasts well with those straight lines. The pose is particularly effective because her knee is pointing in the direction of the arrow, while she is looking in the other direction, leading the viewer's eye to different parts of the picture.

Lighting and technique

This picture is all about colour, and the model's orange hair, make-up and top were chosen for maximum impact. It was taken in the morning, in early spring, when the sun was still fairly low and the sky overcast. This light works well with the cross-processing technique, used here, which involves processing colour slide film in C-41 chemistry to produce a negative. The effect is to boost colour and contrast, producing quite surreal results. Stronger sunlight would have exaggerated the effect too much.

Sun overcast

Hand-held 35mm camera

Fact file

Photographer: Sam Short
Client: Photographer's and model's portfolios
Model: Sam Jocelyn
Location: Car park, Vancouver, Canada
Time of day: 10am, early spring

Technical details

Camera: Canon EOS 3
Lens: 28–105mm
Film: Kodak EPP100, cross-processed
Exposure: 1/60sec at f/8

Fact file

Photographer: Marco Girolami
Client: Smogh fashion catalogue
Model: Roberta, Zoe Model Management, Rome
Creative director: Carlo Ventura
Location: Ponte Sisto, Rome
Time of day: 4pm, June

Technical details

Camera: Nikon F4s
Lens: 105mm
Film: Fuji Provia 100F
Exposure: 1/250sec at f/4

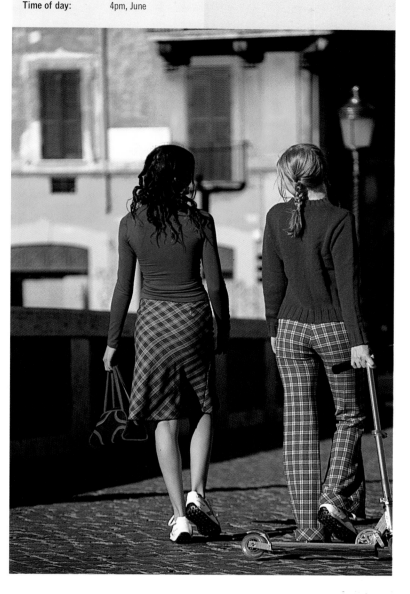

As the day progresses, bright summer sunshine becomes warmer in tone as the sun drops lower in the sky. It's a good time to photograph vibrant clothing because the light brings out the richness of colour. Here, the sun is hitting the painted building in the background, providing a good contrast with the girls' red tops. ▲

'As I was cross-processing the film, I knew the colours would be very strong, which is the effect I was going for.'
Sam Short

'The hard lighting and strong contrast works for a strong, graphic image with vibrant colour, but I wouldn't do the same thing for a pretty, romantic shot.'

John Owen

The brief

John Owen had the idea for producing a fashion story based around this unusual location after spotting it while he was working in Miami. He got together with a stylist and model and they produced it together, with the aim of selling it on to a magazine afterwards.

The location

This striking inside-out location is an artist's representation of a giant room, painted on the walls of a street corner in Miami's fashion district. John came across it just as the artist had finished and knew it would make a dramatic, colourful background.

Composition

John took the shot from a low angle and tilted the camera to alter the perspective on the background, making it look even more bizarre. The model's angular 'action' pose adds to the graphic look and the tight crop gives the impression that she is barely contained within the frame.

Lighting and technique

John deliberately chose to shoot in the strong, midday light, directly above the model, because he wanted deep shadows and a hard look. He also boosted the colour, contrast and grain by underexposing the film by one stop and then pushing it two stops in processing. The film he used, Fuji Provia, is designed to tolerate strong contrast but other films will not be so tolerant. It's important to experiment when push processing transparency film to gauge what you can get away with.

Still using the same hard, midday light with no flash or reflectors, John placed the model, careful to include the three bands of colour in the background which complement the model's shirt superbly well. The positioning of her arms above her head allows the detail on the fabric to be seen, even though it's a very tight crop. ▲

Fact file

Photographer: Anthony-Michel Mautemps
Client: Photographer's portfolio
Model: Chernice
Location: Roosevelt, New Jersey, USA
Time of day: Mid-afternoon, March

Technical details

Camera: Mamiya 645
Lens: 80mm
Film: Fuji Provia 100
Exposure: Not recorded

'I like shooting with at least one direct light source, whether it's a strobe, tungsten or the sun. I find that it produces more vibrant and contrasty colours.'

Anthony-Michel Mautemps

Medium format camera

Sun

The location

Since this was shot for his own portfolio, Anthony-Michel could choose his own location and this is a spot that he frequently finds inspiring. 'It's a federal wildlife reserve with six different lakes and I've been coming here since my teens, to get away from it all,' he explains. 'It's great for photography, too, because the light is fantastic whatever time of day you come.'

Composition

Apart from the vibrant colours, the strength of this shot lies in the model's expression and the direct eye contact she has with the viewer. It's a strong, unpretentious pose, using two stalk-like plants which they found growing out of the ground. These give her something to do with her hands and also cast the horizontal shadow across Chernice's chest which links her black hair with the skirt.

Lighting and technique

Although it looks like it was taken in the blazing heat, this was actually shot in early spring. 'I remember that Chernice was pretty cold when we took it,' recalls Anthony-Michel. He used only available light, with the strong, directional sun coming from above and to the right of the camera. No filters or digital reworking were necessary – apparently the water in the lake really is that colour.

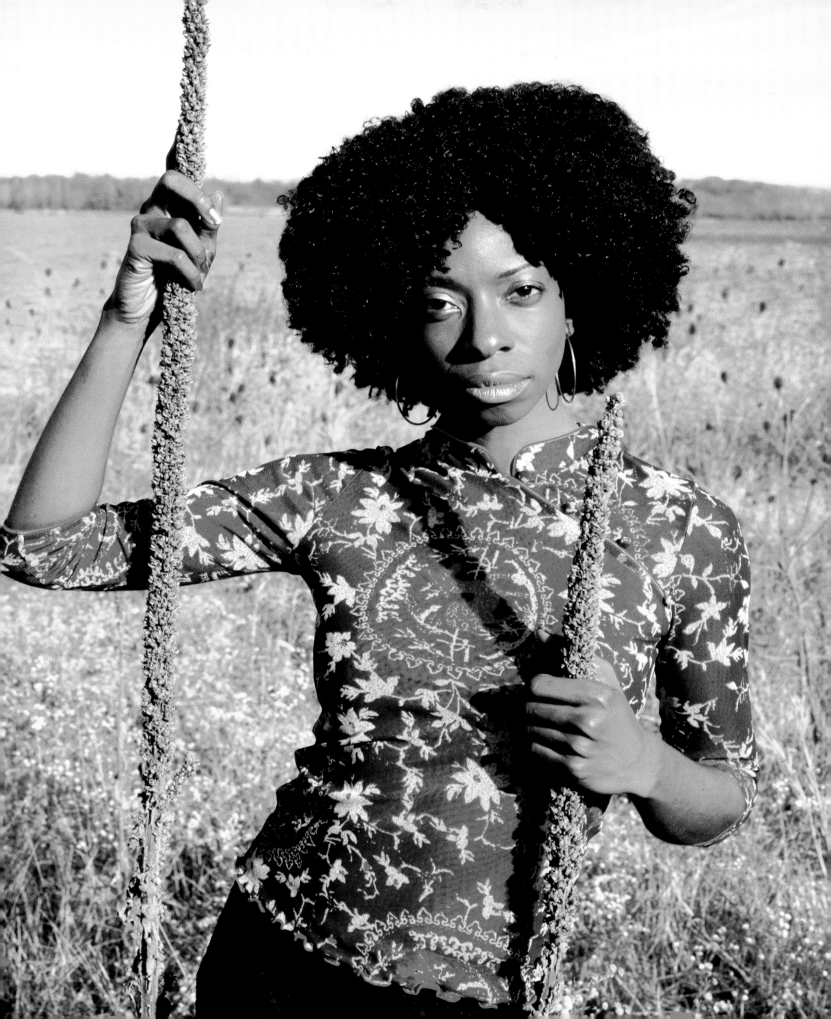

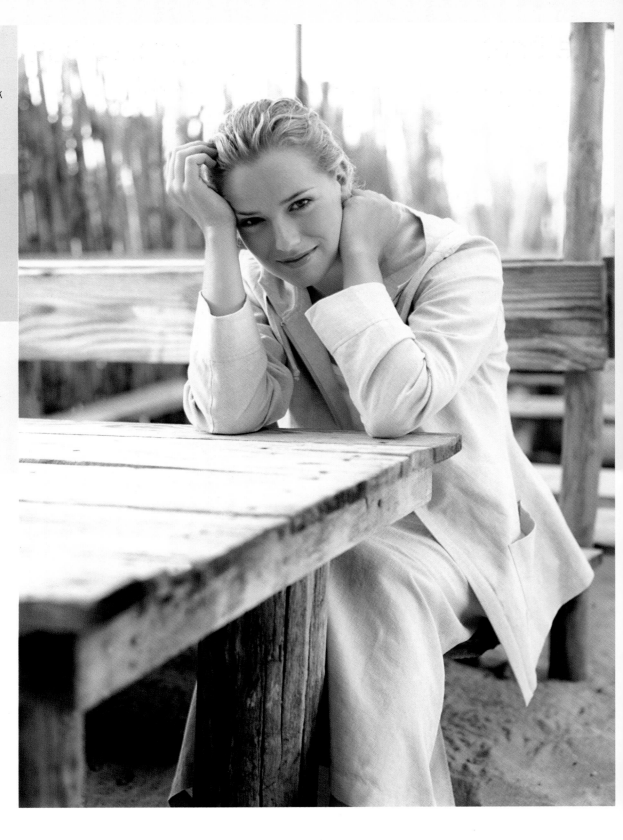

The brief

One of John's regular clients, a mail order fashion catalogue, commissioned him to take a wide variety of shots, from which one would be selected to be used on the cover. A lifestyle feel was required but, apart from that, there was no particular brief. John has the experience to know the kind of images that the client would want.

The location

The beach at St Tropez in the South of France offered the chance to work with many different outfits and backgrounds to create a wide range of looks. The muted, subtle shade of the suit featured here needed similar tones to balance with it. The sandy ground and wooden furniture of this beachside bar were ideal.

Composition

The table and bench give a structure to the composition and the weathered texture of the wood makes the outfit itself look natural and comfortable. The soft range of tones work in harmony together so there is nothing to jar the eye within the frame. The model's pose is also relaxed and she is looking at the viewer in a friendly way, which is the right tone for the customers of this particular catalogue.

Lighting and technique

It was an overcast day but the sky was fairly bright, as you can see from the background. The model is in open shade, under the canopy of the beach bar, which gave John the soft, diffused light he wanted for the overall look of the image. It needed lifting and brightening slightly, however, so a silver reflector was placed either side of the model to bounce light on to her.

Sun behind clouds

Canopy

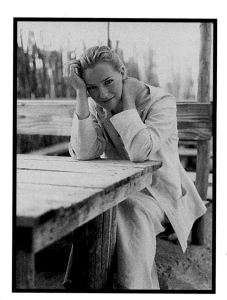

Silver reflector

Silver reflector

Medium format camera

'Usually a cover image will show eye contact and a smile, but there are no hard and fast rules. You can't reproduce the same thing for every shot – the client wants some options to choose from.'
John Owen

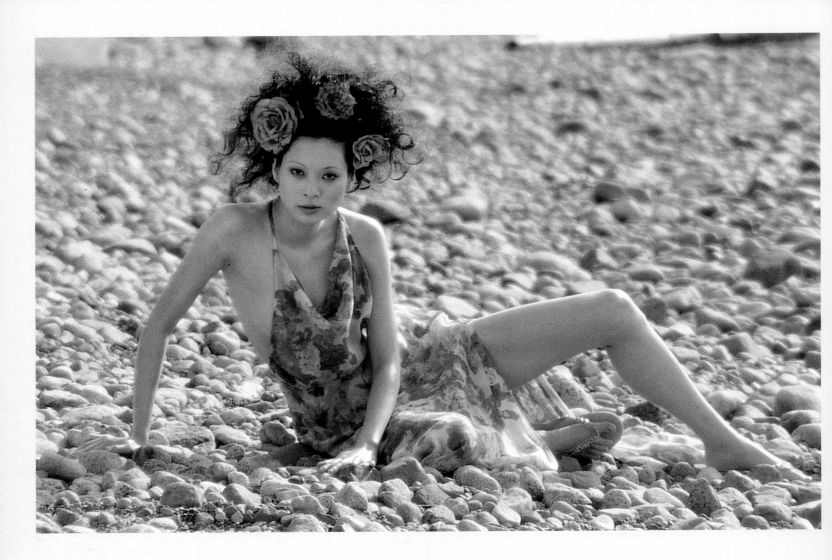

The brief

Sam was commissioned to do a fashion shoot for a lifestyle magazine using various locations in and around Vancouver, which were discussed with the client beforehand. Featuring one model in different outfits, ranging from lingerie to evening wear, there was no single theme to the pictures.

The location

You don't normally expect to see a woman in lingerie on a rocky beach but that's exactly why Sam chose it. She also wanted quite a neutral background, with not a lot of colour, to give the image a soft feel.

Composition

Using a long lens and fairly shallow depth of field has rendered the model sharp but the pebbles in the foreground and background out of focus. This way, they don't distract the eye from the subject but become more of an overall texture that contrasts with the delicate prettiness of the model and her outfit.

Lighting and technique

In the early hours of the morning in early spring, the sun was low enough to light the model directly, without creating hard shadows, or the necessity for reflectors or fill-in flash. To soften the effect further, Sam used a piece of nylon stocking over the lens – a common alternative to using a soft focus or diffusing filter.

Fact file

Photographer:	Sam Short
Client:	Vancouver magazine
Model:	Chen, Liz Bell agency, Vancouver
Location:	Ambelside Beach, West Vancouver, Canada
Time of day:	Early morning, spring

Technical details

Camera:	Canon EOS 3
Lens:	200mm
Film:	Agfachrome ISO 100
Exposure:	1/250sec at f/5.6

'I prefer to use a stocking on the lens – black works well – as I can control the amount of diffusion I want by varying the thickness.'

Sam Short

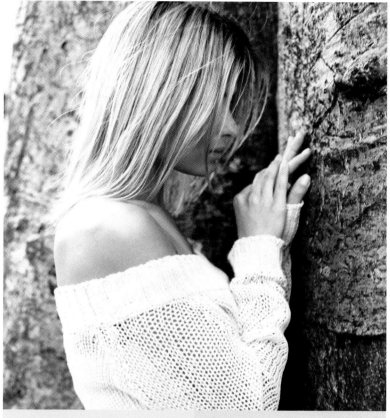

Fact file

Photographer:	John Owen
Client:	Personal work
Model:	Beneatha Hunter, Outlaws Models, South Africa
Location:	Miami, Florida, USA
Time of day:	Late afternoon

Technical details

Camera:	Contax 645
Lens:	80mm
Film:	Fuji Provia 100
Exposure:	1/125sec at f/4

The texture of the tree trunks contrasts with the model's hair and is also complimentary to the loosely knitted top. It gives the garment a natural feeling that a smooth surface wouldn't achieve. The model was in the shade of the tree with a silver reflector to the left of the camera. ▲

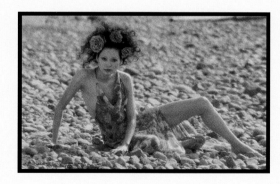

Medium format camera

Sun behind clouds

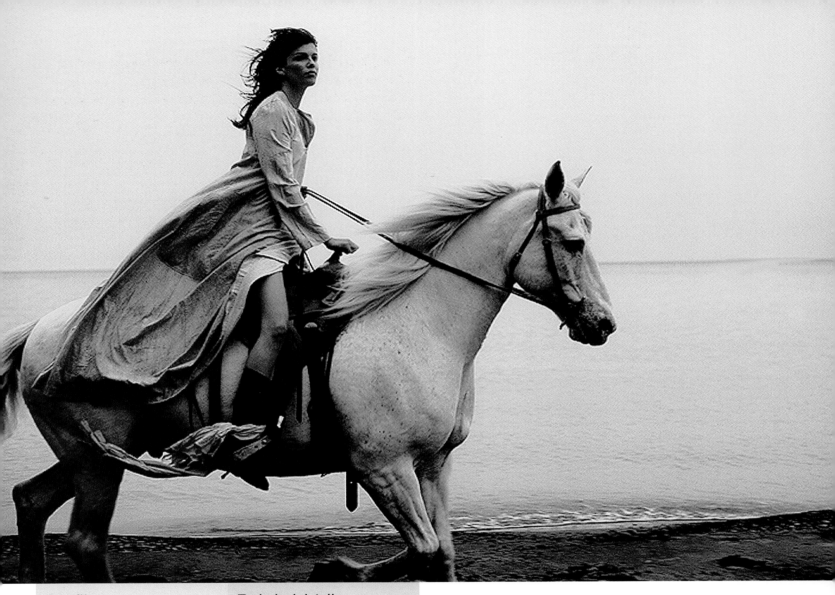

Fact file

Photographer:	David Anthony
Client:	Harper's Bazaar
	(Latin American edition)
Model:	Martine, Next Agency
Location:	Scarborough Bluffs, Ontario,
	Canada
Time of day:	8–9am, June

Technical details

Camera:	Mamiya 645 Pro TL
Lens:	80mm
Film:	Kodak E100 VS
Exposure:	1/250sec at f/8

Sun

' I feel that photographers who need to take five or ten Polaroids of a set-up don't know what they're looking for. They are simply hunting around until something looks good.'

David Anthony

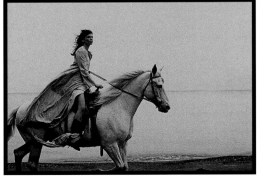

Medium format camera

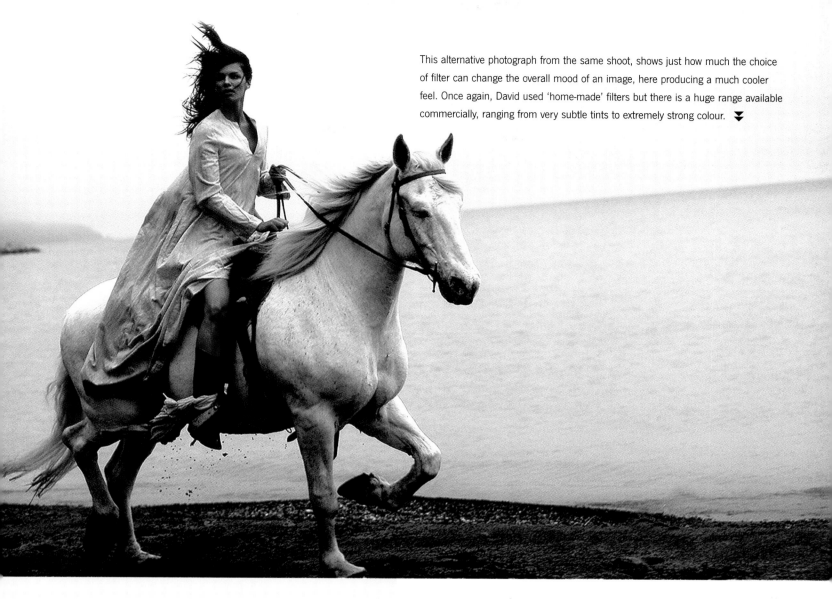

This alternative photograph from the same shoot, shows just how much the choice of filter can change the overall mood of an image, here producing a much cooler feel. Once again, David used 'home-made' filters but there is a huge range available commercially, ranging from very subtle tints to extremely strong colour. ❯

The brief

This was for an autumn/winter edition of the fashion magazine, although photographed in June because of the long lead-times. 'Since the majority of the season's designs had a strong Asian influence, I chose to create a fashion story based upon Japanese cinema,' explains David. 'This shot was a variation of the one selected to open up the story, and ran as a two-page spread.'

The location

Scarborough Bluffs is a spectacular cliff formation, rising above Lake Ontario with a narrow beach at the base. David chose this location because the landscape has a rugged natural drama and he knew he could use it in a variety of different ways for the various shots in the story. Here he made use of the beach, with the lake in the background.

Composition

David rarely takes more than one or two Polaroids of a set-up, before going for the real shot. 'From that one Polaroid I can see what, if any adjustments need to be made and then I make them. I create and "shoot" the photograph in my head prior to using the camera, then I set about recreating what I've already envisioned.'

Lighting and technique

Early in the morning the sun was low, but still quite bright, coming from the right of the camera. To create the warm tone in the image, David used an 81B warm-up filter, combined with a couple of very old glass filters. 'They were made in the 1940s and were originally designed for 8x10 cameras,' he explains. 'I had them cut down and adapted for my 6x7s and 645s. The colours have faded and are most likely not what they originally were.' David always uses a hand-held meter to take a reading and then adjusts the exposure for filters, which reduce the amount of light reaching the lens, if necessary.

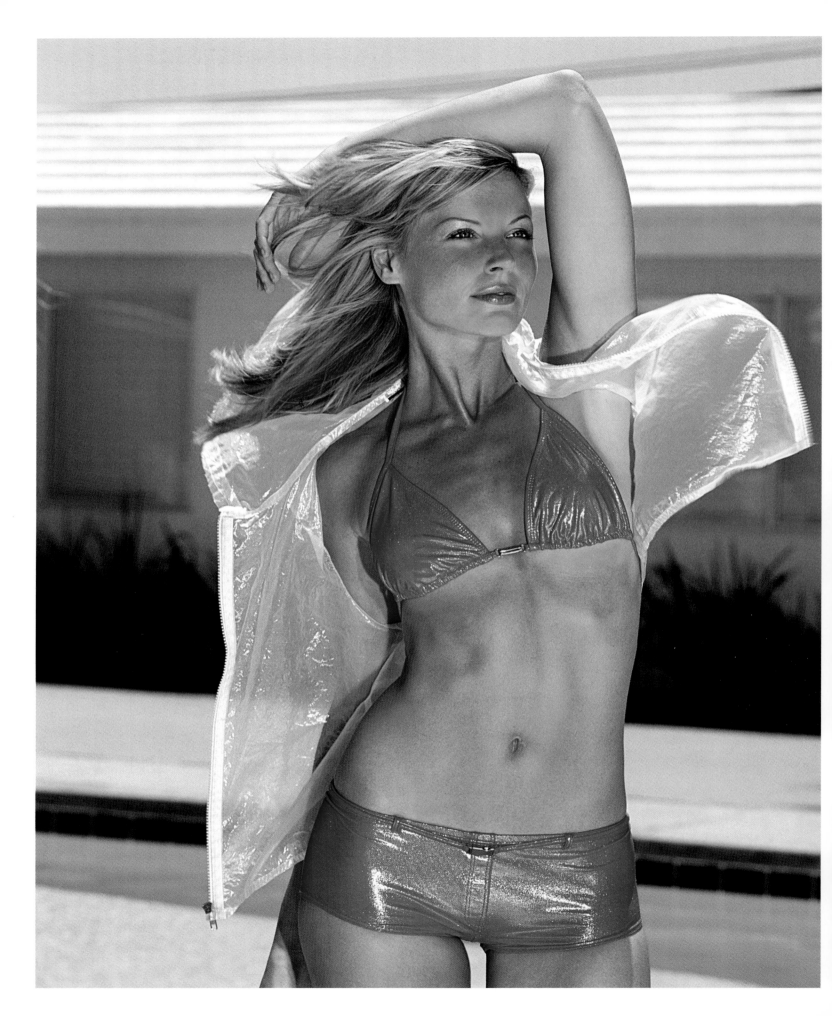

Chapter 4: **The outdoor studio**

Just because you're working out on location, it doesn't mean you have to accept whatever nature throws at you. Very often natural daylight needs a helping hand to create more drama in a shot, warm up the blue cast of a cloudy day or simply fill in obtrusive or distracting shadows.

There are many tools at the photographer's disposal to manipulate, modify or enhance the light, and in recent years they have become increasingly portable, making outdoor photography a serious option even for those used to the controlled surroundings of the studio.

It may be that no more than a burst of on-camera flash or a carefully placed reflector is required to make a subtle but important difference to a shot. More complex set-ups could involve several battery-powered flash heads, perhaps diffused through softboxes or umbrellas. By combining the light from the flash with the existing daylight in different proportions, numerous effects are possible, ranging from the barely noticeable to the dramatic and theatrical.

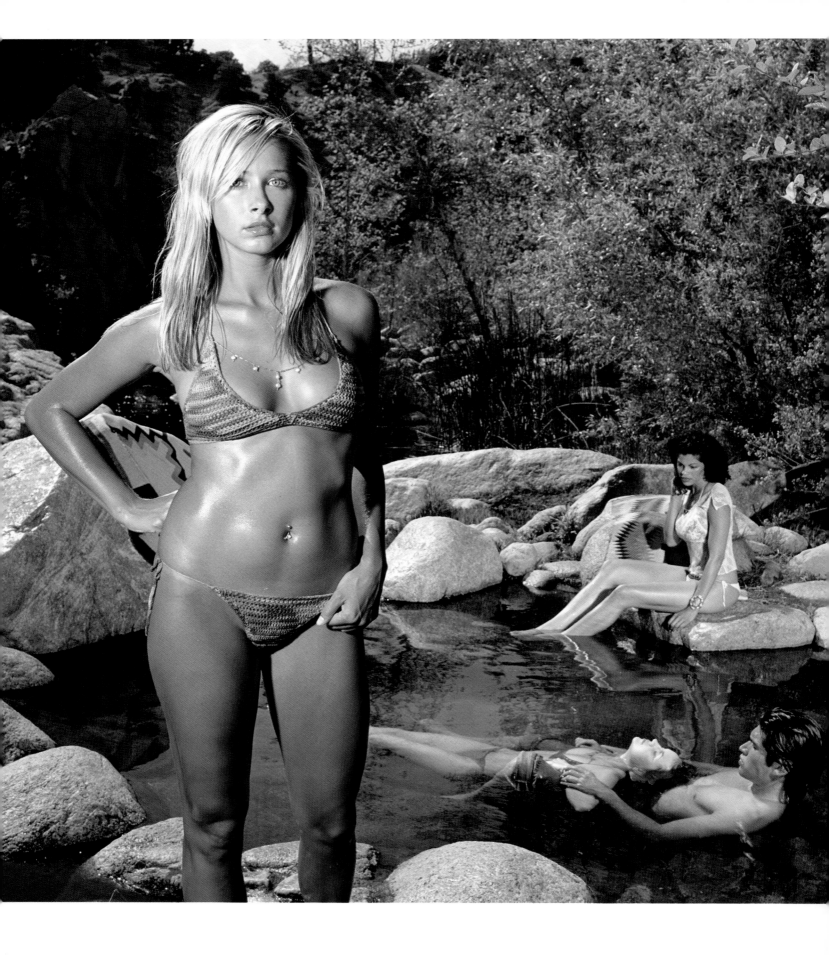

The brief

'A young designer called Ambika designed these beautiful bikinis and I decided to do a spread for my portfolio,' explains Dorit. 'I picked the models and arranged the shoot myself.'

The location

It was quite a trek to get to this stunning setting by a river in the Californian desert. The drive took two-and-a-half hours from Los Angeles and then it was a further 45-minute cross-country hike, loaded down with all the photographic equipment, clothes, food and drinks. 'I scouted for this place with a friend the week before and found it really special,' says Dorit. 'I love places that are hidden from the public and hard to get to.'

Composition

There's nothing realistic about this shot, nor was there meant to be. The setting is like an idyllic oasis, with the models arranged in a staged way and picked out by the artificial light. The model in the foreground immediately arrests the eye, while the other three form an interesting tableau in the background.

Lighting and technique

The natural light was quite strong and was also bouncing off the rocks and water. Dorit supplemented this with flash to create a kind of fantasy atmosphere. A 7B Profoto unit was placed directly in front of the foreground model, with a warming gel over the head to darken her skin tones further. Another Profoto head was placed to the right of the camera to light the other three models. Both flash units were set at 1/2 a stop stronger than the ambient light.

' I tried to create an image that looked surreal but also sexually charged. I wanted a certain innocence from the blonde girl and a sense of self-involvement from the others.'

Dorit Thies

Fact file

Photographer: Dorit Thies
Client: Photographer's portfolio
Models: Jesse and Luis, LA Management; Jaylin, Ford Agency, LA and Ambika
Location: California, USA
Time of day: 2.30pm, June

Technical details

Camera: Mamiya 645
Lens: 55mm
Film: Kodak Portra 160 VC
Exposure: 1/250sec at f/16

Sun

Medium format camera

Flash head
(on three in background)

Flash head
(on girl in foreground)

Fact file		Technical details	
Photographer:	Farrokh Chothia	Camera:	Mamiya RZ 67
Client:	Design and styling company	Lens:	110mm f/2.8 Mamiya Sekor
Model:	Madhu Sapre	Film:	Kodak Tri X
Location:	Manori Beach, India	Exposure:	Approx 1/400sec at f/22
Time of day:	4pm		

The brief

This was taken as promotional material for a design and styling company in India. Farrokh came up with the idea for the image when he spotted a palm leaf lying on the ground and was struck by its graphic quality.

The location

Manori beach, north of Bombay city, was the setting here. Farrokh uses it frequently because he loves the sense of space and the combination of sea, sand and plenty of uninterrupted sky.

Composition

'Looking at the leaf, I thought it would look great in silhouette – a black shape against sea, sky and clouds,' he says. 'Since my model, Madhu has a really strong profile, I photographed her from the side.'

Lighting and technique

Farrokh needed to combine natural with artificial light to create the exact effect he was after. 'I wanted just a spot of light on Madhu, with most of the leaf kept dark,' he explains. 'I used my Norman 400B battery-powered strobe, but instead of using the regular reflector on the head, I used the Norman parabolic dish. This is a very shiny reflector dish that throws the light in a tight beam for a long distance. Since there's no modelling lamp on this head, it's tricky to focus the strobe on the subject and I had to estimate the angle of the spot. As it turned out, it was pretty accurate.'

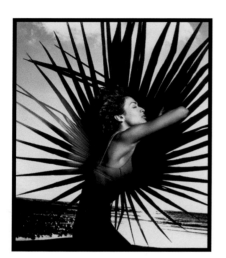

Flash head with reflector

Medium format camera

' Since the composition was precise, and the strobe was focused just on Madhu's head and shoulders, nothing could move more than a couple of inches. The palm leaf was held by the make-up artist. She was just visible behind the model – but I've burned that area in.'

Farrokh Chothia

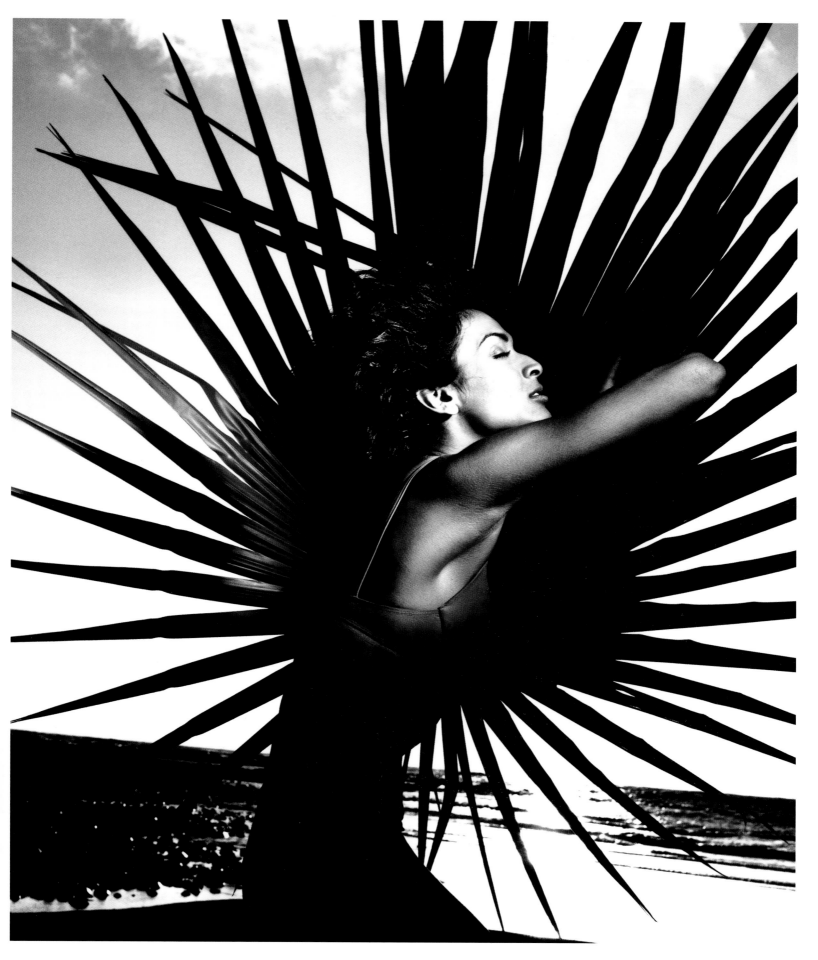

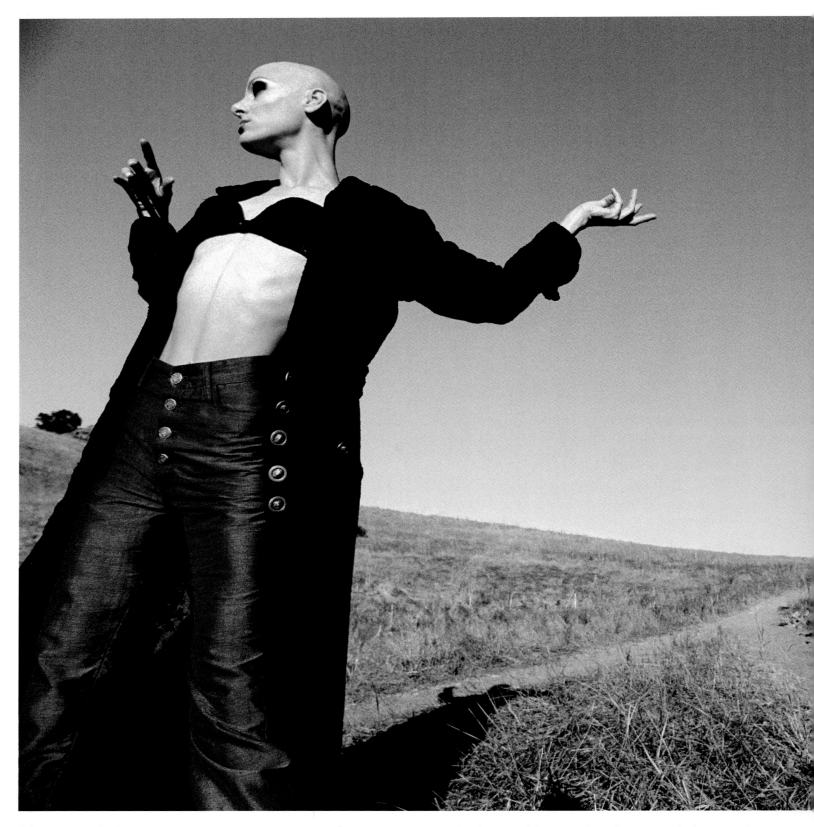

'I wanted the image to give a surreal impression. I chose Hannah, the model, because she looked like a mannequin lost in space.'

Dorit Thies

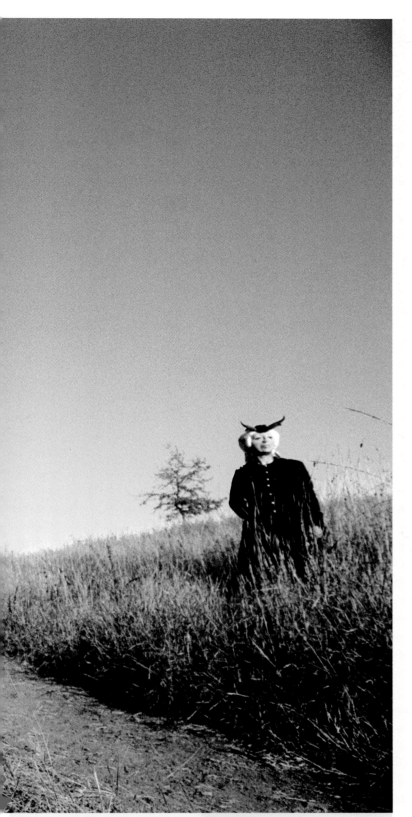

The brief

This was taken for a book called Style Surfing, published by Thames and Hudson. Dorit was given a very loose commission to portray the work of the fashion designer, Terry King, who made her name in the music world.

The location

Dorit chose Malibu Canyon because it had a sense of isolation and wilderness. It provided her with the all-important path and a broad, virtually uninterrupted view of the sky to give a bold background, contrasting with the black clothing of the figures.

Composition

There's a bold and dramatic use of space here, with the model looming large, right at the edge of the frame and the mysterious smaller figure on the far side. Dorit used a 20mm wide-angle lens to distort the perspective and ensure both figures were in focus. 'The path in the background represents either uniting or splitting,' explains Dorit. 'It's my personal interpretation of life that we always have more than one choice. The person in the background – my assistant – is wearing a mask with horns and white hair, representing the devil in disguise.'

Lighting and technique

Dorit planned the shoot for late afternoon so the sun, behind the camera, would provide long shadows and the sky would be a deep, rich blue. She used a Norman 400 battery-powered flash, set at 1/2 a stop stronger than the ambient light, to fill in some light on the model's face.

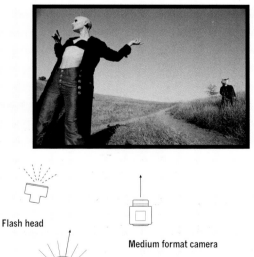

Flash head

Medium format camera

Sun

Fact file

Photographer:	Dorit Thies
Client:	Thames and Hudson
Model:	Hannah Sim, osseuslabyrint.net
Location:	Malibu Canyon, California, USA
Time of day:	4.30pm, August

Technical details

Camera:	Nikon FM2
Lens:	20mm
Film:	Kodak EPP 100
Exposure:	1/250sec at f/22

The brief

'My friend and choreographer, Astad Deboo, was performing in town with this amazing company of martial arts dancers from the north-eastern part of India,' explains Farrokh. 'I have always been fascinated with dance, not being very good at it myself, and jumped at this chance to create an image using their talents, fused with elements of fashion.'

The location

Because of the logistics involved, Farrokh could only shoot this set-up on the terrace of the auditorium where the company was performing. As it turned out, the place was perfect. 'It gave me a clear view of the sky and horizon, and the floor was nicely weathered in the same moody grey tones as the sky – a set of happy coincidences that are very rare in this business. Most importantly, it was free and very private – there are 19 million people in Bombay, and all of them usually turn up to watch me when I'm shooting anywhere in public.'

Composition

Since he would have very little time to shoot this, Farrokh needed the image to be as clear as possible in his mind. He planned for Sushma to be in the centre of the frame and almost detached from what was going on around her. The dancers come from a long tradition of temple warriors, a form of martial arts that has now evolved into dance, and he wanted to convey a feeling of worship in the image.

Lighting and technique

To get the slightly surreal and dramatic look that he had in mind, Farrokh mixed flash with available light. With five people in the frame, he needed plenty of fire power, provided by an Elinchrom 3000 power supply with a single head, fitted with a 70cm dish-shaped reflector and diffuser. This was mounted on a high Manfrotto boom stand, almost like a street light. To balance the background sky with the subjects, he had to set the 3000 pack to full power.

'I had enough time for two rolls of 120 film (10 frames each). I wanted this to be a vertical image, but in the general hysteria I shot the first seven frames with the film magazine in the horizontal mode. I flipped it over, crossed my fingers and fired off the rest before the sun disappeared completely.'

Farrokh Chothia

Fact file		Technical details	
Photographer:	Farrokh Chothia	Camera:	Mamiya RZ 67
Client:	Personal work	Lens:	110mm f/2.8
Models:	Sushma Reddy and the Hula group	Film:	Kodak Tri X
Location:	Marine Drive waterfront, Bombay, India	Exposure:	1/400sec at f/16
Time of day:	Just before sunset		

'The critical thing here was to get the timing right,' explains Farrokh. 'There is always a lag between pressing the shutter release button and the actual exposure of the frame and when your subjects are moving fast, this delay, however small, becomes a problem. I had to fire the shutter a micro second before the peak of the action, so that when the light actually hit the film plane, the subjects would be in the right place (almost).'

Farrokh Chothia

Sun before sunset

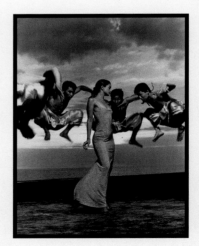

Medium format camera

Flash head with reflector and diffuser on high boom stand

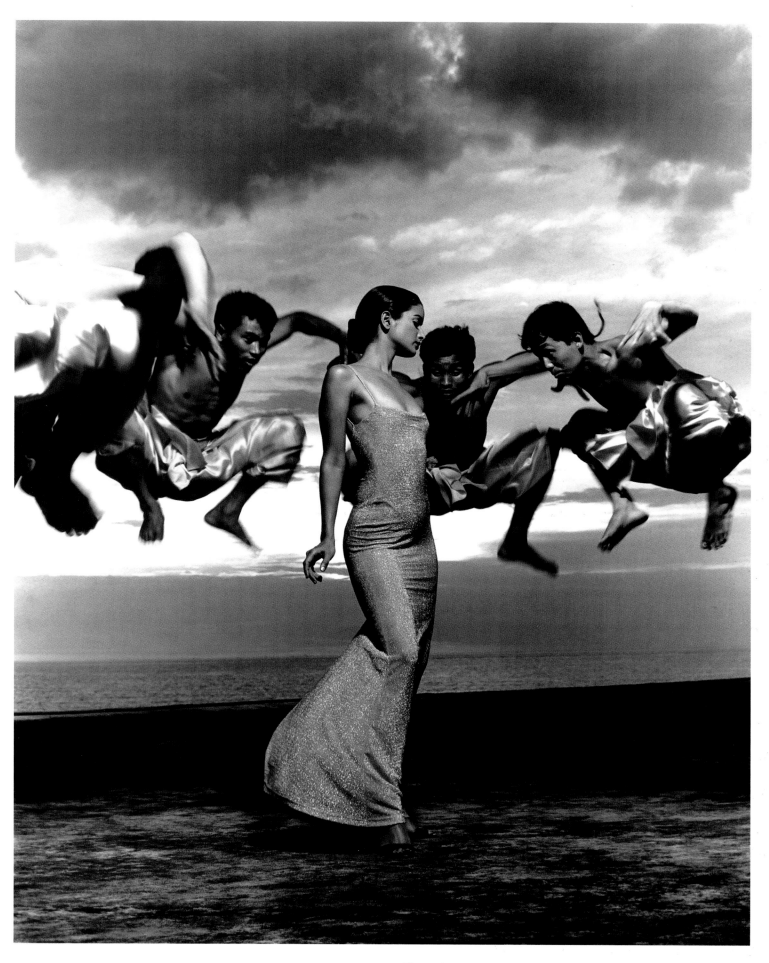

Fact file

Photographer: Marco Tenaglia
Client: Photographer's portfolio
Model: Mila, IS Model Management and Blush Model Management
Location: Sabaudia, Italy
Time of day: Mid-afternoon

Technical details

Camera: Nikon T90
Lens: 24mm
Film: Fuji Astia 100
Exposure: Not recorded

'When you're shooting outside you have to have an open mind to different possibilities depending on the circumstances – especially changes in the weather.'

Marco Tenaglia

Shade over model from roof of bar

35mm camera (hand-held)
Flashgun on hotshoe

Sun

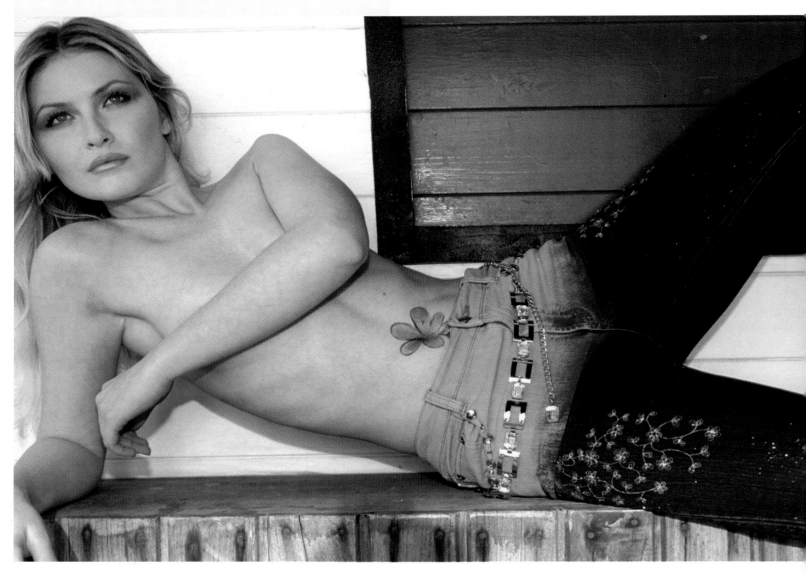

The brief

This was taken for Marco Tenaglia's own portfolio, to show potential future clients who will want to see the range and style of his work. He prefers not to pre-plan his pictures in detail although he usually has an idea of what he hopes to achieve. He often finds that new possibilities develop during the shoot as the light changes or he finds a different angle that works well. It's important for him that the whole team, including the model, the make-up artist and his assistant, co-operate together and that everyone is receptive to ideas.

The location

The beach at Sabaudia, near Rome, is one of Marco's favourite locations because it offers a variety of angles, backgrounds and props within a small area, allowing him to take many completely different shots. Here the model is reclining on the window seat of a beach bar, which was closed at the time.

Composition

Marco has framed the shot very tightly, so the model is almost leaning against the edge of the picture. The diagonal of the arm across her chest works well with the angle of her raised leg, making the pose look comfortable and natural rather than awkward. The green window is an important element because it means the eye is drawn to the model's face, which stands out against the white background.

Lighting and technique

The roof of the bar provided open shade, so there was no direct light from the sun falling on the model. This can have a subtle and flattering effect for portraiture, but Marco wanted to lift the skin tones a little more and so used a small electronic flash mounted on the hotshoe of his camera to provide fill-in. The humble portable flashgun is an inexpensive and simple way of enhancing natural light. It can be made fairly versatile too, by diffusing it with tracing paper, bouncing it off a white wall or ceiling, or using an extension lead to vary its position. To balance flash with daylight for a fill-in effect, the general rule is to expose correctly for daylight and underexpose the flash by one or two stops. You can do this by setting the film speed indicator on the flash by two stops more than the film in the camera (ISO 100 film becomes ISO 400 on the flash). In this case, Marco overexposed the film by one stop from the suggested meter reading to make the skin look clear and flawless.

> ' If you're overexposing by one or two stops to make the skin look smooth, the make-up needs to be stronger so that it looks normal in the final result.'
>
> Marco Tenaglia

This was taken outside the same beach bar but facing in the opposite direction, towards the sea. Later in the day, the sun was lower here, and coming from behind and to the left of the model, as she is in the picture. Again Marco used on-camera flash to brighten up the skin tones and fill-in areas of shadow. ❧

Fact file

Photographer:	Marco Tenaglia
Client:	Photographer's portfolio
Model:	Mila, IS Model Management and Blush Model Management
Location:	Sabaudia, Italy
Time of day:	Early evening

Technical details

Camera:	Canon T90
Lens:	24mm
Film:	Fuji Astia 100
Exposure:	Not recorded

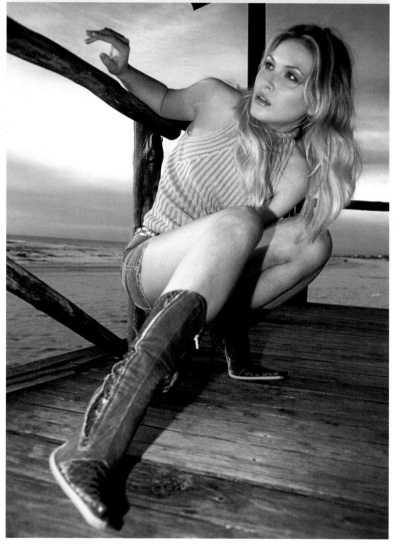

Sun

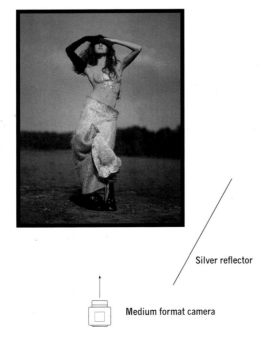

Silver reflector

Medium format camera

Fact file		Technical details	
Photographer:	David Anthony	Camera:	Mamiya 645 Pro TL
Client:	Harper's Bazaar (Latin America edition)	Lens:	80mm and 150mm
		Film:	Kodak E100 VS rated at ISO 80
Model:	Pauline, Next Agency	Exposure:	1/125sec at f/4
Location:	Lake Ontario, Toronto, Canada		
Time of day:	1–2pm, June		

The brief

David was commissioned to photograph the fashion designs of Gianfranco Ferre for the October issue of Harper's Bazaar. The pictures had to look like they were taken in mid-autumn rather than June, and needed to show off the clothing in the best light. Other than that, David was given the freedom to use his judgement, in collaboration with the magazine's fashion editor.

The location

The production team, including fashion editor, stylist, make-up artist and model, travelled to Toronto to shoot these images by the shores of Lake Ontario. 'This place had the landscape we needed,' he says. 'Plus we felt it was time for a road trip.'

Composition

These two images were designed to work together on a magazine spread. David decided to crop the head off the full-length shot for use in the magazine to focus the attention on the skirt. The head of the model is then revealed in the close-up, which also allows the detail of the Ferre logo to be seen. The different levels and tones of the water, trees and sky add subtle interest to the background, with the dark band of trees picked up by the model's glove.

Lighting and technique

Shot in summer, the sun was high in the sky at this time of day and the light was quite hard. A sliver medium-sized reflector was placed at a 60 degree angle from the model, with emphasis placed on the clothing. To make the images really stand out on the page, he wanted deep colour and a warm tone, which wasn't intended to look natural. A combination of two coloured filters achieved this. David's are glass ones from the 1940s and adapted for his own lenses, but similar effects can be achieved with modern filters.

' I prefer to do everything to create an image "in camera" and only use Photoshop for basic retouching and dusting.'

David Anthony

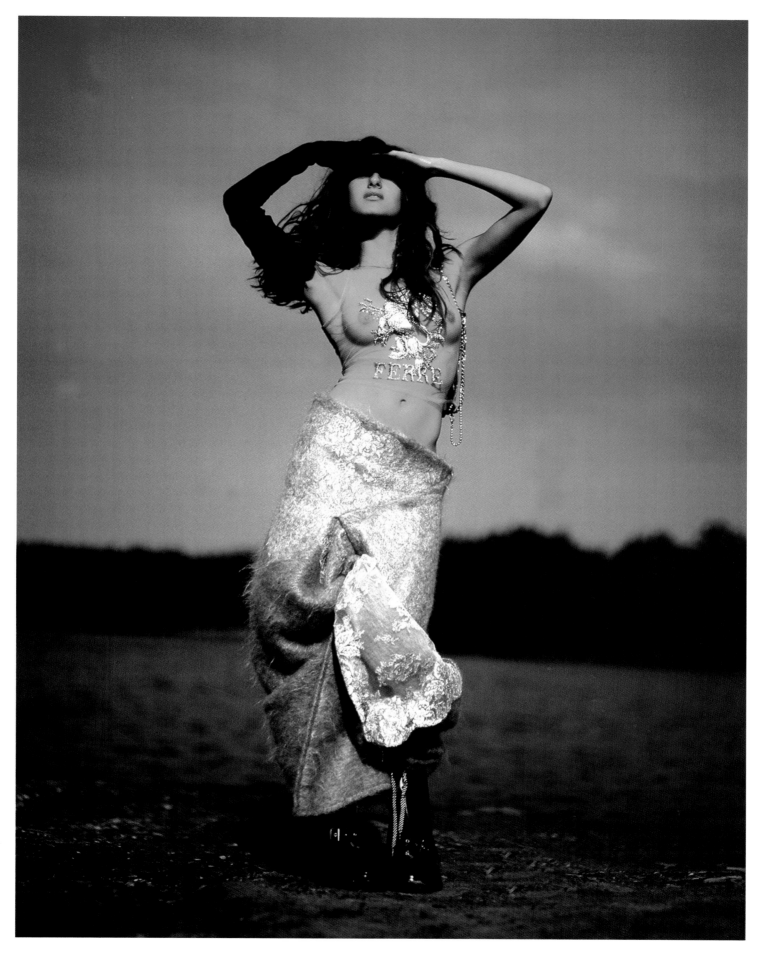

The outdoor studio: Reflection

' I love working in natural areas because they make everyone feel much more relaxed and ready to open up. The city has too many distractions that make people uptight.'

Dorit Thies

Fact file

Photographer:	Dorit Thies
Client:	Photographer's portfolio
Model:	Lana Papke, jetsetmodels.com
Location:	Malibu Canyon, California, USA
Time of day:	3pm, June

Technical details

Camera:	Mamiya 645
Lens:	150mm
Film:	Kodak Portra VC 160
Exposure:	1/250sec at f/16.5

'The model had a great look so I didn't pose her, just let her act naturally. You can tell so much more about her this way.'
Dorit Thies

The location

Dorit uses Malibu Canyon, half an hour north of Los Angeles, frequently because she loves the naturalness of the place, and the fact that she can work undisturbed because mobile phones don't work there.

Composition

This was one of a series of shots Dorit took during a whole afternoon's shoot with the model. She wanted a fairy-tale look to this portrait, using the blue sky to contrast with the fair skin and long blonde hair of her subject. The area of green in the background adds vibrancy to the image and works well with the model's top.

Lighting and technique

The sun behind the camera was casting shadows that were too strong on the left side of the model. Dorit wanted to eliminate these and make the model uniformly bright with a smooth, flawless complexion. She used a Profoto 7B flash to the left of the camera, on the opposite side of the sun. A meter reading gave her an aperture of f/16 and she then set the flash half a stop brighter than the ambient light, at f/16.5.

Fact file

Photographer:	Anthony-Michel Mautemps
Client:	Photographer's portfolio
Model:	Rebecca, Click Modelling
Location:	Brooklyn, USA
Time of day:	Mid-afternoon, spring

Technical details

Camera:	Mamiya 645
Lens:	80mm
Film:	Fuji Provia
Exposure:	1/250sec at f/5.6

Flash head

Medium format camera

Sun

The effect of the flash is very strong here, with no shadows and very little texture on the face. Anthony-Michel used a strobe and softbox to his right and a little above the model. A second strobe with an umbrella was placed to the left, aiming under the model's chin, to act as a fill. ▲

Overcast sun

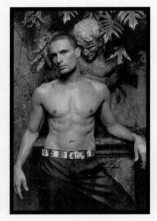

Flash head above model's eyeline

White reflector lying on ground

Medium format camera

'The trick of an advertising shoot is to get the detail across but with ambience and feeling. In this case I chose to favour the image over the product.'

Farrokh Chothia

Fact file

Photographer:	Farrokh Chothia
Client:	ODEL
Model:	Newton
Location:	Private estate, Sri Lanka
Time of day:	5pm

Technical details

Camera:	Nikon F4
Lens:	55mm Micro Nikkor f/2.8
Film:	Kodak Ektachrome 100
Exposure:	1/60sec at f/5.6–f/8

The brief

This image was part of a commission from a Sri Lankan clothing and lifestyle store called ODEL. Each year Farrokh and a team shoot for a week in Sri Lanka for the company's advertising campaigns during the following year. They have to create a bank of images that can be used across all media.

The location

It was taken at the estate of the late Bevis Bawa, one of Sri Lanka's leading architects. 'Outside the house is this Romanesque figure mounted on a pedestal and since our model, Newton, has a body structure close to that of the bust, I decided to photograph his bare torso with the figure,' explains Farrokh.

Composition

'It's a fairly classic composition,' he says. 'I asked Newton to tilt his head so that it looked as though they were both looking in the same direction. With jobs like this, it's important to create a balance between detail and mood. The advertiser needs to show his product, but not at the cost of letting the images become static and boring.'

Lighting and technique

As it was getting late in the day and overcast, Farrokh found he wasn't getting enough light near the bust. He wanted the image to have saturated colours and a lot of detail, which might have got lost if he had used available light with a slow shutter speed. 'I turned to my Norman 400B battery-powered strobe for help, positioning it just above the model's eyeline and to the right of the camera, which was at waist level,' he explains. 'To diffuse the flash, I aimed it down through a scrim frame, and I placed a white reflector on the ground to slightly soften the shadows. A 1/8th orange gel positioned over the strobe enhanced the skin tone. The light was then read off the model using an incident light meter.'

Baldur was helping a friend out on a magazine shoot when he 'stole' Raoul for a couple of frames. The lighting is perfect for showing off his physique and it almost looks as though it was shot in the studio but made to look outdoors. In fact it was taken on location on an overcast day, with diffused sunlight directly behind Baldur. He bent down, shooting from a low angle, which hid his shadow but caught those cast on Raoul which give such good modelling. Baldur used a Bronica camera, bought in 1965, and held a red filter over the lens to deepen the blacks and emphasise the clouds. ❧

Fact file

Photographer:	Baldur Bragason
Client:	Personal work
Model:	Raoul
Location:	Krysuvik, Iceland
Time of day:	5pm, July

Technical details

Camera:	Bronica SA2
Lens:	75mm
Film:	Kodak Tri X
Exposure:	Not recorded

The location

Jeff frequently shoots on the rooftop of his studio, which covers an area of 10,000 square feet. 'It's covered with a silver waterproofing compound which acts as the perfect fill, and I can use the sky as a backdrop,' he explains. 'Another benefit is that the sun doesn't have the same fall-off with distance as studio lights, so anywhere on the roof, the light intensity is the same.' The rooftop might not be used quite so often in inclement Northern Europe, but in Nevada, USA, where Jeff is based, clear and bright natural daylight is not in short supply.

Composition

One of a sequence of shots taken for the model's portfolio, it was her face and, in particular, her eyes that Jeff concentrated on here. The portrait has a Hollywood feel to it, and a sense of mystery and depth, related both through the pose and the lighting.

Lighting and technique

The background of the rooftop is a white-painted concrete wall and the full, direct sunlight was shining on this and reflecting back, filling in the shadow on the model's cheek and acting as a soft rim-light on her hair and the back of her neck. 'I asked my assistant to hold up a plastic milk crate a few feet to the left of the camera, turning the crate slowly so that its lattice construction cast changing patterns of shadow on the face,' says Jeff. 'To get the exposure, I held an incident meter to the shadowed area of her cheek.' In the darkroom, Jeff printed the image very dark and then bleached the print in ferricyanide to bring back the highlights and give it a warmer tone.

Fact file

Photographer:	Jeff Navarro
Client:	Model's portfolio
Model:	Megan, McCarty Talent
Location:	Studio rooftop
Time of day:	Mid-afternoon, February

Technical details

Camera:	Canon A1
Lens:	50mm
Film:	Kodak T-Max 400
Exposure:	1/125sec at f/5.6

White walls reflecting sun

35mm camera

Sun shining through a milk crate

' I had the idea for using the milk crate a while back and this seemed an ideal chance to use it. I wanted something that would give a variety of shadow patterns which would still be similar over several images.'

Jeff Navarro

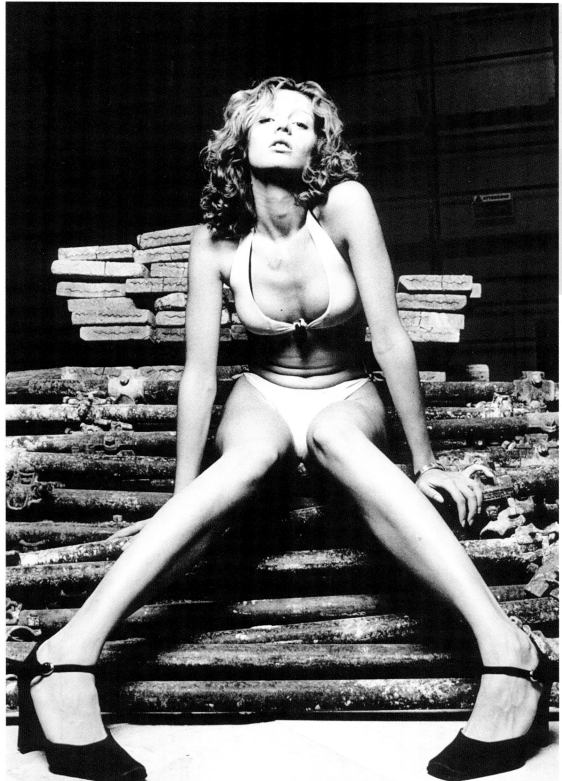

Fact file

Photographer: Marco Girolami
Client: Antarctica Advertising, promotional brochure
Model: Ekaterina, Antarctica, Rome
Location: Factory in Rome, Italy
Time of day: 6pm, July

Technical details

Camera: Nikon F3 HP
Lens: 35mm f/1.4
Film: Agfapan APX 400
Exposure: 1/30sec at f/5.6

At a factory location, Marco took a meter reading of the daylight falling on the model and then set the exposure of an Elinchrom 500 flash unit at two stops over this to make the flash the dominant light source. The flash was diffused through an umbrella and two reflectors were used, one on the right of the camera and another underneath the flash tripod. ▲

T'ELVA

Model: CLARA MASS Location: Mas De Torrent (Goon)

Film: KODAK VC 160

Poll: Iwp

Elabor. Mum March

Chapter 5: **Shooting a fashion story**

It's what every professional fashion photographer wants, a commission from a quality women's magazine to shoot a ten-page editorial for a forthcoming issue. The details, however, can seem a little daunting. You have just one day to take at least 11 pictures using a single model in different locations. That means 11 different changes of clothing, hair and make-up eating into your time. You are given a theme to work to and it's up to you to tempt the readership into buying the clothes featured – that's the purpose of the pictures.

This chapter shows how Kai Haase approached such a task for the top Spanish fashion magazine, Telva. The pictures were all to feature items made from tweed for an autumn edition, and so a warm and comfortable feeling was called for. The only trouble was, the shoot had to take place in far-from-autumnal June because of the magazine's lead-in time.

The medieval Spanish town of Torrent was chosen as the location. The magazine had a connection with a nearby hotel and spa and with its beautiful grounds, adjacent farmland and picturesque town buildings there was plenty of scope for a good variety of images.

Kai arrived a day early with his team – an assistant, the magazine's fashion editor and a hair and make-up stylist, meeting up with the model and a driver on arrival. He spent the time scouting for locations and taking Polaroids and from these he planned each shot, according to where the light would be at different times of the day. Some turned out pretty much as he imagined, others required a little lateral thinking...

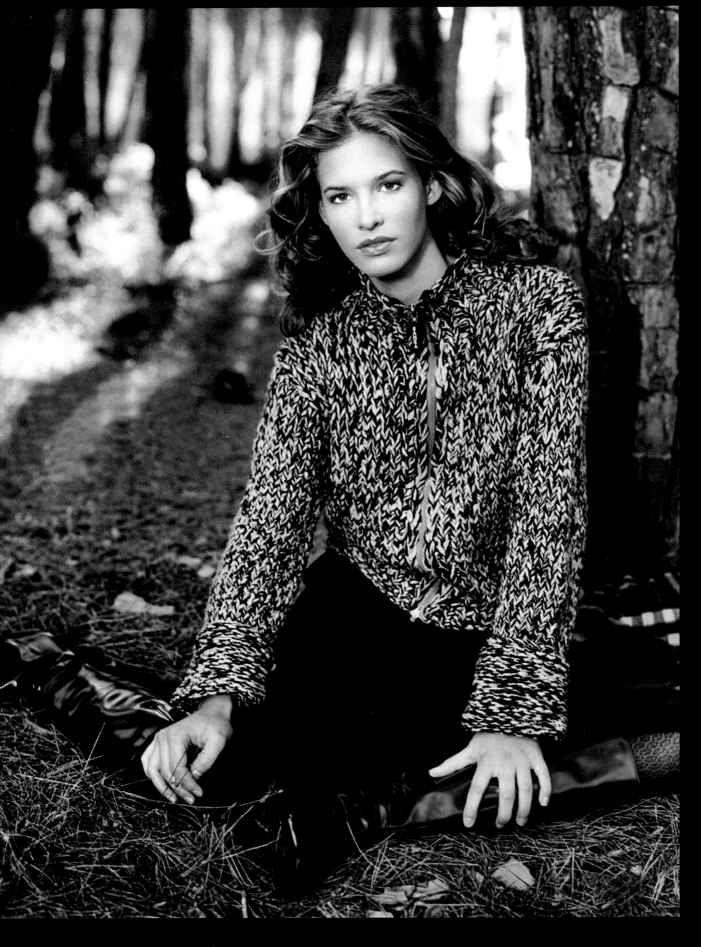

The location

'We were driving through woods on our way to the place where we'd planned the first shot when the fashion editor saw the light coming over the hills, through the trees,' recalls Kai. 'We looked at each other and pulled the van over straight away, then lugged all the gear to this spot, where the light was magical.'

Composition

The model had to do a very quick change into this outfit, chosen because the speckled wool of the jacket was very well complemented by the rough, uneven textures of the ground. The tree in the foreground served as a perfect prop for her to lean against and also adds tone and texture, while the other trees in the background are kept out of focus so as not to distract the eye from the model.

Lighting and technique

Kai placed the model so the light was coming through the trees directly behind her. He took a meter reading from just behind her head, where the light was falling on her hair and used a portable flash unit, fitted with a softbox, to provide fill-in flash. This was balanced with the existing light in such a way that the effect is barely noticeable, but it has just lifted the shadow areas on the model.

Sun

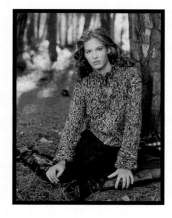

Flash with softbox

Medium format camera

Fact file

Photographer: Kai Haase
Client: Telva magazine
Model: Clara Mass, Francina
Location: Torrent, Spain
Time of day: Early morning, June

Technical details

Camera: Pentax 6x7
Lens: 105mm
Film: Kodak Portra 160 VC
Exposure: 1/125sec at f/8

Taken at the same location, the model's upright pose echoes the vertical tree trunks. She is beautifully rim-lit on one side by the early morning sun and fill-in flash ensured even lighting on the other side. ❖

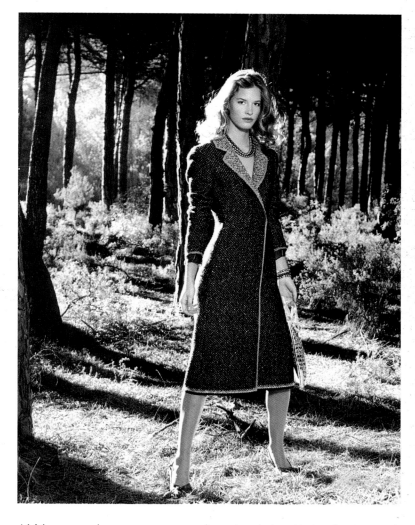

' We made a very early start to the day and the model's make-up was finished well before dawn. These first pictures of the shoot were taken about half an hour after sunrise.'

Kai Haase

'If I had to choose my favourite type of lighting for fashion, it would probably be backlight, with fill-in from the front. It makes the skin tones look warm and the model seems to glow, giving a great feeling.'

Kai Haase

Sun

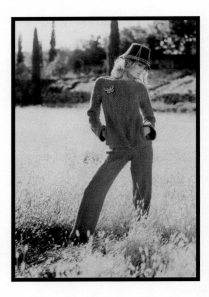

The location

During the recce on the day before the shoot, Kai noticed the way the sun illuminated this field, almost bleaching out the grass, and he planned to return there at the same time of day to do a backlit shot. The natural, open feeling of the setting gives the viewer a sense of how these clothes might be worn, out in the countryside on a perfect autumn day.

Composition

'We tried various poses here – lying on the grass, kicking up her heels – but in the end this looked so much nicer, with the cypress trees included in the background,' says Kai. 'The model was young and not that experienced, but she caught on very quickly to what I wanted and was very easy to work with.'

Flash with softbox

Medium format camera

Lighting and technique

With the sun coming from behind the model's left shoulder creating a rim of light around her, Kai just needed to add a touch more light on her front, to balance out the exposure. He used a portable flash unit with a softbox, to give a large diffuse source of light, but a reflector would be an alternative solution. It's not always easy to judge the exposure with fill-in flash, so several Polaroids were taken and adjustments made until Kai had hit the perfect balance.

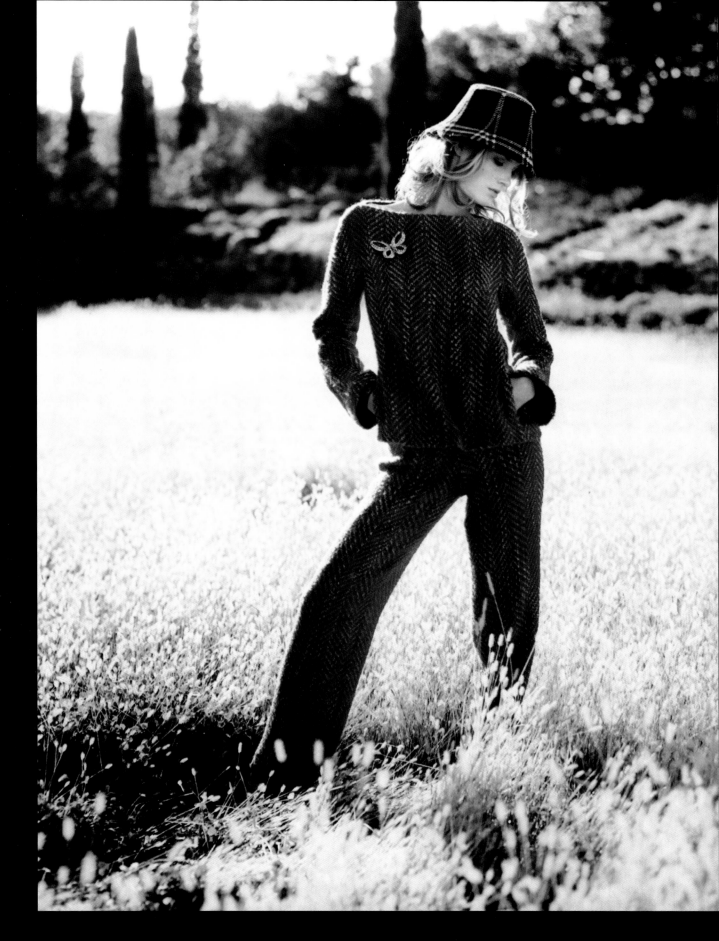

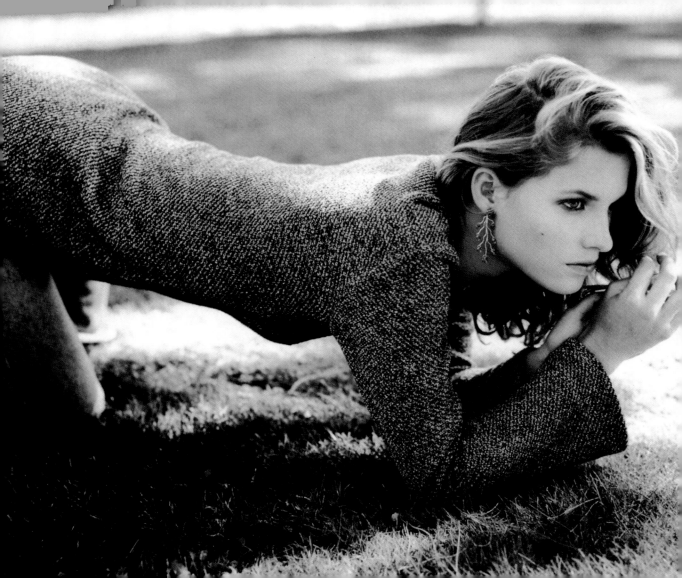

The location

When you're shooting fashion editorial, it's sometimes useful to have one image that breaks up the others, changing the pace and the mood of the story by standing out in some way. In his other tweed pictures, Kai went for quite a strong sense of location, whereas here, it's the model and the clothes that speak out and the setting is kept deliberately bland. It was taken in the grounds of the hotel Kai and the team were staying in, which happened to offer particularly attractive light at this time of day.

Composition

Again, Kai was looking for a change in pose from his other shots in the series, which were either standing, head-and-shoulders or seated. 'At first I felt that this angle didn't make sense, but I decided it worked in a peaceful sort of way,' he says. The faint wall in the background is an important element in the composition, defining the boundary between land and sky and contrasting with the curve of the model's back and head.

Lighting and technique

The sunlight, coming from the right of the picture, was dappled by trees in its path, forming patchy areas of light and shade that appealed to Kai. He used a white reflector to bounce light back on to the model's face to ensure this was evenly lit. Although this was taken with the same colour film used for the rest of the shoot, Kai intended it as a black-and-white image. Conversion is simple using Photoshop computer software, and it gives the client the flexibility to use it in either black and white or colour.

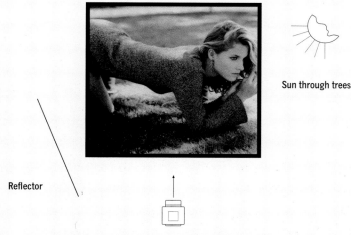

Reflector

Sun through trees

Medium format camera

'I saw the light coming through the trees by the hotel pool and I just put the model there. She's one of the most beautiful girls I've seen.'
Kai Haase

Kai wanted a warm and cosy feel to this shot and, at full-length, it would have revealed too much of the rather summery-looking background for the autumn issue of the magazine. At noon, the sun was high in the sky but trees around and above the model provided open shade for a more diffuse light. Fill-in on her face was provided by a reflector. ▲

The location

Torrent is a medieval town, about an hour north of Barcelona. Its narrow streets are full of character and Kai wanted to make the most of this in a couple of the shots. This spot was ideal as it provided the model with a ready-made seat.

Composition

This image was originally planned to go over a double page spread of the magazine as the lead picture of the story. Kai allowed for this by using the camera in landscape format, but the image was cropped down the left side when it was eventually printed on a single page. Pagination changes frequently happen so art editors like some space to be included in the image, which they can crop out if necessary.

Lighting and technique

This was taken with only natural light, which was disappearing fast in late afternoon. Kai and his team had to work quickly, with the added pressure of knowing that this was to be the lead picture. He found that seating the model and crouching down to give a low camera angle provided the best viewpoint, with the diagonal of the seat leading the eye to the buildings beyond.

Medium format camera on tripod

Setting sun

' This was one of those rare instances where I used a tripod. The Pentax 6x7 is hard to hand-hold without camera shake below 1/30sec, which I needed here because the light was low. I find a tripod restricting and only resort to it when I have to.'

Kai Haase

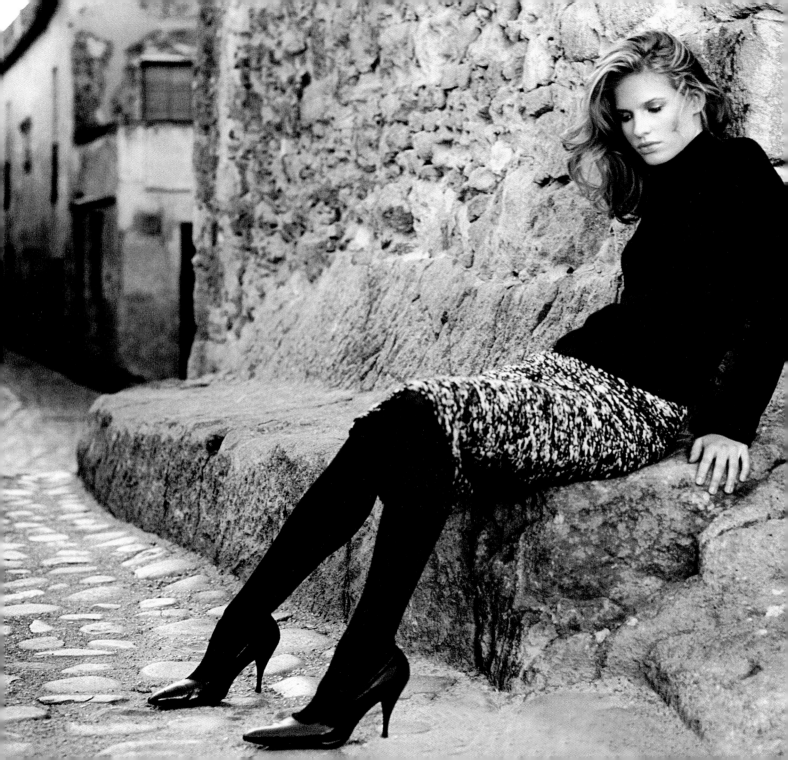

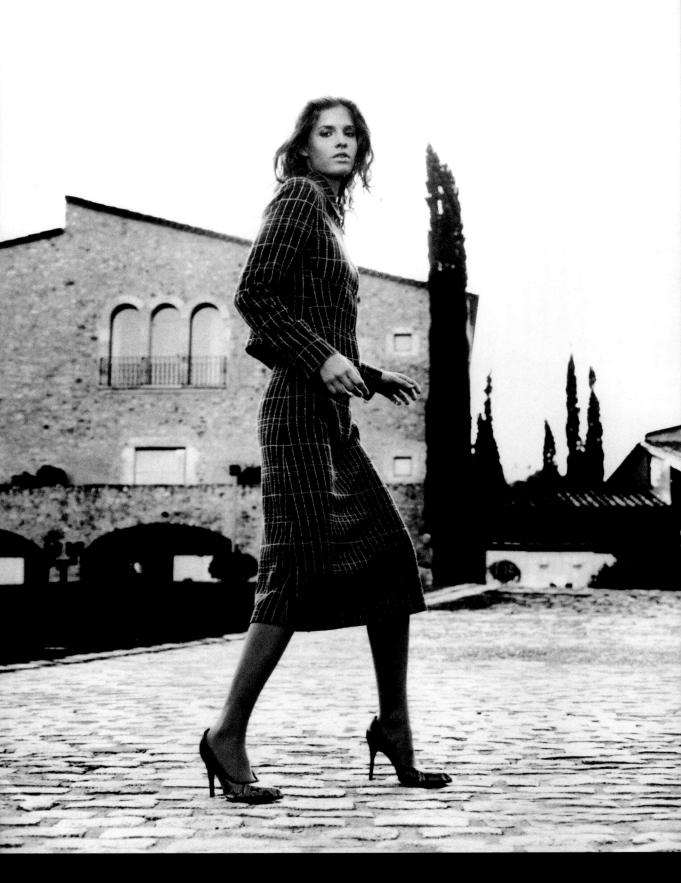

The location

Back at base camp after a long day's shoot, Kai still had one more picture to get in the bag. The driveway of the hotel was a convenient, and attractive, location and worked well for this outfit which has a more 'girl about town' feel than some of the country casual fashion featured in other shots.

Composition

Kai wanted to get across the sense that the girl had just been stopped in her tracks here, but it was essential she stopped at just the right point! She takes central stage in the picture, but a crucial element in its success is the distinctive upright shape of the cypress tree, just on her right, which emphasises the tall elegance of the model. A low camera angle allows the model to look down at the viewer and gives clear space behind her head. This area of sky, behind the angled rooftop and trees, makes an interesting shape in the picture and prevents the background from looking too fussy.

Sun behind tree

Lighting and technique

As evening approached, the sun was heading towards the back of the hotel building – at this moment it was just behind the tall tree, creating a hotspot on the model's chest. Kai had planned to do this shot earlier, when the sun was higher in the sky and streaming down the driveway. The course of the day didn't allow for this so he had to make the best of the light as it was. He lit the model with fill-in flash, diffused by a medium-sized softbox, measuring half a metre by one metre. This spreads the light source over a larger area, so the model is evenly lit from top to bottom, with no hard shadows.

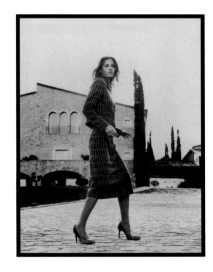

'I was worried about this at first because the light was not the way I'd had it in my mind. I think it worked out well in the end – just different.'

Kai Haase

Flash in softbox measuring
1m x 1/2m

Medium format camera

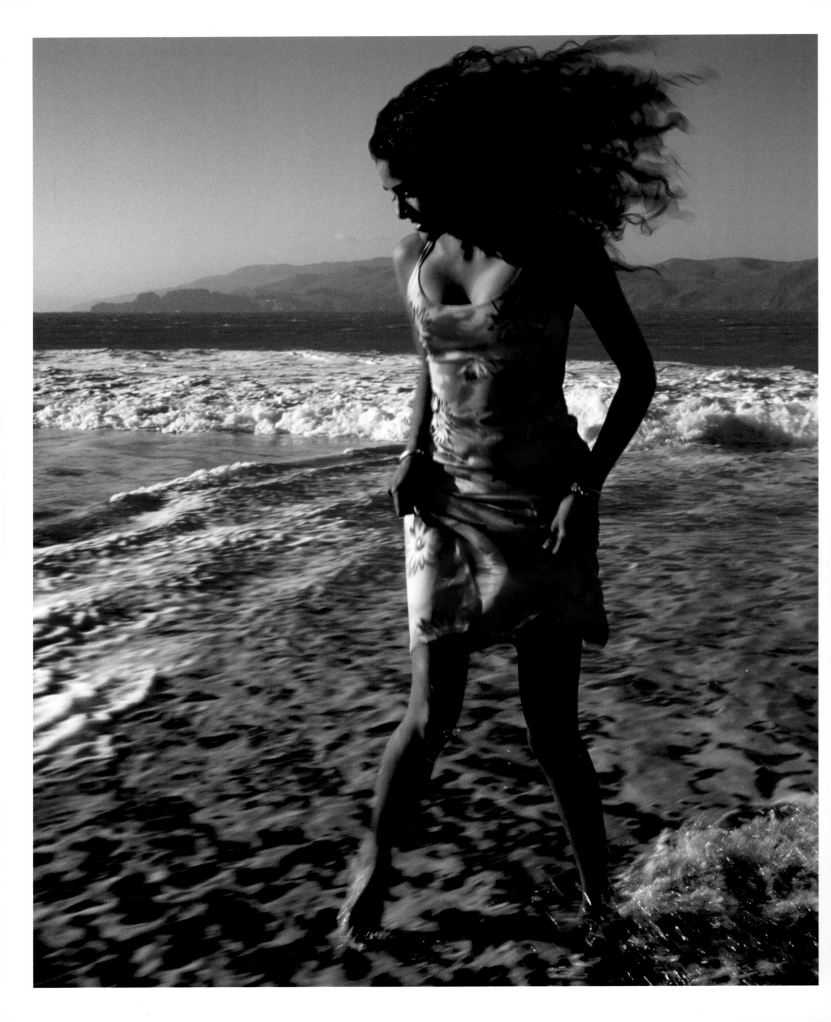

Chapter 6: **Movement & light**

One of the many good reasons for shooting fashion on location instead of in the studio is to demonstrate that the clothes featured are wearable in everyday, natural situations rather than simply in the rarefied atmosphere of the catwalk. Since people are rarely static for long, capturing a sense of movement is a great way of injecting real life and spontaneity into an image.

Subject movement can be frozen using flash or a fast shutter speed, blurred with a slow shutter speed or slow-sync flash or there can be a combination of sharp and blurred areas within the same image. Sometimes the subject is actually quite still, but a slight softness, through selective focus and narrow depth of field, gives the impression of motion. Depending on the approach you take, you can achieve a graphic, reportage-style image, a healthy athletic look or a moody, dream-like quality.

It isn't easy to place a moving subject exactly where you want them in the frame. Trial and error and plenty of film are called for – as well as a good deal of patience from you and the model.

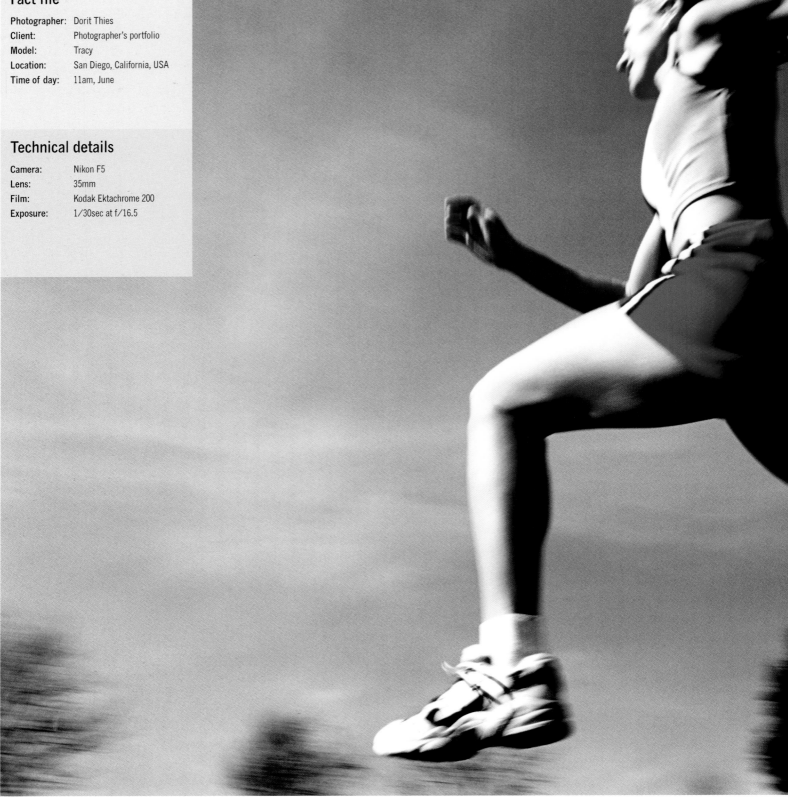

Fact file

Photographer: Dorit Thies
Client: Photographer's portfolio
Model: Tracy
Location: San Diego, California, USA
Time of day: 11am, June

Technical details

Camera: Nikon F5
Lens: 35mm
Film: Kodak Ektachrome 200
Exposure: 1/30sec at f/16.5

'She started the run quite a distance from me to build up enough speed to make a giant leap. She did it about 25 times!'

Dorit Thies

The brief

Dorit met the model in this picture, Tracy, during a commercial shoot for Nike. She's a professional athlete and Dorit liked the idea of working with her to create a graphic action shot for her portfolio and website.

The location

A public park in San Diego was chosen because it had plenty of space and a few trees that Dorit wanted to include in the composition. Another consideration, not to be overlooked, was that it was free and no permission was required to use it.

Composition

Dorit had this image in her mind before the shoot. She wanted it to be horizontal to use as a double-page spread in her book. Shooting from a low angle was also important to make Tracy look monumental and powerful, so Dorit was actually lying on the ground. This also gave her a clear background of blue sky, with just a few trees included to show the blur of movement.

Lighting and technique

There was strong direct sunlight and Dorit asked Tracy to run towards it so her face would be quite bleached out and her strong, muscular legs emphasised by the tonal contrast. To capture the speed of the runner, Dorit used a slow shutter speed and panned the camera as Tracy ran past, pressing the shutter in the middle of the pan movement. The effect of this is to keep the subject relatively sharp while recording the background as a blur.

Sun

35mm camera

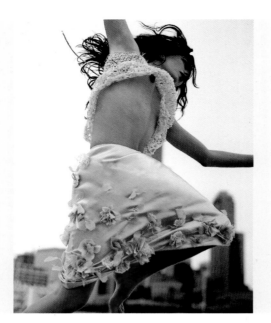

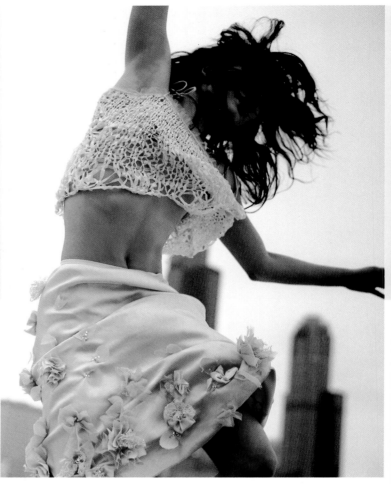

The brief

This was part of a summer editorial for Harper's Bazaar, Latin American edition. The model was wearing light summer fashions and had to look like she was 'warm, happy and having fun'.

The location

The magazine specified that they wanted the story to be shot in Chicago with the cityscape in the background. The only trouble was, Harper's Bazaar, like many other major fashion magazines, shoots the photography anywhere from five to six months in advance of publication. The story was for the August issue but had to be shot in early January when there was snow on the ground.

Composition

The composition was a clever solution to the rather challenging brief, given the time of year. 'To get the model in the air with her hair flying, and have the cityscape behind her, yet above the snow line, we had the model jumping up and down on a small trampoline as if she were leaping,' reveals David.

Lighting and technique

Cloudy, wintry light can have its advantages because it provides diffused, even illumination, like a giant softbox. To give it a bit of a boost, two white reflectors were placed on each side of the model at 45 degree angles, with another silver reflector directed towards the centre of the model to bring out detail in the clothes.
A warm-up filter on the lens reduced the blue tone from the light at that time of year. David didn't record the shutter speed used, but it would have been reasonably fast – like his focusing skills – to freeze the model in mid-flight.

Sun through clouds

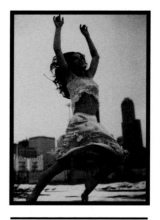

Silver reflector

White reflectors either side of model

35mm camera

Fact file

Photographer:	David Anthony
Client:	Harper's Bazaar (Latin American edition)
Model:	Carly Moore, Elite
Location:	Chicago, USA
Time of day:	Mid-morning, January

Technical details

Camera:	Mamiya 645 Pro TL
Lens:	80mm
Film:	Fuji NPS 400
Exposure:	Not recorded

'The model did well to look warm and happy, because she was absolutely freezing cold.'

David Anthony

The brief

Shot for his own portfolio, André's aim was to show a couple having some fun in the summer.

The location

'It was nothing special,' says André, but the shape and colour of the crop in the field contrasts well with the couple and the pale sky and makes an interesting alternative to grass.

Composition

André deliberately cut out the faces to concentrate on the shape of the bodies in action and make the composition look more dynamic. As with all action shots, there was an element of chance about pressing the shutter at exactly the right time.

Lighting and technique

The sun was coming from the right of the camera, but it was a cloudy day, with no direct sunlight, producing a soft, diffused light with no harsh shadows. André used his compact flashlight on the camera hotshoe and set it at 1/4 power to lift the detail on Frank's belt and brighten up both their shirts. The flash has also helped freeze the movement of the couple. It was easier to do this because they are running towards the camera. If they had been running across the front of it, André would have needed a higher shutter speed to keep them sharp. Alternatively, he could have panned the camera, freezing the subject but blurring the background.

Fact file

Photographer:	André Schuster
Client:	Photographer's portfolio
Model:	Steffi and Frank, ModelPool, Dusseldorf
Location:	Castrop-Rauxel, Germany
Time of day:	4pm, May

Technical details

Camera:	Canon EOS 3
Lens:	50mm
Film:	Kodak Portra 160 VC
Exposure:	1/125sec at f/8

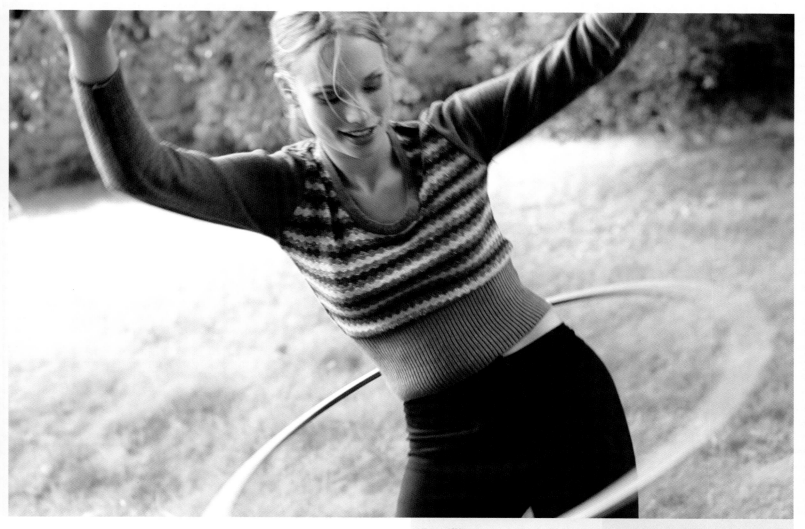

Fact file

Photographer:	André Schuster
Client:	Photographer's portfolio
Model:	Danni, Bond Models, Dusseldorf
Location:	Park, Castrop-Rauxel, Germany
Time of day:	5pm, spring

Technical details

Camera:	Canon EOS 3
Lens:	50mm
Film:	Kodak Portra 160 VC
Exposure:	1/125sec at f/8

Sun through clouds

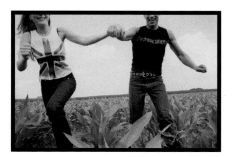

35mm camera with flash

You can see the pool of direct sunlight, coming from the left, in the background. The model was shaded from the harshness of it by a tree and a reflector was placed on the right side of the camera to bounce light back on to her face. A shutter speed of 1/125sec was sufficient to freeze the movement of the model, but the faster spinning hoola hoop is nicely blurred. ▲

used up two films trying to get this picture as the models were running towards me.'
André Schuster

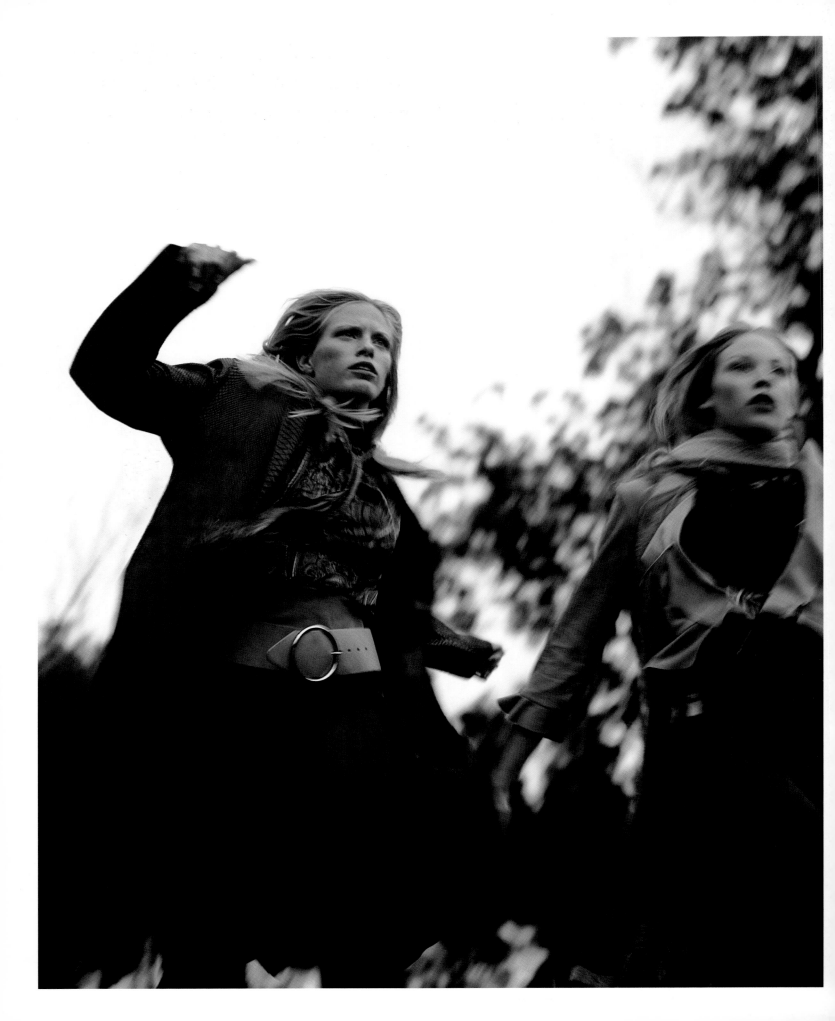

The brief

This was part of an autumn fashion story called 'First Look' which featured the early collections from top designers worldwide. The idea was to combine a sharp, in-focus image with a semi-blurred, moving one on the facing page of the magazine.

The location

A countryside setting was chosen, with trees that could be used in the background to give an autumnal feel. The location takes a back seat in this image, however. The models are centre stage and could be virtually anywhere outdoors.

Composition

David wanted to catch a feeling of energy and vibrancy and he did it in the literal sense, with the models leaping over him as he was lying on the ground, shooting upwards. The model on the right is moving out of the frame, which makes the shot look spontaneous and candid, rather than formally posed.

Lighting and technique

It was an overcast day with rain falling sporadically, but the existing light was adequate without the need for reflectors or flash. David took a meter reading from the waist of the models to ensure an accurate exposure for what he felt was important in the shot. He always focuses manually and has learned to do so very quickly. Here he pre-focused at the models' shoulder height so that he needed to make only minor adjustments at the crucial moment.

'I used a shutter speed of 1/60sec to blur what I wanted to be blurred, yet retain detail in the important aspects of the clothing.'
David Anthony

Sun through clouds

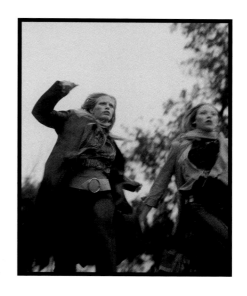

Medium format camera

Fact file

Photographer:	David Anthony
Client:	Chicago Woman Magazine
Models:	Claire and Julie, Elite Agency, Los Angeles
Location:	Mid Illinois, USA
Time of day:	Early afternoon, August

Technical details

Camera:	Pentax 6x7
Lens:	105mm
Film:	Forte Pan ISO 200
Exposure:	1/60sec at f/5.6

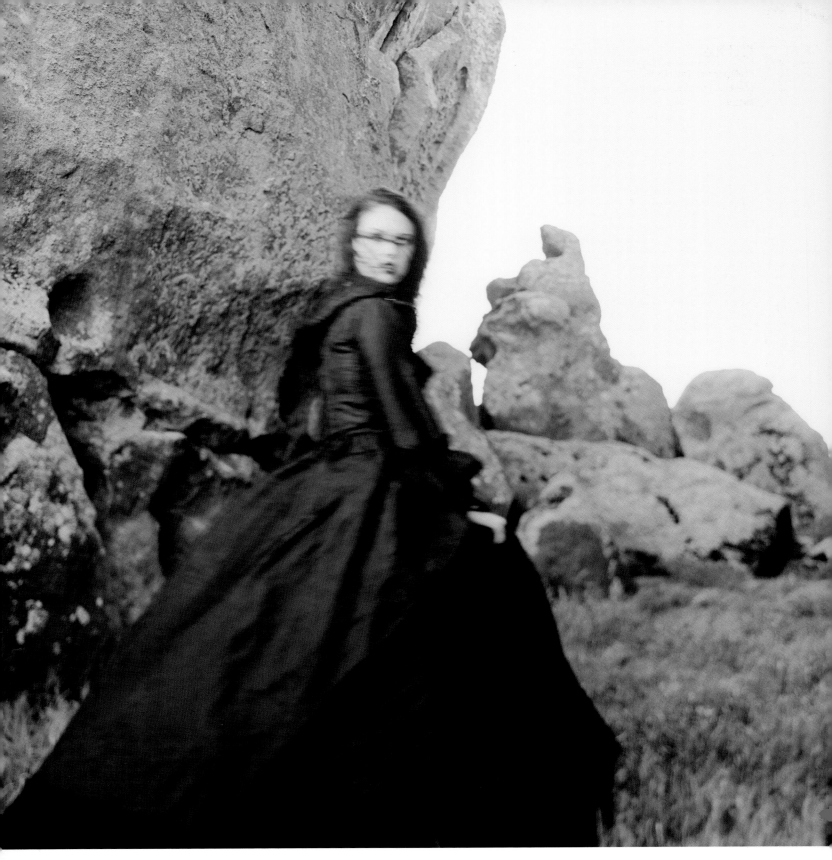

'I hand-hold the Fuji GX680, even though it's heavy and unwieldy. I like the idea of being as loose as possible with this cumbersome camera, so that every frame is different.'

David Maisel

Sun diffused by clouds

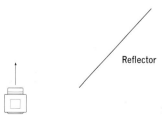

Medium format camera hand-held

Reflector

The brief

David took this for his own portfolio. 'It was part of a process of accessing a dream state, of bringing to life images that I have in my consciousness and need to make real,' he explains. 'I think the genesis of this shot came from the movie The Piano, which began with images of a lone woman, dressed in a hoop skirt, in an isolated forlorn landscape.'

The location

David isn't giving away too many details about this location, except that it is about 90 miles from San Francisco. He likes the other-worldly rock formations and has used it many times for commissioned projects, finding that it yields something completely different each time. This shot fulfilled a long-standing aim to use the place for personal work.

Composition

There's a sense of mystery to this shot. The way the model is turning her head back, and holding her skirt gives the impression that she is trying to escape from something. The slight blur of the figure contributes to this idea of movement and the strange rocky landscape lends a timeless but eerie quality.

Lighting and technique

Although the sunlight was quite bright, it was diffused by cloud cover so the light was fairly even across the image. A reflector was used to bounce a little light back into the dark fabric of the hoop skirt to fill in some of the detail. David uses a medium format camera and with a slow shutter speed, selective focus, shallow depth of field and vignetting caused by lens tilt, the subject is deliberately blurred to give her an ethereal quality.

Sun diffused by clouds

Medium format camera

'According to legend, Huldra appears in Norwegian woods, enchants men with her beauty and lures them into her pagan den. At first she appears to be a mortal woman, but her long skirt hides a cow's tail.'

Gry Garness

The brief

Gry came up with the idea for a fashion story, based on 'Huldra', a mythical Norwegian figure. She got together a stylist, make-up artist and models from three different agencies and did the shoot with her own time and money. The make-up artist, Rebecca Sommer then approached Black Book, a New York-based fashion magazine, which published the pictures.

The location

A rural part of East Sussex was chosen to stage the shoot because it had several different landscape features within a relatively small area. For this shot, it was the long grass that appealed to Gry.

Composition

The mood Gry has created is one of an unworldly presence – as though if you touched this woman she might disappear. Shooting from a low angle through the grass with a long lens, introduces this feeling of mystery, giving the viewpoint of someone hiding in the grass and watching the woman unobserved.

Lighting and technique

The way the model is leaning forward and the softness around her dress and hand, give the impression that she is moving, although she was actually quite still as Gry pressed the shutter. She used a 5x4 view camera which allows the film plane and lens to be tilted, raised and lowered. Here, Gry tilted the back standard slightly (about 5–10 degrees) which usually makes the subject appear slightly elongated and A-shaped, with a smaller head and bigger feet. It also means the distance between the lens plane and the film plane is no longer parallel and uniform, but shorter at the bottom and longer at the top. Combined with a shallow depth of field, this has contributed to the blur in the lower part of the image. The Polaroid film was also solarised (see page 32) which has produced the 'fluff' effect in the grass. It was taken on an overcast, gloomy day, with no directional light.

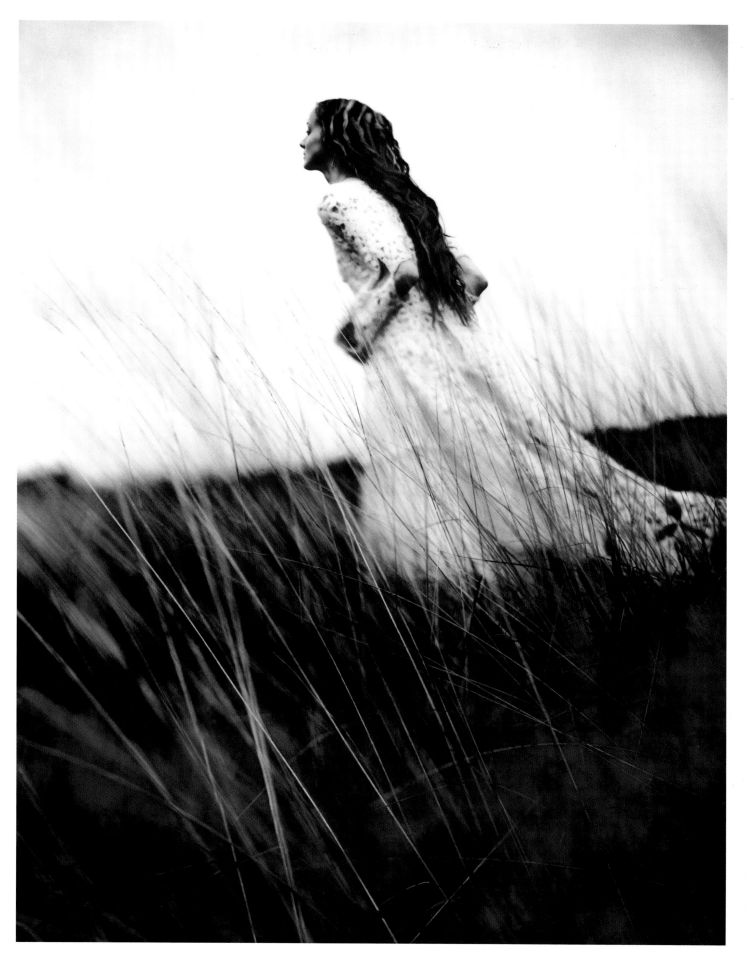

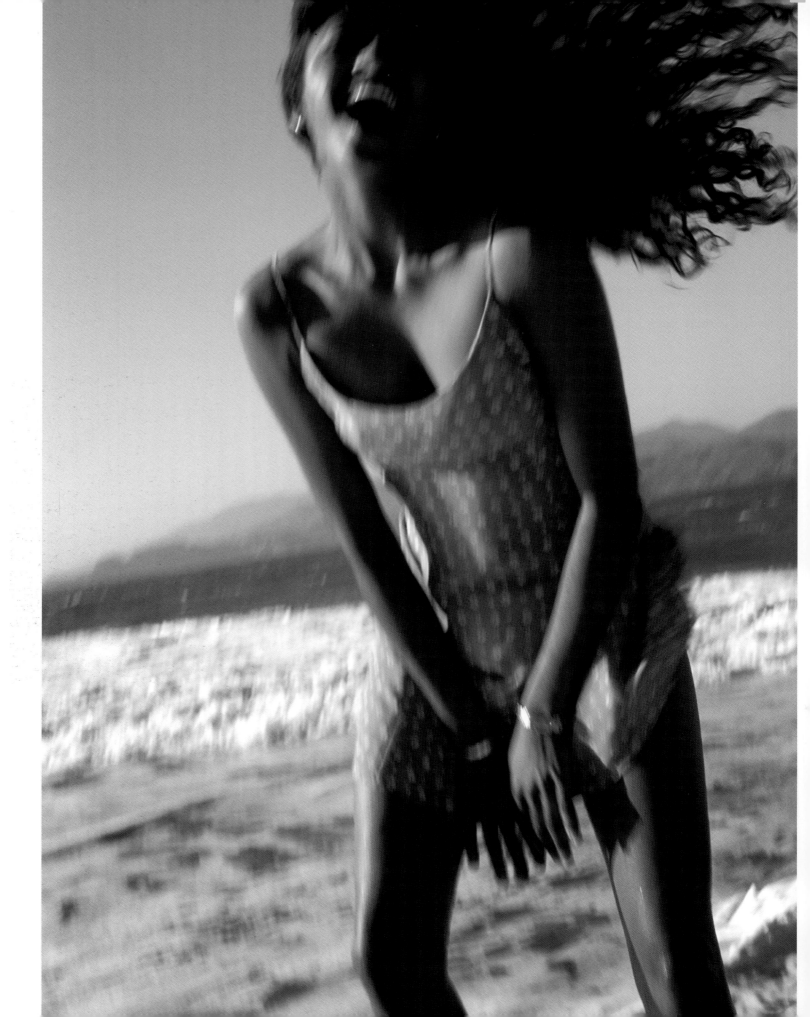

The location

A favourite location of Patrick's, China Beach has a great visual combination of sea, surf, sand, dark brown rocks and a view of the Golden Gate Bridge. 'It's also sheltered and fairly quiet, so models can feel more relaxed,' he says.

Composition

Hand-holding the camera, Patrick followed Sandra into the surf and took a series of pictures as she frolicked in the waves. The fairly slow shutter speed allowed some of the model's movement to be registered which adds to the feeling of spontaneity, life and fun. 'The ocean is very cold and she's just been hit by a wave as I grabbed this shot,' he says. 'I liked the way the wind caught her hair and the expression on her face.'

Lighting and technique

This beach is lit by the setting sun all the way down to the horizon, so it receives the full effect of the orange-red rays with no need for any filtration. Patrick used slow ISO 50 transparency film which he rated at ISO 40 to further saturate the colours. He set the camera on aperture priority at f/5.6 to give him enough depth of field to keep the model and her surroundings in focus.

Fact file

Photographer:	Patrick Roddie
Client:	Photographer's portfolio
Model:	Sandra DeSilva
Location:	China Beach, San Francisco, USA
Time of day:	Before sunset, August

Technical details

Camera:	Nikon F100
Lens:	50mm f/1.4
Film:	Fuji Velvia
Exposure:	1/60sec at f/5.6

Setting sun

35mm camera

'I tried to keep her in the frame while she moved about and I waited for something cool to happen, which, in this case, it did.'

Patrick Roddie

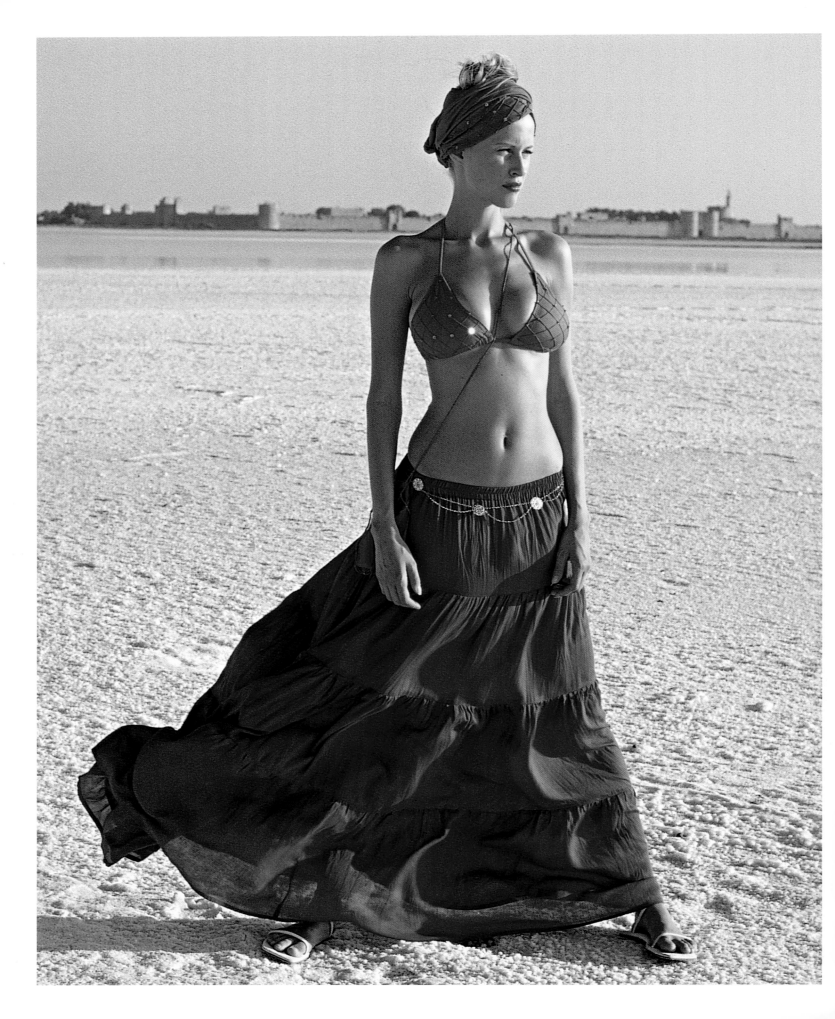

Chapter 7: **Sun, sand & skin**

If you ask fashion and glamour photographers to name their favourite location, many would mention a beach. The natural combination of big skies, sand and sea lends itself to endless possibilities, suitable for many different looks throughout the seasons.

This chapter focuses on the kind of images that exude the warmth of the summer sun. It looks at how to use the reflective qualities of the sand and sea, ways of shooting in the difficult midday light and the much-favoured qualities of the so-called 'golden hour' before sunset. It also explores methods of lighting the face and body in close-up – including using a shower curtain and an old bed sheet.

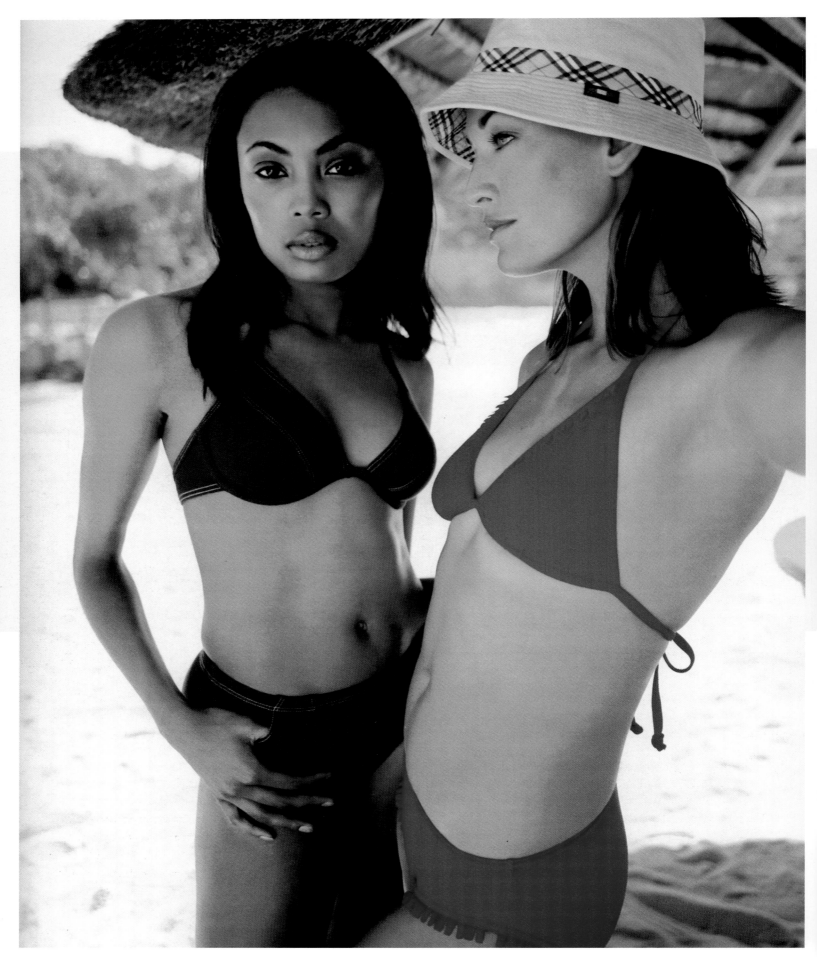

The brief

Because of the production schedules of magazines, swimsuit features frequently have to be photographed some months before, when the weather may be anything but summery. This often requires travelling to a distant location with the opposite seasons. In South Africa, the winter weather, though cool in the evening and mornings, can still be warm and sunny enough to make wearing swimwear look realistic, which is what Kai had to do here.

The location

Rather than transport the photography team to the Caribbean at great expense, a large holiday hotel complex in the game resort at Sun City was chosen. This poolside 'beach' is entirely artificial – the only one of its kind in South Africa.

Composition

Kai used his favourite 55mm wide-angle lens from a close distance, which gives a slightly unnatural perspective on the models and makes them both seem especially dominant in the frame. He's played on the contrast between the models well, with one seen in profile while the other makes eye contact with the viewer. Placing the two differently coloured bikinis so close together adds to the impact.

Lighting and technique

The midday sun was falling on the models straight from above, so Kai placed them in the open shade of a canopy and used a white reflector to bounce light on to them. This gives a more even and diffused light. Kai took an incident light reading from the light falling on the girls so they were correctly exposed. It meant that the much brighter background was overexposed and appears bleached-out, but that makes no difference to the quality of the image.

Fact file

Photographer:	Kai Haase
Client:	Femina magazine (South Africa)
Models:	Lushano and Imani, Outlaws and Ice, South Africa
Location:	Sun City, South Africa
Time of day:	Midday, winter

Technical details

Camera:	Pentax 6x7
Lens:	55mm
Film:	Kodak Portra 160 VC
Exposure:	Not recorded

'I don't usually like shooting in strong midday light normally, but in the open shade of the umbrella, it worked out.'
Kai Haase

Fact file

Photographer:	Kai Haase
Client:	Femina magazine (South Africa)
Model:	Anna Paula, Zero, Cape Town
Location:	Sun City, South Africa
Time of day:	Mid-afternoon, winter

Technical details

Camera:	Pentax 6x7
Lens:	55mm
Film:	Kodak Portra 160 VC
Exposure:	Not recorded

You have to take care over metering when shooting on the beach in strong sunlight because the brightness of the sand can fool a camera's meter into underexposing. There was a big contrast here between the bright background, the shadow areas and the dark bikini. Kai used a hand-held meter to take a reading from under the model's chin, which was roughly a mid-tone. He then checked the exposure by taking Polaroids. ⬳

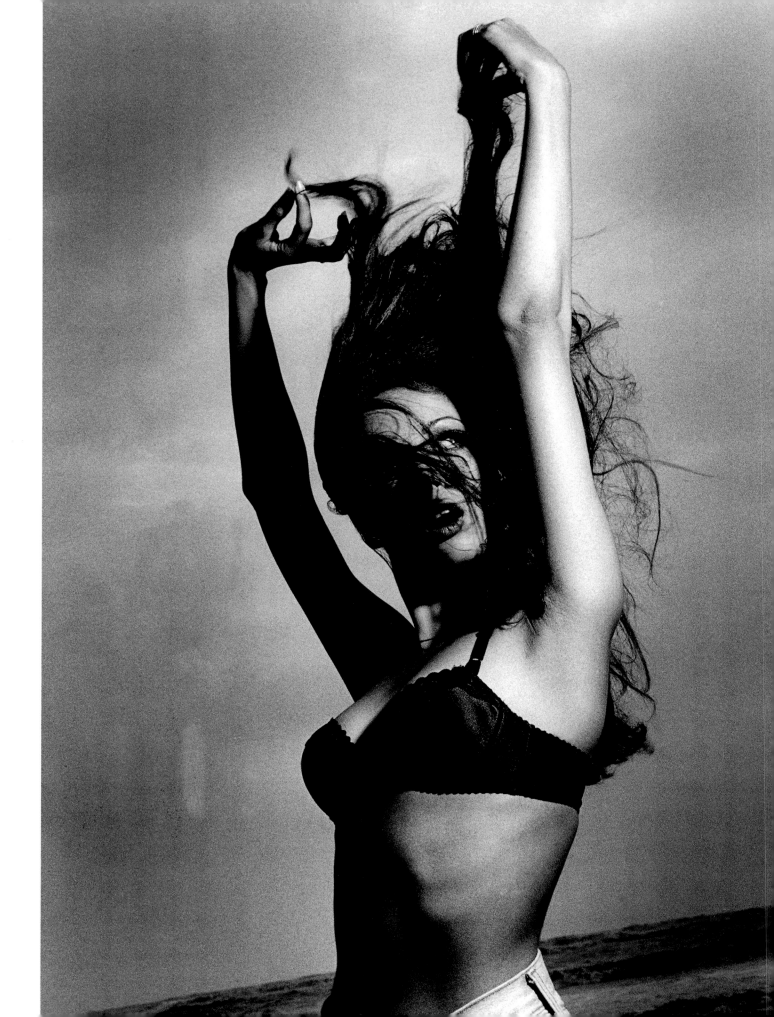

The brief

Farrokh Chothia was on a commercial shoot that finished in half the time he had estimated, 'thanks largely to our model for the day, Malaika,' he says. 'She was so good that I got all I needed for the client with a couple of hours to spare. The sky was turning nice and moody, like a monsoon painting, so I asked Malaika if we could try one or two shots for our books. She had on a white shirt, which would have burnt out with the light I was going to use, so she took it off and we went for a classic jeans-and-bra look.'

The location

The beach is a favourite location for Farrokh. 'It's deeply connected to the human psyche – a meeting place of earth, water, wind and light. As a photographer, these elements are a gift for me to use, as I want. Sometimes I manipulate one of them as in this case – or use an excess of one of these over the others, shooting at midday with a blazing sun overhead, for example.'

Composition

By shooting from a low angle, Farrokh has given his subject a sense of power and dominance. He's included as much as he could of the dramatic sky, with just enough of the sea to give a feel of the location. The model's pose combines energy with elegance and the overall impact of the shot is very much helped by the strong contrast of light and shadow on her body.

Lighting and technique

A crucial element to the success of this picture is the creative mix of natural and artificial light. Farrokh first took a reading from the clouds using a spot meter, and calculated the exposure needed to register them as a darkish grey – clouds that are backlit by the sun tend to be bright. This exposure, 1/250sec at f/16, would have rendered the subject as a near silhouette, so he lit her with a Norman 200 battery-powered strobe, held by an assistant above and to the right of the camera. The power of the flash was adjusted to give an incident reading of f/16 off the model's face, resulting in a final, balanced exposure.

Fact file

Photographer:	Farrokh Chothia
Client:	Photographer's and model's portfolios
Model:	Malaika Arora
Location:	Manori beach, near Bombay, India
Time of day:	Sunset

Technical details

Camera:	Nikon F3
Lens:	55mm
Film:	Kodak Tri X rated at ISO 200
Exposure:	1/250sec at f/16

' Using artificial light, you can change the exposure of the subject in relation to the background, giving infinite variations to the look of a picture.'
Farrokh Chothia

Sun behind clouds

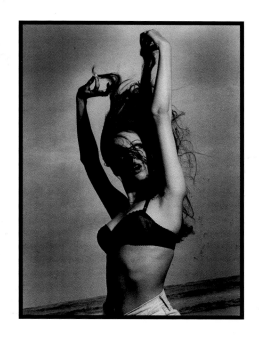

Hand-held 35mm camera

Portable flash unit

Fact file

Photographer: Farrokh Chothia
Client: Model's portfolio
Model: Lakshmi Menon
Location: Bentota beach, Sri Lanka
Time of day: 11.30am

Technical details

Camera: Nikon F3
Lens: 85mm f/1.4
Film: Kodak Tri X
Exposure: 1/250sec at f/2.8

The brief

This image was part of an MTV India programme called Model Mission. The idea being that every three months or so, MTV would launch a new face and part of the show would be the shooting of the girl's portfolio. 'I don't often do portfolios, but the essential thing to remember is that these are pictures you're creating for the model, and that it must lead to commercial work for her,' says Farrokh. 'It's a good idea to try and make your subject look different in each set-up – the more versatile you are as a model, the more work you will get. Of course, the most important thing is to bring out what is unique and singular about your subject.'

The location

Farrokh and the TV crew had travelled from India to Sri Lanka for this shoot. This image was photographed on Bentota Beach, on the south-western coast of the island.

Composition

'We had just finished the long fashion shoot when the make-up artist scooped up some sand and smeared it over Lakshmi's face and body,' comments Farrokh. 'I thought it would be great to do a head shot with just her face and the sand.'

Lighting and technique

By this time, the sun was pretty high up in the sky, but still at a slight angle. Farrokh positioned Lakshmi so that the sun was now acting as a backlight. He used a white Lastolite reflector just below her face and just out of the frame to accentuate the light that bounced off the sand and sea, and to add a catchlight in her eye. For a close-up like this, Farrokh usually tries to use an f stop that gives him the shallowest depth of field – he likes to blur the background so as to make the subject stand out sharply.

Sun

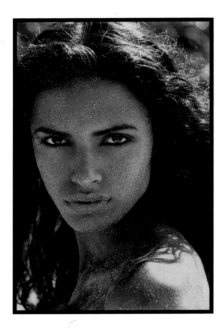

Reflector

Hand-held 35mm camera

' Lakshmi has a set of truly beautiful and piercing eyes and reflecting light up from underneath them made them look even more hypnotic.'

Farrokh Chothia

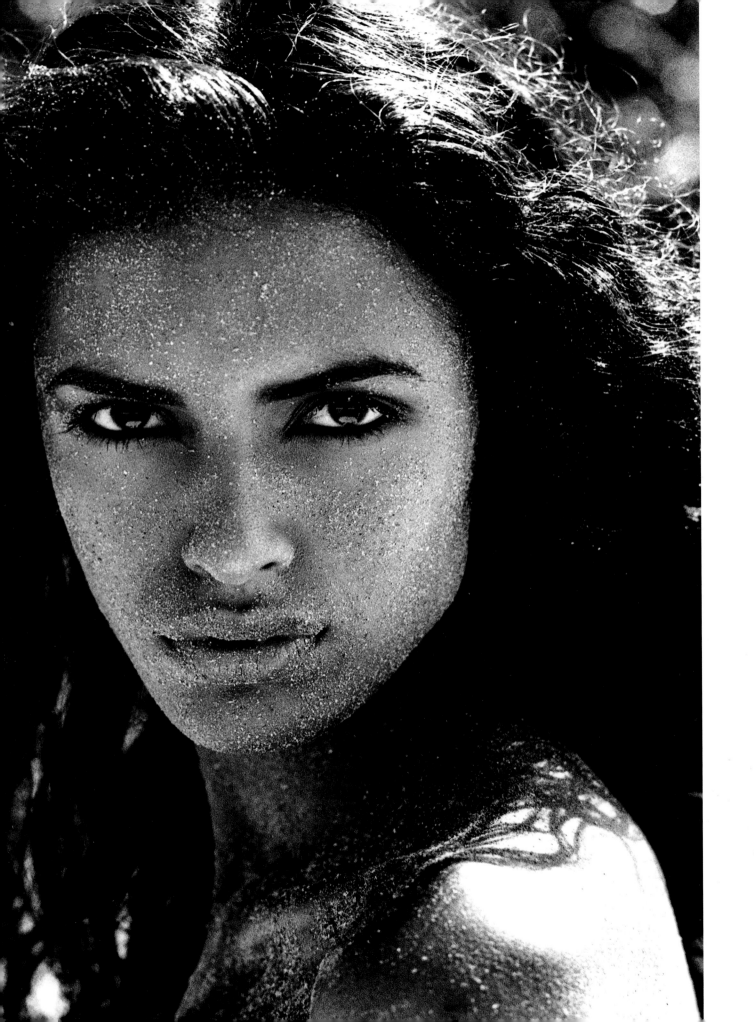

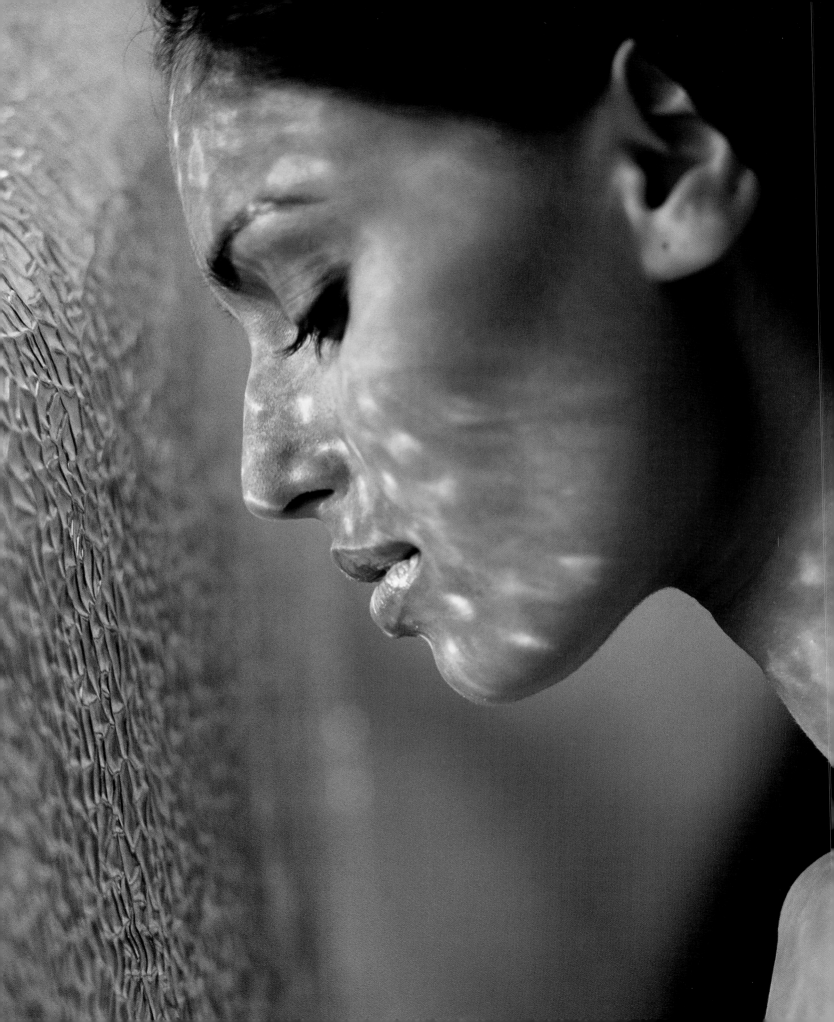

The brief

'This was part of a shoot commissioned by an advertising agency for its clients, Palmolive soap,' recalls Farrokh. 'It was launching a new range called Naturals and had commissioned me to shoot the campaign. The basic idea was to project the feeling of naturalness, light, sparkling water and a sense of bathing with nature. These two images, however, did not make it to the final ads.'

The location

Farrokh was adamant that they shoot on the island of La Digue, in the Seychelles because he felt it fitted the brief completely. 'It's one of the few places on earth that has been relatively untouched by mass tourism and also has some of the most beautiful and unique landscape in the world.' Although you can't see it in these close-ups, the location, especially the beach of Source d'Argent, played a crucial part in the other images in the campaign.

Composition

Essentially, the campaign was a wide-angle one, with the compositions placing the model in a corner, with a lot of space round her to show the location. As fillers, Farrokh shot several close ups of her face, hands, feet and so-on. These images could be used as 'drop-ins' if the art director later needed them.

Lighting and technique

'At the request of the art director, we carried a plastic shower curtain with us – this was of a speckled kind, much like a crystal glass,' says Farrokh. 'His idea was to use sunlight filtering through this so as to project a water-like pattern on the model's face. The sun was just over the horizon, the light was golden and I had the make-up artist and the stylist hold up the curtain at right angles to the sun's rays. The light filtered beautifully through this and I had Ujjwala's face right up close to the plastic, so as to keep the pattern sharp. I had a white Lastolite reflector on the fill side, about three feet away from her face, to bring up the shadows a bit.'

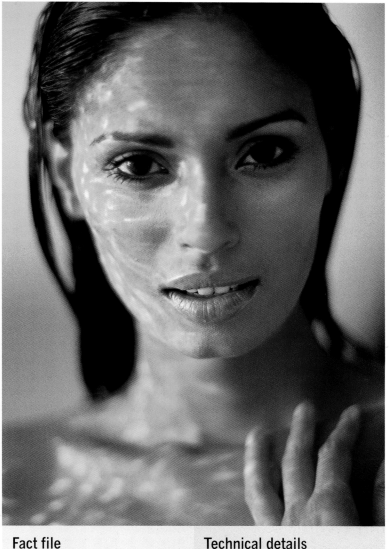

Fact file		Technical details	
Photographer:	Farrokh Chothia	Camera:	Nikon F3
Client:	Palmolive soap	Lens:	85mm f/1.4
Model:	Ujjwala Raut, IMG Models, Paris	Film:	Kodak Ektachrome 100
Location:	La Digue, Seychelles	Exposure:	Between 1/60 and
Time of day:	Just before sunset		1/125sec at f/2

Fact file		Technical details	
Photographer:	Farrokh Chothia	Camera:	Nikon F3
Client:	Palmolive soap	Lens:	85mm f/1.4
Model:	Ujjwala Raut, IMG Models, Paris	Film:	Kodak Ektachrome 100
Location:	La Digue, Seychelles	Exposure:	Between 1/60 and
Time of day:	Just before sunset		1/125sec at f/2

' The exposure for a picture like this is always a bit tricky – if you expose for the highlights, the rest of the face gets underexposed. I decided to read the darker part of the light coming through the plastic and expose for that value, and then bracket a bit for safety.'

Farrokh Chothia

Fact file

Photographer: Patrick Roddie
Client: Personal work
Location: Black Rock City, Nevada, USA
Time of day: Evening, August

Technical details

Camera: Nikon F100
Lens: 50mm f/1.4
Film: Fuji Velvia
Exposure: 1/60sec at f/1.4

'The Burning Man festival is a photographer's dream. The late afternoon light is crisp and unparalleled, especially when combined with cobalt-blue skies and the exotic attire of the people attending.'

Patrick Roddie

The brief

This is part of an unusual ongoing personal project of Patrick's – a series of identically composed shots of hips. So far he has over 1000, featuring a huge variety of costumes and body types.

The location

The Burning Man festival (www.burningman.com) is a week-long festival held at the end of August each year when 20–30,000 people participate in radical acts of self-expression. It's held in the Nevada desert on a totally featureless prehistoric lake bed at an altitude of 3,000 feet.

Composition

Patrick directs all his volunteer models in his hips series the same way. 'I got her to stand with her feet 18 inches apart, lock her knees, straighten her back, lift her right hand and then let it drop,' he explains. 'I chose this composition because of the ease of duplicating it. I anchor the frame with the right hand in the bottom left corner and the navel in the top right.'

Lighting and technique

For nearly all the hip shots, Patrick keeps the sun above and behind his left shoulder but in this case the sun had set about five minutes previously. Because there was so little light, Patrick had to have the lens wide open at f/1.4 giving minimal depth of field and a slightly soft focus. There is also a blue cast to the image because the sun had disappeared behind the mountains. As always with Patrick's outdoor pictures, no filters, reflectors or flash were used.

'I don't ever plan my compositions. I just press the shutter when it looks "right". I have the advantage of having no photographic training, so I'm less bound by convention.'

Patrick Roddie

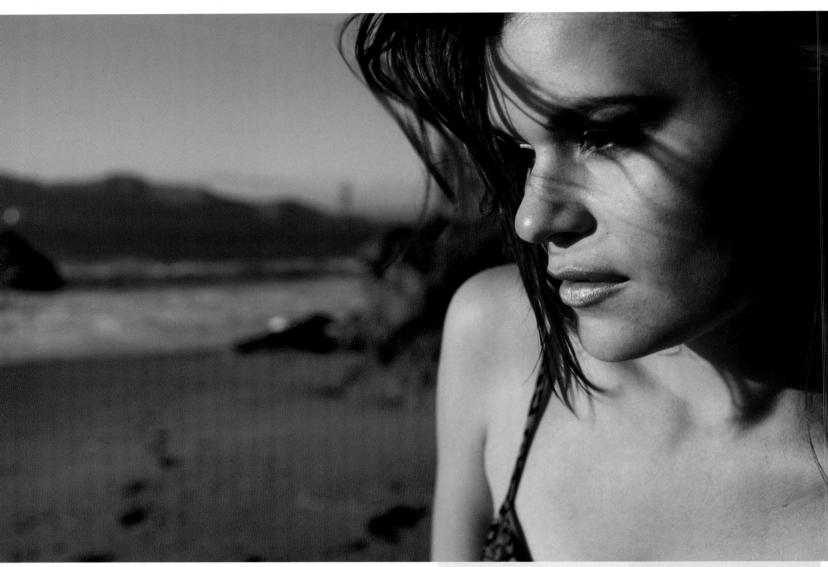

Fact file

Photographer: Patrick Roddie
Client: Portfolio work
Model: Courtney Connor
Location: China Beach, San Francisco, USA
Time of day: 30 minutes before sunset, June

Technical details

Camera: Nikon F100
Lens: 35mm f/2
Film: Fuji Velvia
Exposure: 1/125sec at f/5.6

The brief

When shooting for his own portfolio rather than a client, Patrick's aim is to show the diversity of his range and style and to capture whatever is distinctive about the model. His shoots last several hours but he usually works very simply, with a hand-held 35mm camera and only natural light.

The location

Patrick is lucky enough to have a beautiful but not over-populated beach on his doorstep, which can be used in a multitude of ways to create completely different-looking images. The light is excellent there, particularly during late afternoon and into the evening when the whole beach catches the last warm rays of sunshine.

Composition

Patrick often uses tight crops but the space to the side of the model – half the frame – is effective here. It puts her in the context of her surroundings and gives the impression that she is looking into the space. An aperture of f/5.6 ensured that she stands out distinctly from the slightly out-of-focus background.

Lighting and technique

The only light source was the setting sun, to the left of the camera and just above the horizon. This is a favourite time for Patrick, and many other photographers, because it gives a healthy and attractive golden glow to the skin. 'Typically shoots last up to six hours and the best pictures are taken towards the end, coinciding with the golden hour,' he says. 'Much of my work is getting the models to be as relaxed as possible. I hardly direct them at all and simply ask them to do their own thing and be themselves.'

Sun

Hand-held 35mm camera

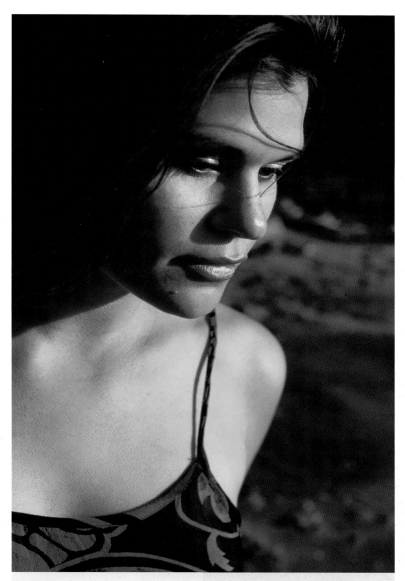

Fact file

Photographer:	Patrick Roddie
Client:	Portfolio work
Model:	Courtney Connor
Location:	China Beach, San Francisco, USA
Time of day:	25 minutes before sunset, June

Technical details

Camera:	Nikon F100
Lens:	50mm f/1.4
Film:	Fuji Velvia
Exposure:	1/60sec at f/4

Taken five minutes later than Patrick's other picture of Courtney, the sun is to the right of the camera and a little lower towards the horizon. Some photographers would have used a reflector on the left-hand side to fill in the shadows on her face and hair. In fact this dark area, and that of the cliffs in the background, adds contrast, which helps the impact of the picture. ▲

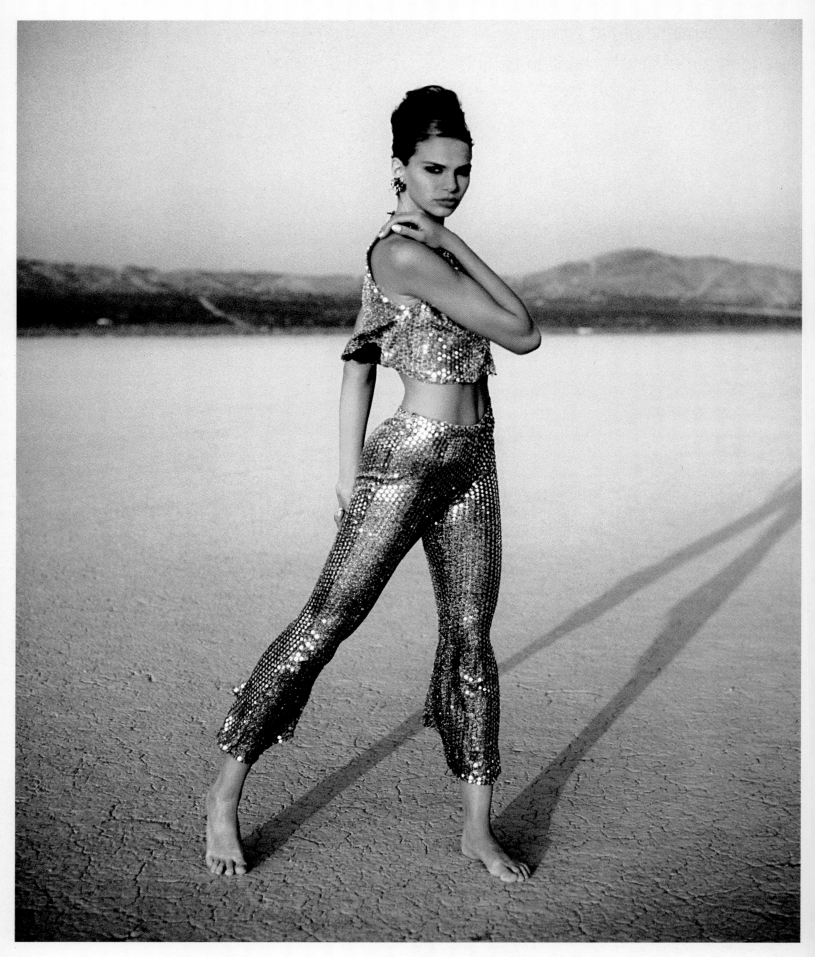

'The vast expanse of flat ground extended almost to the horizon behind us, letting us shoot until the sun had all but disappeared.'

Jeff Navarro

The brief

The fashion designer, Janet Planet, wanted some pictures for promotional purposes, to show the 'exotic, otherworldy funkiness' of her clothing. They shot a whole range of outfits during one afternoon.

The location

Planning to shoot many different outfits in one afternoon, Jeff and Janet wanted a single location that would work with all of them. It needed to be a simple background to allow the clothes, rather than the setting, to dominate in the images. The huge, flat Californian dry lake bed, El Mirage, proved ideal.

Composition

It isn't easy producing a full-length shot without any kind of prop for the model to work with. All eyes are on the pose, which the model carries off well here. The strip of land on the horizon neatly divides the top third of the image and the long shadow is a good natural device for breaking up the monotone lower background.

Lighting and technique

Apart from being a great neutral backdrop for the model and clothes, the advantage of using such a wide open space is that Jeff could carry on shooting until late in the day, with nothing to block the light or cause unwanted shadows. There are no reflectors or any other tools used here, just the low, warm-toned late afternoon sun, which makes the skin tones and the fabric of the outfit glow.

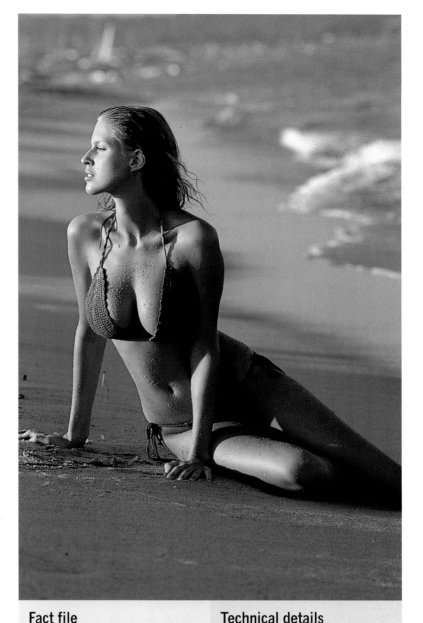

Fact file

Photographer:	Sammy Georges
Client:	Photographer's portfolio
Model:	Eva Schwaigerova, Nathalie, Paris and Profile, London
Location:	St Tropez, France
Time of day:	Late afternoon, August

Technical details

Camera:	Nikon F5
Lens:	180mm f/2.8
Film:	Kodak Ektachrome 100
Exposure:	1/125sec at f/5.6

The tourists were beginning to leave the busy beach when Sammy took this, making the most of the warm tones of the light late in the day. He positioned the model so she was backlit – her pose echoing the diagonal line of the sea. No reflectors were used to fill in the shadows as these help define the contours of her body. ▲

Fact file

Photographer:	Jeff Navarro
Client:	Janet Planet
Model:	Cara McKeown
Location:	El Mirage, Southern California, USA
Time of day:	6pm, early autumn

Technical details

Camera:	Canon A1
Lens:	50mm
Film:	Fujichrome RDP 100
Exposure:	1/60sec at f/5.6

Fact file

Photographer:	Farrokh Chothia
Client:	Personal work
Model:	Helen Brodie
Location:	Seychelles
Time of day:	11.30am

Technical details

Camera:	Nikon F3
Lens:	55mm macro
Film:	Kodak Tri X
Exposure:	Approx. 1/125sec at f/4

Sun behind tree

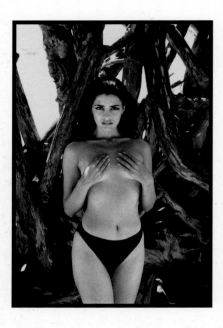

Bed sheet/reflector on ground

Hand-held 35mm camera

The brief

Taken during a shoot for Elle magazine, this was not part of the commissioned story, but a wise use of the opportunity by Farrokh. 'I always try to create at least one image for myself for every commercial job I do,' he says. 'Magazine shoots are great for this – there's always a great model with you, and the stylists and make-up people are always eager to create interesting images for our collective portfolios. It's more difficult during advertising jobs, because the pressure is pretty high – and the client doesn't like us fooling around in his or her time.'

The location

This was Farrokh's first visit to the Seychelles and he considers it one of the world's most beautiful places. 'We were shooting on one of the beaches, and I saw this amazing piece of driftwood. Actually, I think it was a tree that was once right at the water's edge, and as the water recessed over the years, it began to weather with constant exposure to wind and sand. These textures are great for black-and-white work.'

Composition

Farrokh used the tree in the background as a striking contrast between its gnarled and worn texture and the clear, almost translucent skin of the model. He chose a simple, classic pose to give the shot the appearance of a portrait.

Lighting and technique

The sun was high in the sky and direct light would have been very harsh so Farrokh positioned the model on the shaded side of the tree. He placed a bed sheet – his version of a white reflector – on the ground in front of her and this bounced back some of the sunlight that was filtering through. 'This is really a bottom-lit picture – and I really like what bottom light does to the collar bone,' he says.

'A really great and inexpensive way to get beautiful warm bounced light is to stain a bed sheet with tea. Soak it for about 15–20 minutes, wash and dry.'

Farrokh Chothia

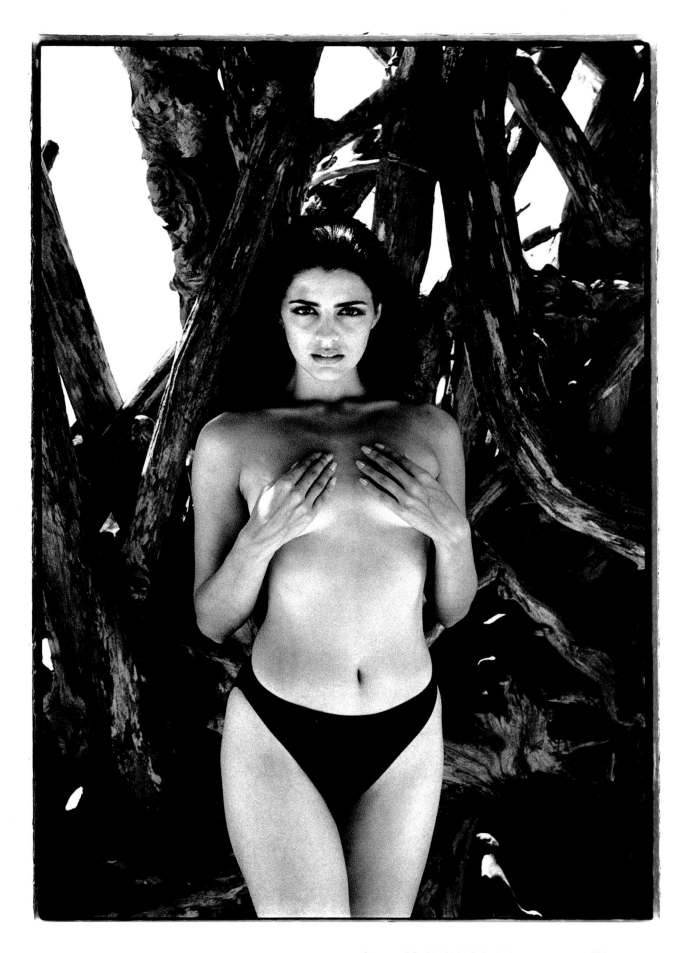

Glossary

Ambient light
The existing light on the scene without any added by the photographer.

Aperture priority
The photographer selects the aperture and the shutter speed is determined automatically.

B setting
Keeps the shutter open for as long as the release remains pressed.

Bracket
To make a series of exposures of the same subject, often at one half or one third stop intervals.

Burning in
Giving part of a print extra exposure.

Cable release
Flexible cable that screws into the camera shutter release. Allows the shutter to be fired, or held open on 'B', to reduce camera shake.

Differential focus
Using a shallow depth of field to emphasise one part of the picture by showing it sharply focused while other areas are out of focus. Also called selective focus.

Diffuser
Translucent material used to diffuse light.

Fill light
A large light source used to fill in the shadows. The light intensity is less than the main, or key, light.

Fill-in flash
A burst of flash to illuminate any areas of shadow and reduce lighting contrast.

Filter
A piece of glass or plastic fitted over the lens to modify the light passing through it.

High key
High key pictures concentrate on white or pale tones, often with flat, overall lighting to avoid shadows.

Incident light metering
Using an exposure meter from the subject position, pointing back towards the camera.

Lighting contrast
The difference between the amount of light falling on the shadow areas and the brightly-lit areas of a subject, usually measured in stops.

Medium format
Cameras that use 120 roll film, taking pictures larger than 35mm. Usually 645 (6x4.5cm picture size), 6x6 or 6x7.

Neutral density filter
Grey filter that dims the image by a known amount.

Open flash
Firing the flash manually while the camera shutter is open.

Panning
Moving the camera to follow a subject moving across the picture. Produces a relatively sharp subject against a blurred background.

Reflector
A rectangular or round sheet of white, silver or gold material or card, used to bounce light on to the subject. Also refers to a dish-shaped surround to a flash head.

Ring flash
A circular flash unit that fits around the lens to provide shadow-free lighting.

Scrim
Metal mesh attachment to lighting unit to reduce intensity.

Slow-sync flash
Combining a blurred effect from a long exposure with the freezing of motion with flash.

Softbox
A box diffuser of varying size placed over the light source to produce a large area of soft, even lighting.

Strobe
An alternative term for electronic flash.

Tungsten-balanced film
Colour film balanced to suite light sources of 3200K.

Umbrella
A special umbrella covered with highly reflective, semi-transparent material and attached to the flash unit. The flash is fired through the umbrella to soften or diffuse it and into the umbrella for reflected light.

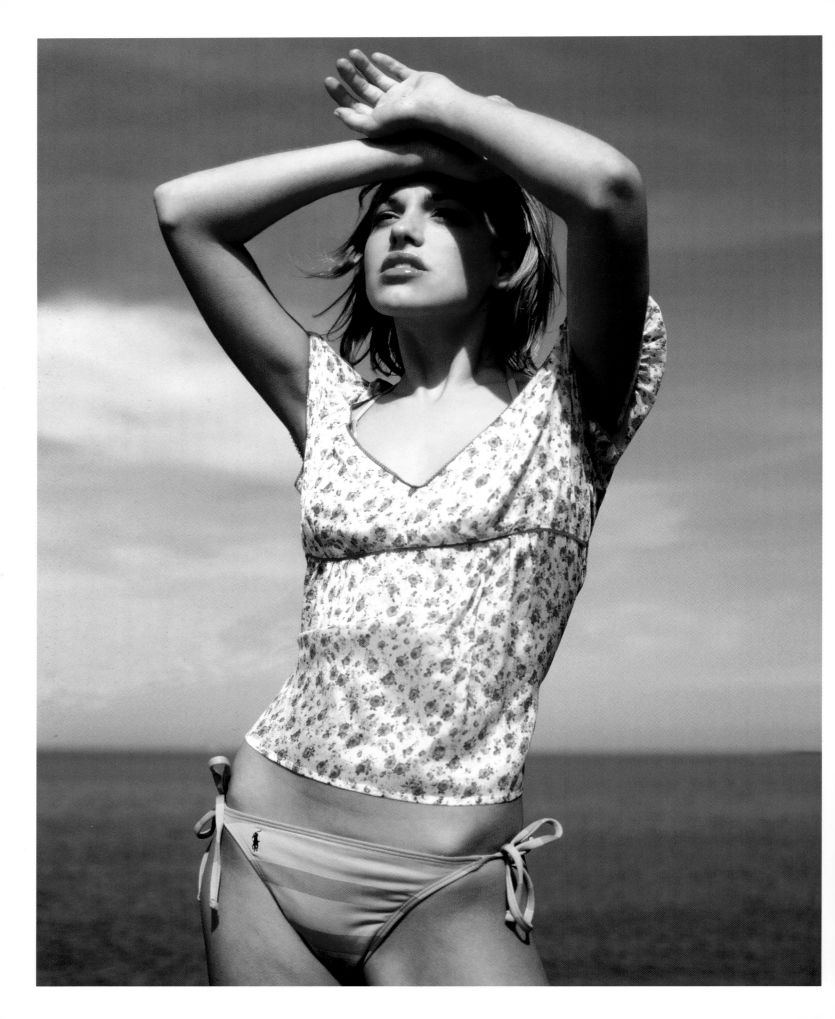

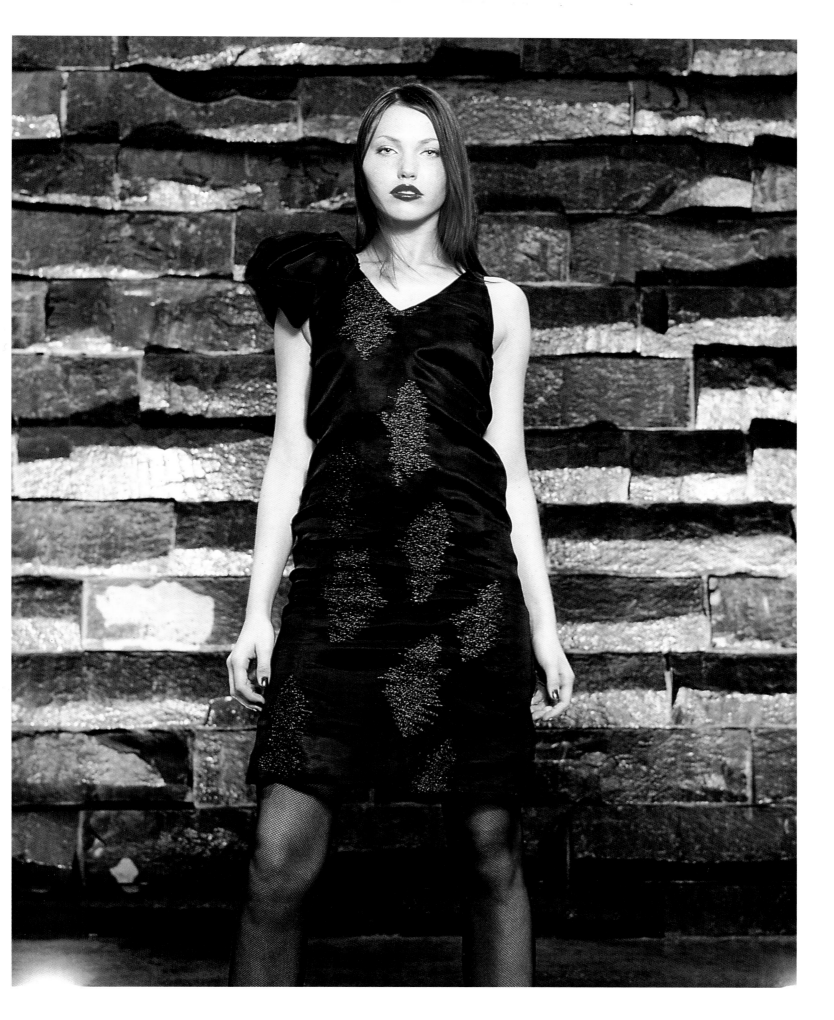

Contacts

David Anthony
Chicago, USA
email: anthonyphoto@ameritech.net
web: www.winstonwest.com
 p. 6, 7, 8, 14, 43, 58, 59, 73, 86,
 87, 100, 101, 124, 125, 128, 156, 160

Baldur Bragason
Stockholm, Sweden
email: baldur@bragason.com
web: www.bragason.com
 p. 6, 7, 46, 49, 105, 157

Cosmin Bumbut
Bucharest, Romania
email: bumbutz@bumbutz.com
web: www.bumbutz.com
 p. 17

Farrokh Chothia
Bombay, India
email: fellini@vsnl.com
web: www.farrokhchothia.com
 p. 6, 9, 93, 97, 104, 140, 143, 144,
 145, 153

Yanick Dery
Montreal, Canada
email: yanick@yanickdery.com
web: www.yanickdery.com
 p. 51

Fabien Dettori
Paris, France
email: fabiendettori@yahoo.com
web: www.chez.com/fabdettori
 p. 38–39, 50

Christian Dietrich
Zurich, Switzerland
email: cd@christiandietrich.ch
web: www.christiandietrich.ch
 p. 6, 34

Gry Garness
London, England
email: info@grygarness.com
web: www.ggarness.dircon.co.uk
 p. 6, 30, 33, 133

Sammy Georges
Paris, France
email: sammy@sammy-georges.com
web: www.sammy-georges.com
 p. 136, 151

Marco Girolami
Rome, Italy
email: info@marcogirolami.it
web: www.marcogirolami.it
 p. 47, 48, 60, 61, 69, 77, 107

Barry Gnyp
Vancouver, Canada
email: barry@gnyp.com
web: www.gnyp.com
 p. 7, 64

Kai Haase
email: kai@kaihaase.com
web: www.kaihaase.com
 p. 6, 12, 20, 21, 40, 41, 108–118, 138, 139

Albert Lewis
Oakland, USA
email: albertlewis@mac.com
web: www.albertlewisphotography.com
 p. 65

Kenn Lichtenwalter
New York City, USA
email: kenn@lichtenwalter.net
web: www.lichtenwalter.net
 p. 18, 19, 70, 71

David Maisel
San Francisco, USA
email: david@davidmaisel.com
web: www.davidmaisel.com
 p. 44–45, 130

Anthony Michel-Mautemps
New York City, USA
email: anthony@mautemps.com
web: www.mautemps.com
 p. 7, 81, 103

Jeff Navarro
Denver, USA
email: jeff@navarrostudio.com
web: www.navarrostudio.com
 p. 106, 150

Stefano Oppo
Milan, Italy
email: stefano@stefanooppo.com
web: www.stefanooppo.com
 p. 6, 74–75

John Owen
London, UK
email: johnowenuk@aol.com
web: www.fashion-photographer.co.uk
Agent: Beverley Kendall
 (beverley@pilotcreativeagency.com)
 p. 6, 22, 23, 26, 53, 78, 79, 82, 85

Patrick Roddie
San Francisco, USA
email: patrick@webbery.com
web: www.webbery.com
 p. 2, 6, 7, 8, 28–29, 35, 54, 62, 63,
 120, 134, 146, 147, 148, 149

André Schuster
Castrop-Rauxel, Germany
email: as@andreschuster.com
web: www.andreschuster.com
 p. 66, 67, 126, 127

Sam Short
Vancouver, Canada
email: images@samshortphotography.com
web: www.samshortphotography.com
 p. 25, 76, 84

Chuck Smith
Minneapolis, USA
email: chuck@chucksmithphoto.com
web: www.chucksmithphoto.com
 p. 68

Marco Tenaglia
Rome, Italy
email: marco.tenaglia@imagesystem.it
web: www.imagesystem.it
 p. 98, 99

Dorit Thies
Los Angeles, USA
email: doritt@earthlink.net
web: www.doritthies.com
 www.altpick.com/doritthies
 p. 6, 36, 37, 56, 57, 88, 90, 94–95
 102, 122–123

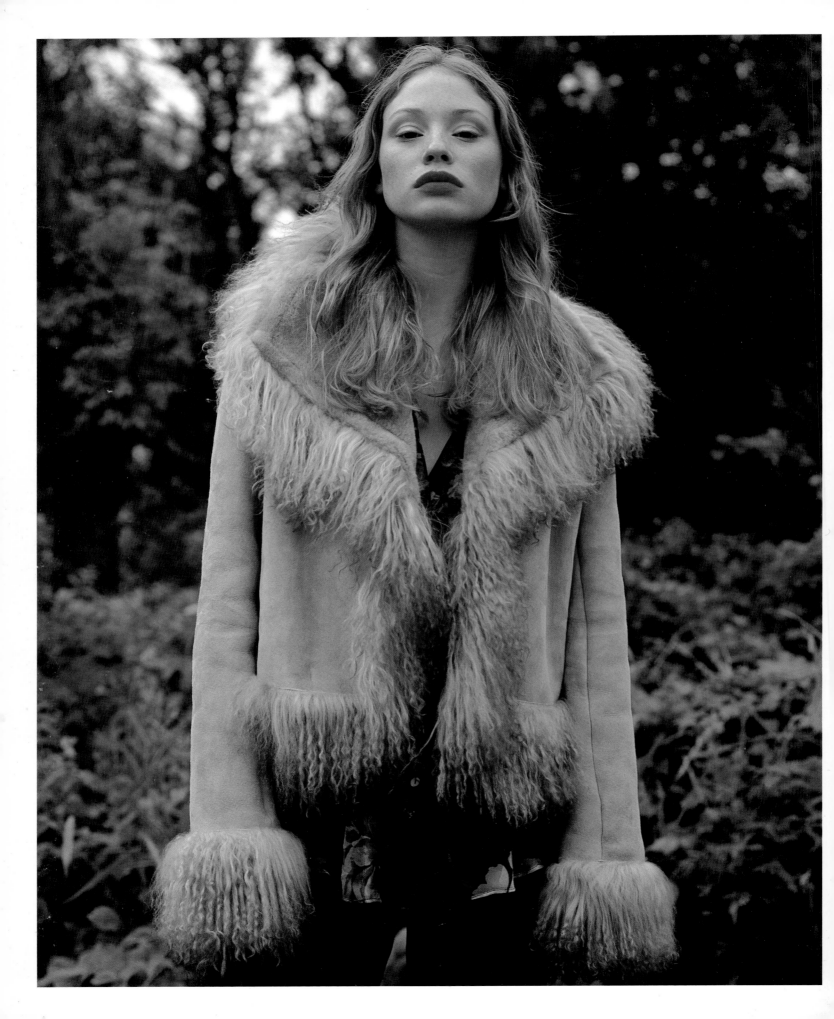